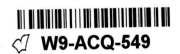
GUERCINO'S
Friar with a Gold Earring

GUERCINO'S
Friar with a Gold Earring

Fra Bonaventura Bisi
Painter and Art Dealer

David M. Stone

with contributions by Sarah Cartwright

SCALA

TheRingling

THE JOHN & MABLE RINGLING MUSEUM OF ART

STATE ART MUSEUM OF FLORIDA | FLORIDA STATE UNIVERSITY

Copyright © 2023 The John and Mable Ringling Museum of Art/Florida State University and Scala Arts Publishers, Inc.

Published to accompany the exhibition of the same title held at The John and Mable Ringling Museum of Art, October 14, 2023–January 7, 2024.

Lead support for this publication was provided by the Kathleen Binnicker Swann Foundation. Additional support for the publication and exhibition was provided by The Sir Denis Mahon Foundation, Margaret and Mark Hausberg, and The Samuel H. Kress Foundation. The exhibition was supported by the Ringling Museum endowment funds of Bob and Diane Roskamp and Steve and Stevie Wilberding, and was paid for in part by Sarasota County Tourist Development Tax revenues and the Florida Department of State, Division of Arts and Culture.

First published in 2023 by
Scala Arts Publishers, Inc.
c/o CohnReznick LLP
10th floor, 1301 Avenue of the Americas
New York, NY 10019 USA
www.scalapublishers.com
Scala—New York—London

Distributed outside of The John and Mable Ringling Museum of Art/Florida State University in the book trade by
ACC Art Books
6 West 18th Street
Suite 4B
New York, NY 10011 USA

In association with
The John and Mable Ringling Museum of Art
5401 Bay Shore Road
Sarasota, FL 34243 USA
www.ringling.org

Library of Congress Control Number: 2023935445
ISBN 978-1-78551-415-9

Edited by Susan Higman Larsen
Designed by Laura Lindgren Design, Inc.
Printed and bound in China

10, 9, 8, 7, 6, 5, 4, 3, 2, 1

FRONTISPIECE: Guercino, *Portrait of Fra Bonaventura Bisi* (detail), ca. 1658–59. Oil on canvas, 94 × 76.5 cm. The John & Mable Ringling Museum of Art, Sarasota; inv. SN11531

CONTENTS

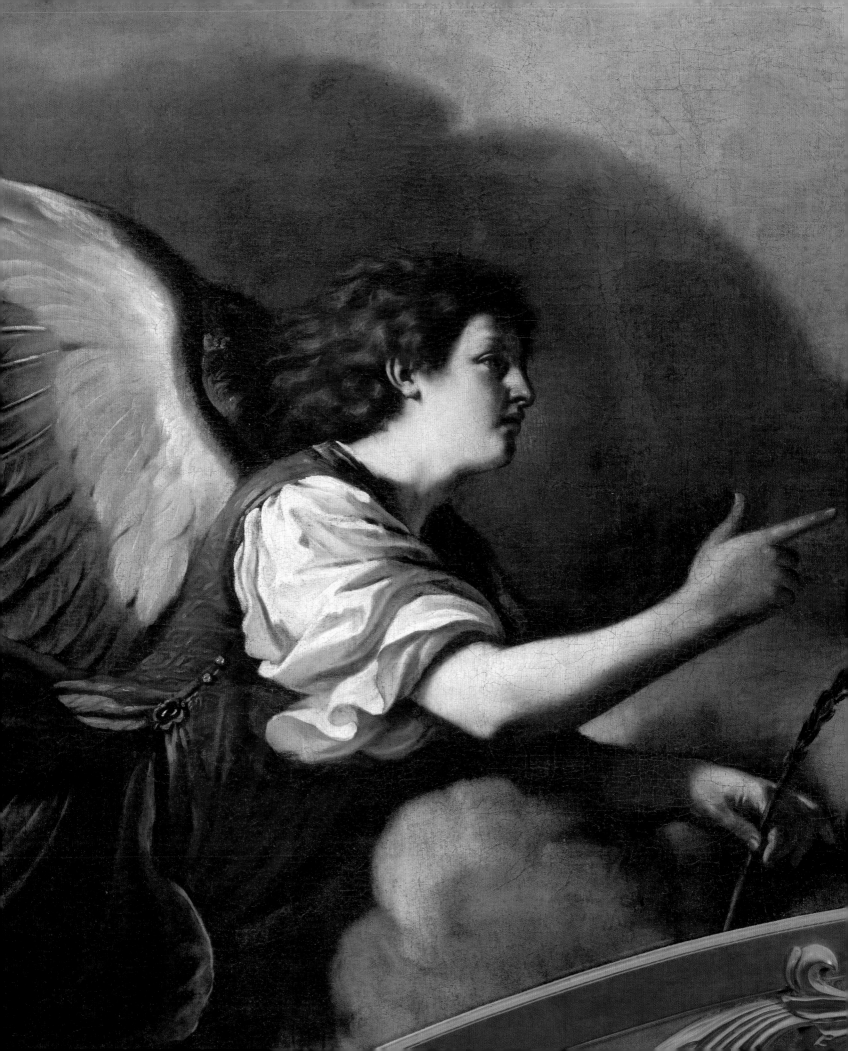

FOREWORD

At about 4:00 a.m. on December 9, 2015, our former Curator of Collections, Virginia Brilliant, and I were in my office bidding by telephone with Christie's London on a work we were keen to have for The Ringling's European collection: Guercino's *Portrait of Fra Bonaventura Bisi*, dated 1658–59. I can still recall the excitement and celebration of that early morning acquisition. Visitors to our galleries knew Guercino well through the magnificent *Annunciation* purchased by John Ringling, and I was especially pleased that we would now be able to show them the artist's remarkable talent as a portraitist. And what an unusual portrait it is: a Franciscan friar surrounded by books but who, instead of reading, is eagerly showing us drawings, while wearing a gold hoop along with his traditional tonsure and habit.

When Sarah Cartwright, our current Curator of Collections, came to me with the idea of a collaborative project with David M. Stone that would focus on the portrait, I was immediately supportive. David, a distinguished scholar of Italian Baroque art and an expert on Guercino, had uncovered much new information on Fra Bisi and had expressed interest in working with us on an exhibition and a book. This seemed the perfect way to explore our intriguing new acquisition and to shed light on the extraordinary life of Fra Bisi, a Franciscan Minor Conventual friar who was also a painter of miniatures, an art adviser to important collectors, and a friend of Guercino.

This project was delayed by the COVID-19 pandemic, and we are extremely grateful for the cooperation and flexibility of the museums, libraries, and private collectors in both the United States and Italy who agreed to lend to the exhibition. We are also grateful to Scala Arts Publishers for their continued collaboration, which has resulted in another superb Ringling publication. I want to thank David Stone for his leadership in this project, and for his extensive archival research into Fra Bisi and his milieu. For this publication, David has written two substantial essays that investigate Guercino's portrait as well as Fra Bisi's life and his importance for the collecting of drawings in seventeenth-century Italy. I also want to thank Sarah Cartwright, the Ulla R. Searing Curator of Collections at The Ringling and co-curator of this exhibition, whose two important essays here offer the first examination of Fra Bisi's earring and an up-to-date overview of Italian miniature painting in Bisi's day. Working with David, Sarah organized the loans and reproduction rights from our museum partners and managed the publication. Sarah also worked with our outstanding Collections department, led by Amanda Robinson, on loans, shipping, exhibition design, and the final installation in our galleries. Thanks also go to our Development team under the leadership of S. Mark Terman, who helped secure significant support for this project.

I am especially grateful to the Kathleen Binnicker Swann Foundation for its lead support of this publication, and for the additional support

Guercino, *Annunciation* (detail), 1628–29

for the publication and exhibition provided by The Sir Denis Mahon Foundation, Margaret and Mark Hausberg, and The Samuel H. Kress Foundation. The exhibition was supported by the Ringling Museum endowment funds of Bob and Diane Roskamp and Steve and Stevie Wilberding, and was paid for in part by Sarasota County Tourist Development Tax revenues and the Florida Department of State, Division of Arts and Culture.

Both the exhibition and book are intended to offer our visitors the opportunity to explore an important painting in The Ringling's collection in substantial depth. Such work is part of our commitment to creating original exhibitions and scholarship on our rich collections. I hope this will be a model for new projects in the future, furthering our understanding of the works acquired by John Ringling and by the many curators who followed him in building this extraordinary collection of European art.

Steven High
Executive Director
The Ringling

ACKNOWLEDGMENTS

My research on Guercino's *Portrait of a Friar with a Gold Earring* goes back three decades, when my friend Matthew Rutenberg (1956–2019)—an art adviser not unlike Bisi in his tremendous enthusiasm and great connoisseurship skills—took me to the Manhattan home of the Mezzacappa family to see their newly purchased treasure, now the focus of our exhibition and this book. In late 2015, Virginia Brilliant, then a curator at The Ringling, asked my advice about the canvas when it came up for auction. I was thrilled when the museum purchased it, and we started talking immediately about organizing a small show. After Virginia's departure, Sarah Cartwright, the new Ulla R. Searing Curator of Collections, embraced the project and has done a great job of coordinating the loans and fundraising, and moving things forward despite all the setbacks created by the pandemic. Throughout, I have benefited from the steady support of The Ringling's director, Steven High.

Many friends helped me with my research; I have neither words nor space to adequately thank them. They not only answered myriad scholarly questions and looked over challenging passages in archival documents, but were even willing to photograph works of art and pages from books when for two years I could not travel to Italy. Barbara Ghelfi—armed with crucial information graciously supplied by Fra Maurizio Bazzoni, OFM Conv., librarian at Bisi's church of San Francesco in Bologna—went all the way to Assisi to measure and photograph two virtually unknown works Bisi donated to the basilica. I am eternally grateful to her. Enrico Ghetti helped find and photograph numerous documents in the Modena archive. Sheila Barker, Daniele Benati, Jonathan Bober, Babette Bohn, Perry Chapman, David Ekserdjian, Joseph Farrell, Ignacio José García Zapata, Laura Giles, Edward Goldberg, Fausto Gozzi, Florian Härb, Tim McCall, Mark McDonald, Rachel McGarry, Raffaella Morselli, Louise Rice, and many others thanked in the notes, gave generously of their time and expertise.

Access to Bisi's miniatures and prints, and to the drawings he offered or sold to the Estensi and Medici, was only possible because of the support of curators in several institutions. I am forever indebted to Federico Fischetti, curator at the Galleria Estense, for whom no question was too small, no favor too time-consuming. His knowledge of the Modena context was invaluable. Much the same can be said of Cristina Roccaforte, archivist at the Centro di Documentazione Francescana (Archivio della Basilica e Sacro Convento) at Assisi. I also thank Fra Thomas Freidel, OFM Conv., at the Museo del Tesoro, Assisi, for facilitating my work. The team at the Gabinetto dei Disegni e delle Stampe at the Uffizi, Florence, especially Laura Donati and Maria Elena De Luca, made my days examining drawings there a joy. Thanks also to Alessandra Curti and Clara Maldini at the Biblioteca Comunale dell'Archiginnasio, Bologna.

For photographs and various *cortesie*, I am much obliged to Christopher Apostle, Christa Aube, Benedetta Basevi, Francesco Bonetti, Corey Brennan, Danielle Carrabino, Lavinia Ciuffa, Pietro Di Natale, Giancarlo Fabbri, Mariaelena Gabuzzini, Joshua Glazer, Sebastian

Hierl, Victor Hundsbuckler, Stéphane Loire, Lorenzo Lorenzini, Louis Marchesano, Angelo Mazza, Giorgia Menghinella, Francesco Minarini, Catia Morganti, Felicity Myrone, Riccardo Naldi, Barbara O'Connor, Francesca Piccinini, David Pollack, Catherine Puglisi, Tiffany Racco, Manuela Rossi, Tiziana Sassoli, Robert Simon, Eve Straussman-Pflanzer, Cecilia Treves, Aidan Weston-Lewis, and Linda Wolk-Simon. And I cannot fail to mention two of my PhD advisees at the University of Delaware, Gabriella Johnson and Erin Hein: they helped track down and scan articles and huge chunks of exhibition catalogues when they were supposed to be writing their dissertations. I can only hope that in the near future they, in turn, will have such wonderful students.

John Marciari, between marathons and Piranesi, gave me encouragement and detailed advice on every aspect of this project. I hope he finds evidence herein of how much I benefited from his guidance and deep knowledge. Lastly, my wife Linda Pellecchia, besides keeping me focused on the things that matter, was never too busy to help with transcriptions, translations, and the interpretation of works of art. I am forever grateful to her.

David M. Stone
Professor Emeritus
University of Delaware

I would like to thank above all David Stone for suggesting this collaboration and for sharing his ideas and knowledge with me, and Steven High for his steadfast support of the project. I thank Jennifer Norman and Beth Holmes, of Scala Publishers; editor Susan Higman Larsen; and designer Laura Lindgren for creating such a beautiful publication. Kyle Mancuso deserves special thanks for his work to obtain comparative images and his invaluable help with research and language questions. Christian Lunardi provided the exceptional new photographs of Guercino's *Annunciation* and *Portrait of Fra Bonaventura Bisi* reproduced here. For their help in bringing this book to fruition, I thank former Ringling colleagues David Berry and Jemma Fagler, and current ones Sydney Lemelin, Michelle Young, Elisa Hansen, Chris Bonadio, and Jay Boda. For their work on the exhibition, I am indebted to the expert staff in our Collections Department, especially Ellie Bloom, Amanda Robinson, Heidi Taylor, William Rollins, and Keith Crowley, as well as our conservators Barbara A. Ramsay and Emily Brown. I thank my curatorial colleagues at The Ringling for their support, insight, and wise counsel. My PhD adviser, Jonathan J. G. Alexander, was never far from my thoughts while writing about miniature painting, and I am grateful for the opportunity to learn from him. Finally, I thank my mother and my daughter for their patience, love, and support.

Sarah Cartwright
Ulla R. Searing Curator of Collections
The Ringling

ABBREVIATIONS

ASF — Archivio di Stato, Firenze
ASMo — Archivio di Stato, Modena
BCABo — Biblioteca Comunale dell'Archiginnasio, Bologna
c. — carta
ca. — circa
CdA — Carteggio d'Artisti (artists' correspondence)
doc. — documento
fasc. — fascicolo (fascicule)
fol./fols. — folio/-s
inv. — inventory number
MAP — Medici Archive Project

MdP — Medici del Principato
MS — manuscript
n./nn. — note/-s
OFM. Conv. — Ordo Fratrum Minorum Conventualium (Ordine dei Frati Minori Conventuali; Order of Friars Minor Conventuals)
r — recto
v — verso

NOTE: Dimensions are height before width.
For prints, measurements are for image (including inscriptions) unless otherwise stated.

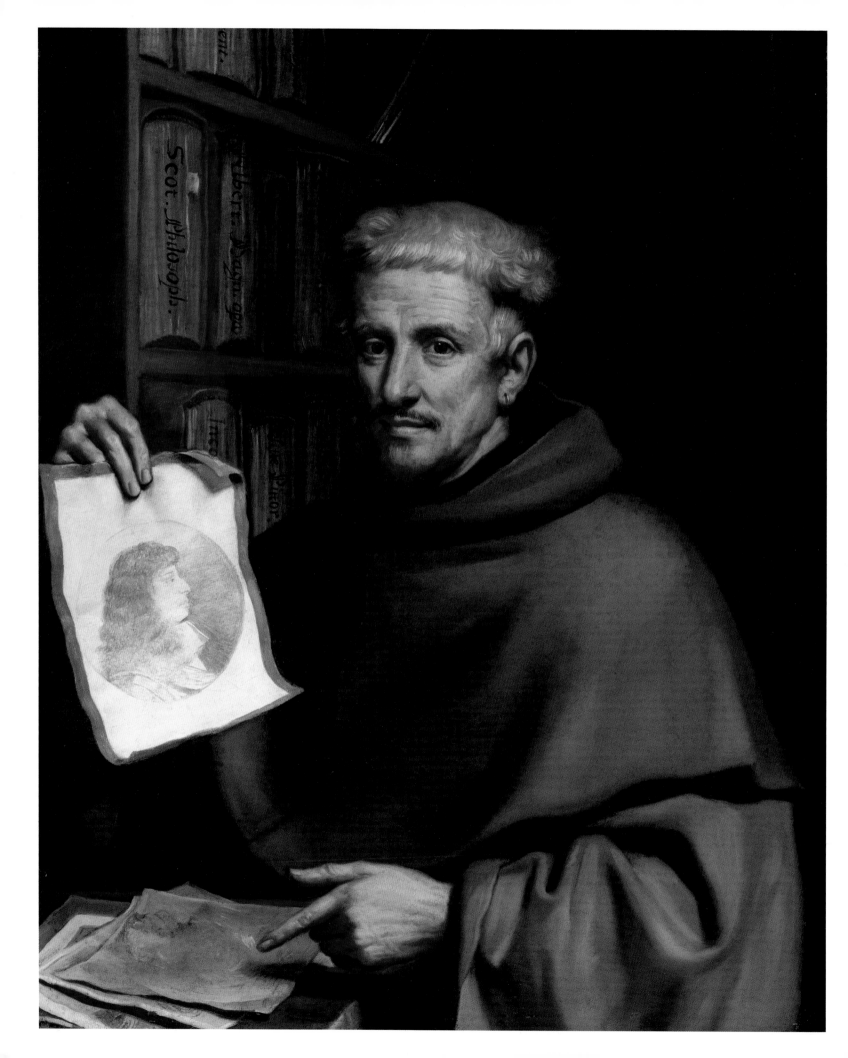

Guercino's *Bisi*

David M. Stone

The Portrait: Style and Meaning

The Ringling's portrait of a friar with a gold earring by Guercino (1591–1666) presents the viewer with a puzzle.[1] In the painter's soft, shaded colors, laid down with gentle brushwork, a Franciscan with a thin mustache and hints of a goatee, wearing the gray habit of the Minor Conventuals, stares back, almost smiling, at the viewer (fig. 1). Situated in a small space—perhaps a monastic cell—the man with a shaggy, gray tonsure and, oddly, a gold hoop earring stands before a plain bookcase crammed with thick, impressive tomes shelved on their fore edges. Though partially cast in shadow, the titles inscribed on the books' head or tail edges are decipherable.[2] They are works by venerable theologians and philosophers, such as Duns Scotus, Albertus Magnus, and (at top, possibly) St. Bonaventure.[3] The massive book slightly obscured by the friar's hair is not from a medieval writer but a rising star among the Conventuals, the local theologian Bartolomeo Mastri, called Il Meldola (1602–1673).[4] Just above the sitter's shoulder are two common sixteenth-century art sources, one by Sebastiano Serlio and the other, presumably, the *Vite de' Pittori* by Giorgio Vasari (1511–1574). The books are curated indices of the dual occupations of the sitter.

The aged friar, with tired eyes and sunken cheeks—he looks about sixty—stands slightly behind and to the right of a table, upon which rests a tantalizing pile of exquisitely rendered

drawings. Guercino knew that to paint drawings is not only an act of virtuosity but also a clever conceit about artistic practice (line versus color) and a semiotic brain teaser.

The variety and mounting of the drawings deserve attention. Some are clearly in red chalk on buff paper; one—the third from the top—seems, from the tiny fragment poking out, to be in pen and brown ink and wash. The drawing on top, the profile of a woman with a long neck, done in black chalk with white highlights on blue paper, suggests the work of Parmigianino (1503–1540), arguably the most revered draftsman among collectors in Emilia. At least two of these sheets appear to have white borders, which, in Guercino's optical shorthand, indicate drawings carefully cut, with a bit of margin, from larger sheets of white paper to which they had been glued down. To a connoisseur, these are the signs of an Old Master drawing that had been—as were so many since the late Cinquecento—part of an album. The iconography is clear: the friar with a gold earring collects and/or sells drawings. One could not be blamed for concluding that the fiction Guercino has invented here is that the man is giving a sales pitch or consultation. But some of the clues provided by the picture have yet to be considered.

In his right hand, the friar holds up an elegant red chalk drawing mounted on blue paper. The sheet depicts the bust of a handsome young man

FIG. 1 Guercino, *Portrait of Fra Bonaventura Bisi*, ca. 1658–59. Oil on canvas, 94 × 76.5 cm.
The John & Mable Ringling Museum of Art, Sarasota, Museum purchase, 2015; inv. SN11531

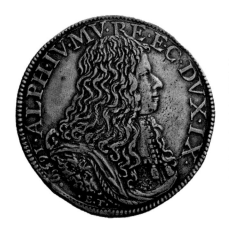

FIG. 2 Elia Teseo, Ducatone, 1659. Silver, 31.46 g, 45.1 mm (diam.). Private collection (courtesy Numismatica Ars Classica, Zurich-London)

set within a circle, shown in strict profile facing right. This format is often associated with medals or coins of rulers, and everyone in Guercino's Bologna would have recognized the young aristocrat with flowing, curly hair as Alfonso d'Este (1634–1662). By the time this portrait was likely made, he had become Duke Alfonso IV, ruler of Modena and Reggio, his father Duke Francesco I (1610–1658) having died when Alfonso was nearly twenty-five. A 1659 coin shows Alfonso at roughly the same age as in the painting (fig. 2).[5]

In 1992, when the canvas first came to the attention of scholars and appeared at auction, the legendary Guercino expert Denis Mahon identified the sitter as Fra Bonaventura Bisi (1601–1659).[6] A Minor Conventual at the Chiesa di San Francesco in Bologna, Bisi was a well-known miniature painter, engraver, and art adviser-dealer to the Estensi and Medici.[7] He was nicknamed "il Pittorino," a punning reference to his miniatures and an endearing diminutive of the Italian word for painter. He was actively engaged with selling works to Alfonso years before Francesco died, but the gesture Bisi performs here of "raising up" a regal image of the young prince for admiration conveys the idea that Alfonso has suddenly "risen" in stature. Bisi's dual gestures construct a clever idea, tying the drawings on the table "for Alfonso" with another drawing that "is" Alfonso. Bisi is the conduit between the two.

A rare engraving by Domenico Maria Muratori (1661–1742) reproduces Guercino's portrait in reverse, introduces variations (such as an oval format), and identifies Bisi in the flattering inscription: "You will have an image of Father Bonaventura Bisi of Bologna not from paper [i.e., this print], but from altars, Academies, and Museums" (fig. 3).[8] Strangely, Muratori did not acknowledge the author of the painting that served as his source. The print now uniquely showcases, with its panoply of artist tools, Bisi's identity as a painter. Instead of holding up a drawing of a patron, the friar, still with his earring, presents a work on paper or parchment of the Madonna and Child in a tondo. The top image in the pile to which Bisi points might be a portrait of one of the friar's favorite artists, Guido Reni (1575–1642).

The provenance of The Ringling portrait must now include new evidence. In about 1760, Marcello Oretti described the painting as hanging in a room adjacent to the sacristy in San Francesco. Oretti also mentions Muratori's print and the red chalk "testa" being held up in the painting, but he thought Guercino's canvas was a self-portrait by Bisi.[9] Two publications, from 1827 and 1869, respectively, list the work as a portrait of Bisi by Guercino in the Aldrovandi collection in Bologna.[10] It is not known how or when the picture left the church and wound up with the Aldrovandi. Since Guercino's painting is not registered in the *Libro de' conti* (Guercino's account book, which lists payments for works from 1629 to 1666), or mentioned by his biographer Carlo Cesare Malvasia in the *Felsina Pittrice* (1678), it is a mystery who commissioned it and where it was originally meant to hang. Guercino and Bisi were friends,[11] and the portrait may have been a gift, which would explain its absence from the account book. However, Bisi supplied lapis lazuli (to make ultramarine pigment) to artists, including Guercino, who painted works for Bisi in exchange for this expensive mineral.[12]

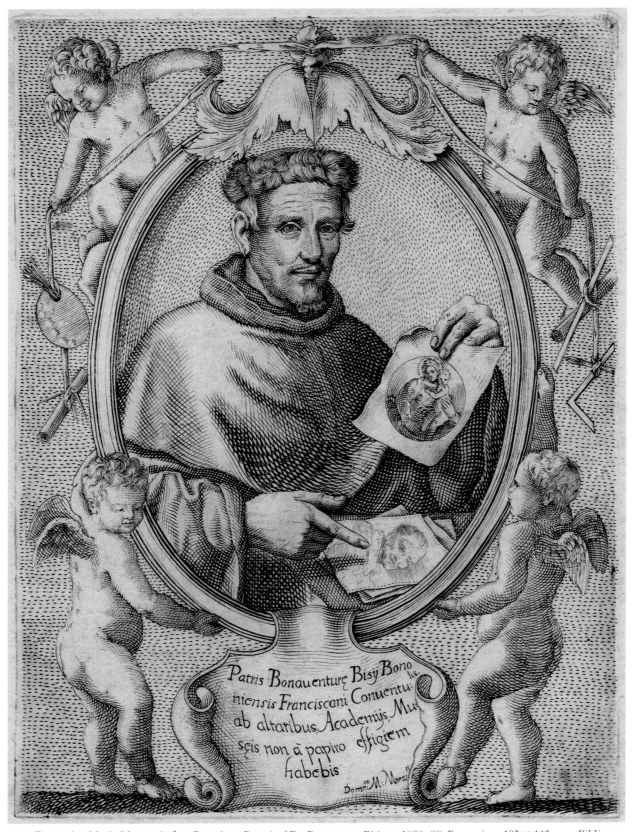

FIG. 3 Domenico Maria Muratori after Guercino, *Portrait of Fra Bonaventura Bisi*, ca. 1680–89. Engraving, 185 × 143 mm. Biblioteca Comunale dell'Archiginnasio, Bologna; Collez. Ritratti, b.7, fasc. 77, n. 2

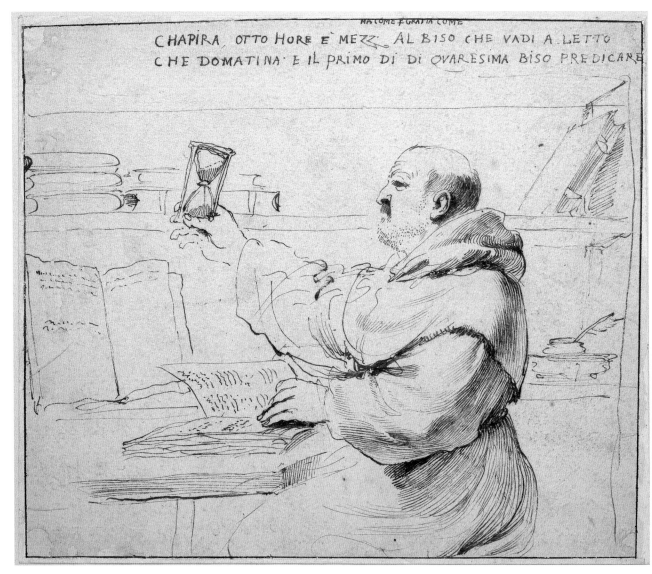

FIG. 4 Guercino, *Caricature of Fra Bonaventura Bisi*, ca. 1640. Pen and ink, 198 × 237 mm. Ashmolean Museum, Oxford; inv. KTP870

Exchanges are not recorded in the *Libro*. Perhaps Fra Bisi ordered the work and intended to present it to Alfonso in celebration of the latter's recent elevation to duke and as a testament to the ruler's great passion for collecting drawings. The iconography and rhetoric of the painting suggest this. If true, the friar's death soon after may have derailed the plan, and the picture did not make its way to Modena.

Guercino may have portrayed Bisi—often called Biso, Bigio, and Bigi in documents—in two humorous drawings. In neither does the sitter's physiognomy resemble that shown in The Ringling canvas or the Muratori print, both essentially unknown works when these drawings were connected to the friar. The first, of ca. 1640, depicts a Franciscan suddenly aware of the time while preparing a sermon (fig. 4).[13] The identity of the sitter

as Bisi derives from the punning caption, which translates roughly as "Really? Come on; Really? It's 8:30; Biso get to bed; tomorrow morning is the first day of Lent and you have to [BISOgna] preach." Because of his name, Bisi is already a bit of a pun: the color of the Conventuals' habit, by statute, was "bigio" (gray), which in Emilia was often pronounced "biso." Moreover, a common word for a Franciscan friar was "un frate bigio" (or biso). Thus, this drawing could be making fun of any friar, not necessarily Bisi. The second drawing, a superb example of Guercino's line-and-dot technique, is possibly a bit earlier in terms of style, and the figure looks younger (fig. 5).[14]

If the drawings do depict Bisi, which I doubt, their lack of resemblance with the man in Guercino's painting could be the result of the sitter having not only aged, but become ill and lost weight. Bisi's letters mention maladies, including what may have been kidney stones[15] and possibly a stroke or paralysis ("una discesa nelle Guance") that left him unable to open his mouth. He wrote about the latter on March 11, 1659, to Alfonso: "I hope this passes soon or I'm going to pass."[16] Malvasia refers to the aged Bisi as "decimato" (destroyed).[17]

The painting's date likely falls between 1658, when Alfonso became duke, and Bisi's death on December 5, 1659. Guercino's documented pictures of about this time are perfectly consonant in style with the Bisi portrait. A good example is his *Self-Portrait before a Painting of "Amor Fedele et Eterno,"* painted in 1655 for the Venetian connoisseur Donato Correggio (fig. 6), one of the few portraits listed in Guercino's account book.[18] The brushwork in the face, hair, and hands is similar to the handling of these areas in The Ringling canvas, although the effects of light and color are softer and more delicate in the latter. Guercino's characterization of Bisi is intimate, naturalistic, and charged with great humanity, whereas the self-portrait, by contrast, seems almost awkwardly

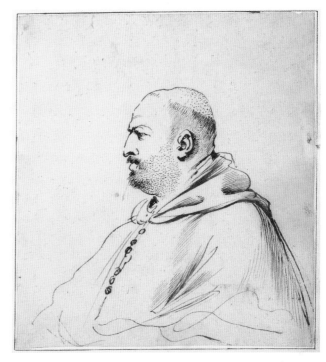

FIG. 5 Guercino, *Unshaven Monk*, ca. 1630–50. Pen and ink, 177 × 165 mm. Princeton University Art Museum; inv. x1948-1308

formal. Giovanni Francesco Barbieri got his nickname, Il Guercino, "the squinter," because of his cross-eyed condition (a strabismus). I think he generally avoided images of himself, and here he seems uncomfortable, squeezed in and dwarfed by the painting on his easel. The rendering of the dog is unsurpassed in Guercino's oeuvre, and we can only wish he had done more pictures of animals.

Another work of 1655 is the recently discovered *Portrait of Canon Girolamo Giraldi of Cento* (fig. 7).[19] With its marvelous face, penetrating eyes, and carefully observed gray hair, it is perhaps an even better comparison with the Bisi portrait. Guercino's handling of this powerful cleric's drapery, full of complex folds, is astonishing, capturing a broad range of tonalities within the blacks that few Seicento painters could rival.

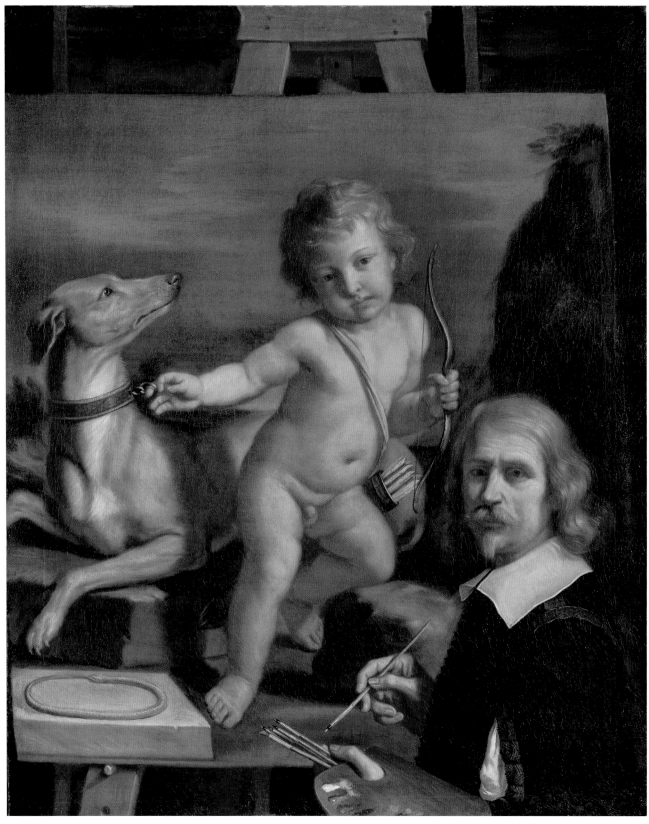

FIG. 6 Guercino, *Self-Portrait before a Painting of "Amor Fedele et Eterno,"* 1655. Oil on canvas, 116 × 95.6 cm. National Gallery of Art, Washington, DC; inv. 2005.13.1

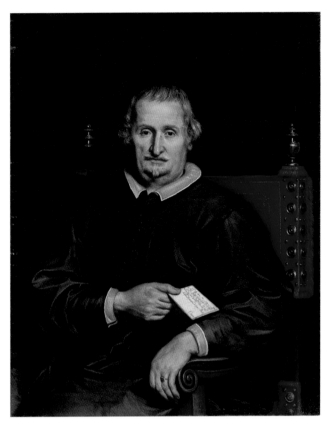

FIG. 7 Guercino, *Portrait of Canon Girolamo Giraldi of Cento*, 1655. Oil on canvas, 99.5 × 79.5 cm. Private collection (courtesy Sotheby's)

Bisi as an Artist

Guercino's flattering image of Bisi as the learned and religious connoisseur-dealer to the ruler of Modena provides no clue that the sitter was also a serious painter. Antonio di Paolo Masini called the friar a "most famous miniaturist, whose works were desired by great princes."[20] Malvasia said of Bisi:

> He made miniatures of the works of Guido [Reni] and thus experienced his heavenly ideas, and preserved intact the perfection of the contours, which was an astonishing thing. Even Reni enjoyed them, and the friar created a following for these delightful,

tiny things among Religious and other art-lovers; extending all the way to giving them as gifts not only to local rulers but to [Pope] Urban VIII.[21]

What follows is a brief analysis of Bisi's parchment paintings and two fascinating prints.[22] But first, a discussion of the context in which Bisi launched his artistic career before taking his vows in about 1619–20.[23]

BISI'S BOLOGNA AND THE CARRACCI REVOLUTION

Bisi was born on October 9, 1601, in Bologna, not far from the church of San Francesco, where he would spend most of his life. His father, Antonio, was a shoemaker. Bisi grew up during a pivotal moment in Bologna's artistic history. The city—with its tall towers, famous university, naturalist collections, and recent leadership by Archbishop Paleotti in the Catholic Reform—had just experienced one of the most important artistic revolutions in Italian history. This was the naturalist, anti-*maniera* art movement and Academy founded in 1582 by Ludovico Carracci and his two younger cousins, Agostino and Annibale. From them came such illustrious students as Guido Reni, Domenichino, Francesco Albani, and Alessandro Tiarini. After first studying with Bartolomeo Passerotti (1529–1592), Lucio Massari (1569–1633), a brilliant but under-appreciated painter, moved to the Carracci Academy. He would become Bisi's teacher, probably in about 1615.[24]

Like Annibale, Massari had many stylistic modes, which he varied according to size, subject, and context. He was capable of medium-size, distilled pictures featuring a Carraccesque landscape and classicizing treatment of the body, as in a compelling *Penitent St. Jerome* of ca. 1613, once attributed to Domenichino (fig. 8).[25] A prolific frescoist, he also created large canvases of a theatrical character with terrific costuming, like

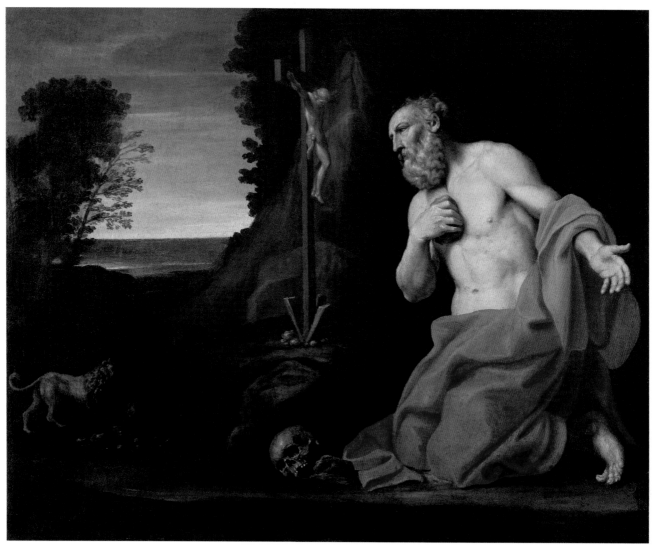

St. Paul Exhorting the Ephesians to Burn Heretical Books (fig. 9), an impressive work of around 1612.[26] In addition, Massari painted some of his religious scenes as images of ordinary domestic life, reminiscent of compositions by Federico Barocci (1535–1612) and the early Carracci. This is best seen in his charming *Holy Family doing the Wash* ("La Madonna del Bucato") of about 1620 (fig. 10).[27]

As Bisi matured, we infer, he fell in love with Guercino's early works in Cento, much inspired by Ludovico, such as *St. Peter Receiving the Keys from Christ* of 1618 (fig. 11).[28] Guercino soon became famous not only for dynamic compositions charged with pyrotechnics of light and dark, executed with a loaded brush, as in his masterpiece *Samson Captured by the Philistines* of 1619 (fig. 12),[29] but also for his inimitable preparatory

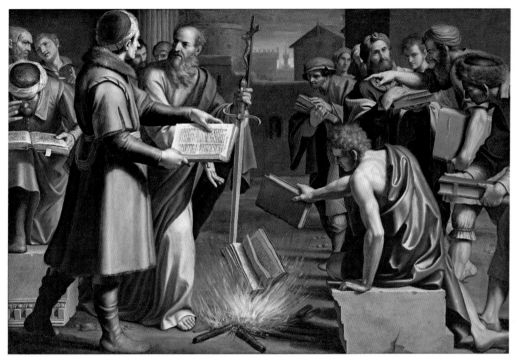

FIG. 9 Lucio Massari, *St. Paul Exhorting the Ephesians to Burn Heretical Books*, ca. 1612. Oil on canvas, 193 × 277.5 cm. Galleria Fondantico, Bologna

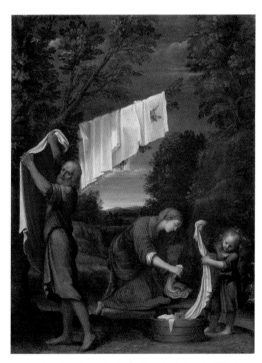

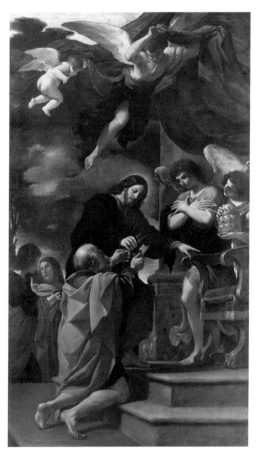

FIG. 10 Lucio Massari, *Holy Family doing the Wash* ("La Madonna del Bucato"), ca. 1620. Oil on canvas, 52.7 × 38.8 cm. Uffizi, Florence; inv. 6719

FIG. 11 Guercino, *St. Peter Receiving the Keys from Christ*, 1618. Oil on canvas, 378 × 222 cm. Pinacoteca Civica, Cento

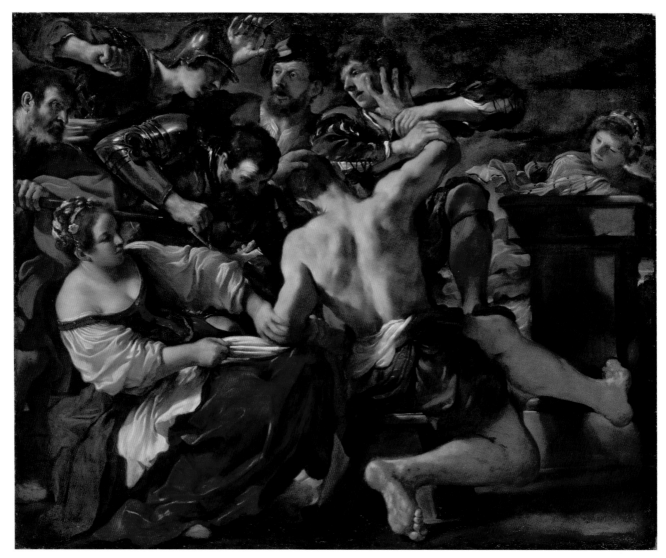

FIG. 12 Guercino, *Samson Captured by the Philistines*, 1619. Oil on canvas, 191.1 × 236.9 cm. Metropolitan Museum of Art, New York; inv. 1984.459.2

drawings, such as a newly discovered sketch for the *Samson*—a whirlpool of energy in pen and wash—recently on the art market and now in the Metropolitan Museum (fig. 13).[30] If Bisi traveled to Rome,[31] he would have marveled at Guercino's 1621 fresco for the family of the recently elected Bolognese pope Gregory XV Ludovisi (1621–23), which celebrates the new age ushered in by their pontificate with an allegory of *Aurora* (fig. 14).[32]

After Guercino returned from Rome in 1623, Bisi would witness firsthand the Cento master's slow transition toward a brighter palette, clearer shading, and more opulent, crystalline drapery structure, as seen in The Ringling's elegant *Annunciation*, made for Reggio Emilia in 1628–29, the very years when the style shift became complete (fig. 15).[33]

Guercino's late style sought to emulate the ethereal beauty of paintings by Guido Reni.

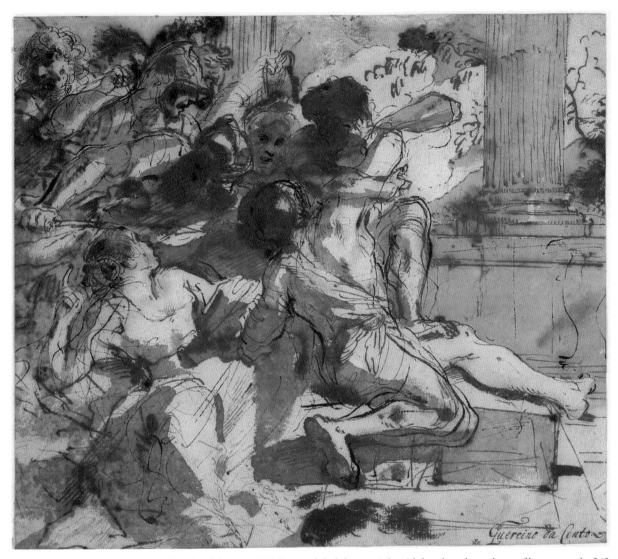

FIG. 13 Guercino, *Samson Captured by the Philistines*, 1619. Pen and dark brown ink with brush and two hues of brown wash, 243 × 280 mm. Metropolitan Museum of Art, New York; inv. 2018.196

The latter's mature work, such as *Virgin Nursing the Christ Child* of about 1628–30, made him the most esteemed artist in Emilia, perhaps in Italy (fig. 16).[34] Based on Bisi's works, letters, and Malvasia's comment quoted earlier, it is safe to say that the friar would have swooned over this stunning painting in Raleigh, once owned by King Philip IV of Spain and displayed in the Escorial.

BISI: TALENTED PRINTMAKER

Two prints are known by Bisi, both signed. The first is a refined *Holy Family with St. Elizabeth and the Infant St. John the Baptist*, dedicated to the eminent antiquarian Cassiano dal Pozzo. It was printed in 1631 (in two states) and then again in 1634 (fig. 17).[35] Bisi's *Holy Family* has been said by De Vesme and others to be based on the 1565 engraving by Oselli (Gaspar ab Avibus; born

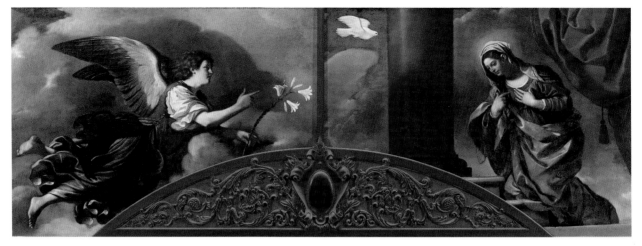

FIG. 15 Guercino, *Annunciation*, 1628–29. Oil on canvas, each section: 193.7 × 276.2 cm. The John & Mable Ringling Museum of Art, Sarasota, Bequest of John Ringling, 1936; inv. SN122

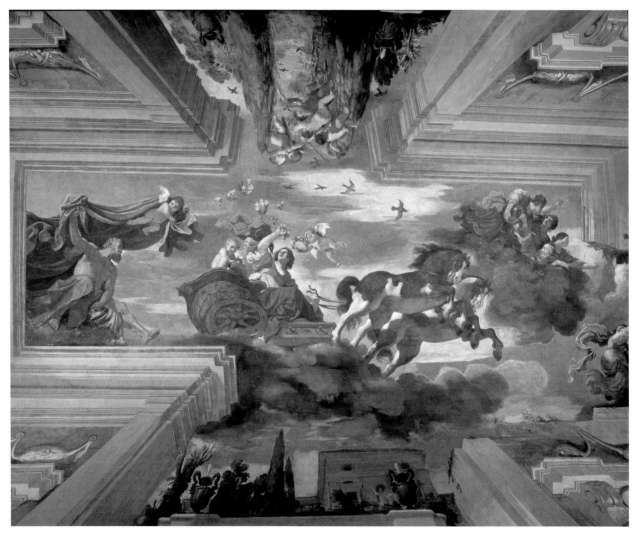

FIG. 14 Guercino, *Aurora*, 1621. Ceiling fresco (mix of fresco techniques, oil). Casino Ludovisi, Rome (courtesy HSH Princess Rita Boncompagni Ludovisi)

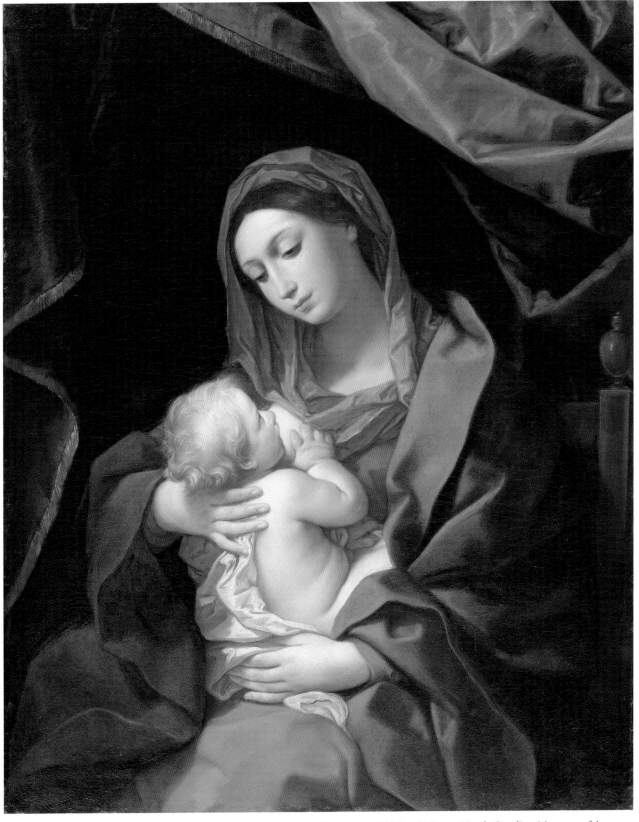

FIG. 16 Guido Reni, *Virgin Nursing the Christ Child*, ca. 1628–30. Oil on canvas, 114.3 × 91.4 cm. North Carolina Museum of Art, Raleigh, Gift of Mr. and Mrs. Robert Lee Humber in memory of their daughter, Eileen Genevieve; inv. G.55.12.1

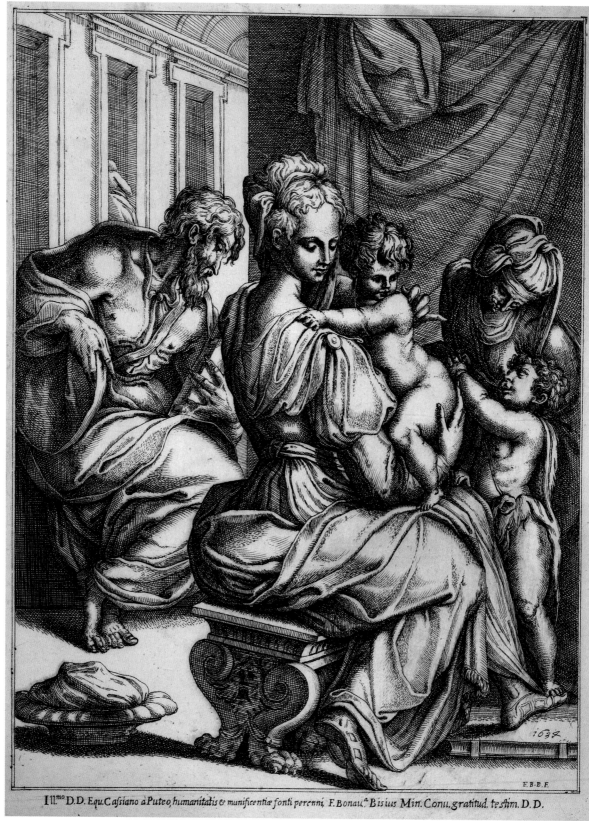

Ill.^{mo} D.D. Equ. Cassiano à Puteo, humanitatis & munificentiæ fonti perenni, F. Bonau.ᵃ Bisius Min. Conu. gratitud. teſtim. D. D.

FIG. 17 Fra Bonaventura Bisi after Vasari, *Holy Family with St. Elizabeth and the Infant St. John the Baptist*, 1634. Engraving with etching, 335 × 264 mm. British Museum, London; inv. Ii,5.138

FIG. 18 Gaspare Oselli (Gaspar ab Avibus) after Vasari, *Holy Family with St. Elizabeth and the Infant St. John the Baptist*, 1565. Engraving, 311 × 219 mm. National Galleries of Scotland, Edinburgh; inv. P 5360

FIG. 19 Giorgio Vasari, *Holy Family with St. Elizabeth and the Infant St. John the Baptist*, ca. 1540–45. Pen and brown ink, brown wash, heightened with white, over black chalk, on blue paper, 332 × 227 mm. Museum Heylshof, Worms; inv. 133

ca. 1536) after a design by Vasari (fig. 18),[36] but this is not correct. It can be demonstrated that Bisi's work directly reproduces Vasari's drawing (fig. 19).[37] First, both prints are in reverse of Vasari's sheet. Second, whereas Oselli's print shows the Madonna's left hand, near the Child's shoulder, extending two fingers, Vasari's drawing and Bisi's reproduction of it show only her pinky extended. Finally, only Bisi's print includes the haunting figure in robes, shown in profile, seated in a niche above Joseph's shoulder, on the right in the Vasari (a figure the latter put in for scale?).

Early attributions of the Vasari drawing were to Parmigianino—the Madonna's long, twisted neck is nearly a direct quote of the latter's works. I hypothesize that Bisi, for whom Parmigianino was his "idolo," purchased this drawing or a fine copy of it—unaware that it was by Vasari—and, with pride of ownership, made this successful engraving.

Bisi's second print, of about 1638–40, is so rare it is only known in one impression, preserved in the great album of architectural prints assembled by Cassiano dal Pozzo, the *Speculum Romanae*

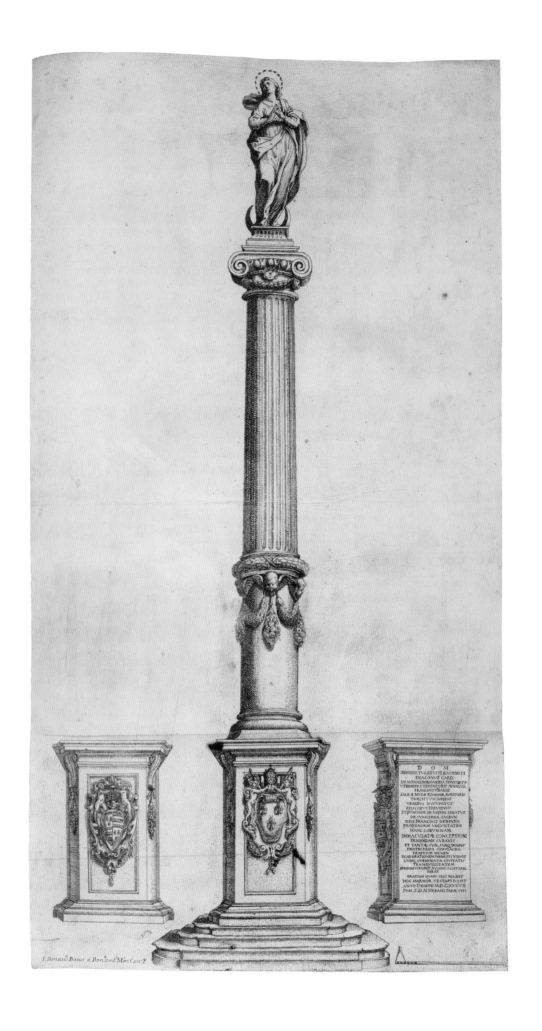

Magnificentiae (fig. 20).[38] This tall plate of the *Column of the Virgin of the Immaculate Conception* depicts the monument in Piazza della Seliciata (today Piazza Malpighi), adjacent to Bisi's church of San Francesco (fig. 21). The brick column, with carved macigno capital and base, was built by Francesco Dotti in 1636–38, during the pontificate of Urban VIII, whose arms (with Barberini bees) are featured prominently on the front. Commissioned at great expense by the friars at San Francesco, with additional funds raised by Cardinal Benedetto Ubaldi, papal legate to Bologna (1634–37), it was topped by a copper statue of the *Immacolata* by Giovanni Todeschi (active 1620s and 1630s), which, according to tradition, was based on a drawing by Guido Reni.[39]

"JUST DOTS": BISI'S MINIATURE PAINTINGS AND THEIR CRITICAL RECEPTION

Bisi's miniatures, painted in tempera on parchment, are mentioned throughout his correspondence. They also turn up sporadically in early inventories,[40] and one is even referenced in the inscription of a print. Il Pittorino's paintings were celebrated during his lifetime in at least two short publications dedicated to him, his art, and his generosity. Only two extant miniatures can be identified from these sources, but they provide the basis for attributing two other extraordinary works to Bisi's hand.

The first of these documented paintings, actually three illuminations, is part of a *cartagloria* or altar card—a framed text, frequently illustrated, placed on the altar as an aide-mémoire for the priest saying Mass.[41] A creation of the Tridentine reforms of the sixteenth century, they could be made as a single, separately framed *carta* for each text or, as in this case, likely a gift by Bisi to the Basilica di San

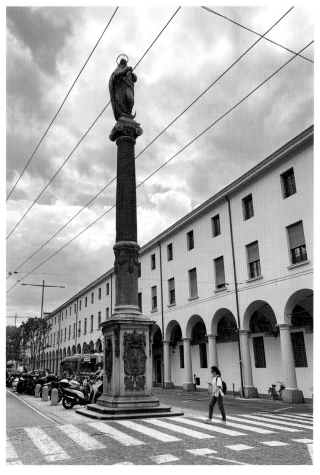

FIG. 21 Francesco Dotti and Giovanni Todeschi, Column of the Virgin of the Immaculate Conception, 1636–38. Brick, macigno, copper; approx. 14 m (height). Piazza Malpighi (formerly Piazza della Seliciata), Bologna

FIG. 20 Fra Bonaventura Bisi, *Column of the Virgin of the Immaculate Conception*, ca. 1638–40. Etching and engraving, 576 × 308 mm. British Library, London; Maps 7. Tab. 1, *Speculum Romanae Magnificentiae*, fol. 72

Francesco at Assisi, a triptych containing three of the central texts (fig. 22).[42] Here the "Gloria" is on the left (from which the "carta di gloria" gets its name), the "Canon" (about the Eucharist) is in the center, and the "Credo" is on the right.[43]

Bisi's *cartagloria* is cited successively in the inventories of the sacristy from 1671 to 1758.[44] Most of the entries mention Bisi's name (and nickname "il Pittorino"), and some single out his unusual technique: "fatte a punta di pennello" (made with the point of the brush). The friar's paintings were

FIG. 22 Fra Bonaventura Bisi, *Cartagloria*, signed and dated 1645. Tempera on parchment, 43.3 × 74.5 cm (frame). Parchments: sides each 38.2 × 13 cm; central 32.5 × 27 cm. Museo del Tesoro, Basilica di San Francesco, Assisi; inv. 1162

famous for his nearly exclusive use of dots instead of lines.

The scene at the top of each lateral is bounded by a brilliantly designed frame through which winds a single, unbroken, Franciscan knotted cord—a wonderful conceit of the brotherhood of the Minori Conventuali whose habits were tied by these *cordigli* in imitation of their founder, St. Francis. On the left is a small image, the *Angel Appearing to St. Francis with a Carafe of Clear Liquid* (fig. 23), and on the right is the *Communion of St. Bonaventure* (fig. 24). Both are likely designed by Bisi.

In the main panel, Bisi created a superb illusionistic frame imitating carved stone in an ancient Roman guilloche pattern with alternating flowers and seraphim. The top of this section (fig. 25) contains an inspired reproduction of the *Last Supper* from Raphael's (1483–1520) Vatican Loggia frescoes (1517–19),[45] which Bisi would have known from prints, especially one by Francesco Villamena (d. 1624).[46] And there were likely many painted copies in Emilia, giving an idea of the colors. A detail from the miniature's left side shows off Bisi's remarkable dot technique (fig. 26). He seizes on the jarring juxtapositions of heads

DAVID M. STONE

FIG. 23 Fra Bonaventura Bisi, *Cartagloria* (detail), *Angel Appearing to St. Francis with a Carafe of Clear Liquid*, 10 × 13 cm

FIG. 24 Fra Bonaventura Bisi, *Cartagloria* (detail), *Communion of St. Bonaventure*, 10 × 13 cm

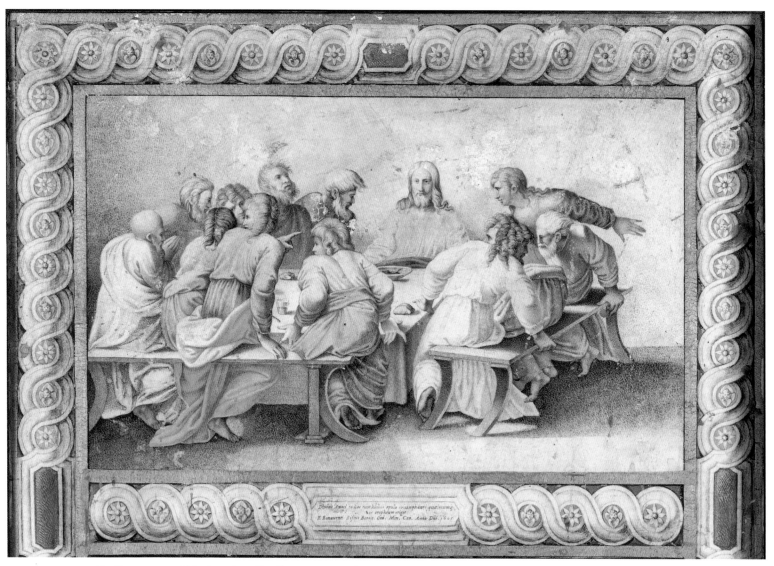

FIG. 25 Fra Bonaventura Bisi, *Cartagloria* (detail), *Last Supper* after Raphael, 13 × 21.5 cm

and the odd hairstyles, nearly turning them into abstractions.

At the lower center Bisi included a Latin inscription, and signed and dated his work: "Divino Amori in hoc cum ho[mini]bus epulo triumphanti qualecum[que] / hoc trophaeum erigit / F. Bonavent. Bisius Bonon. Ord. Min. Con. Anno D[omi]ni 1645." (Fra Bonaventura Bisi of Bologna, Order of Friars Minor Conventual, erects this trophy, such as it is, to Divine Love, who exults with mankind in this feast. In the year of our Lord 1645.)[47] This is Bisi's only signed and dated painting thus far identified.

Also in the Museo del Tesoro of Assisi's basilica is an elegant silver chalice that has a carved inscription under the foot: "F Bonau[a] Bisius a Bon. 1644" (figs. 27–29).[48] This small but finely crafted work has no attribution but is very likely, based on style, the product of a Bolognese silversmith.[49] A 1646 inventory records that it was donated by Bisi.[50] The "nodo" or knot below the cup features the Four Evangelists. The base depicts four Franciscan scenes, including the *Angel Appearing to St. Francis with a Pitcher of Clear Liquid*, the same story depicted in the *cartagloria*. I suspect Bisi had a hand in designing the chalice, or at least chose its themes.

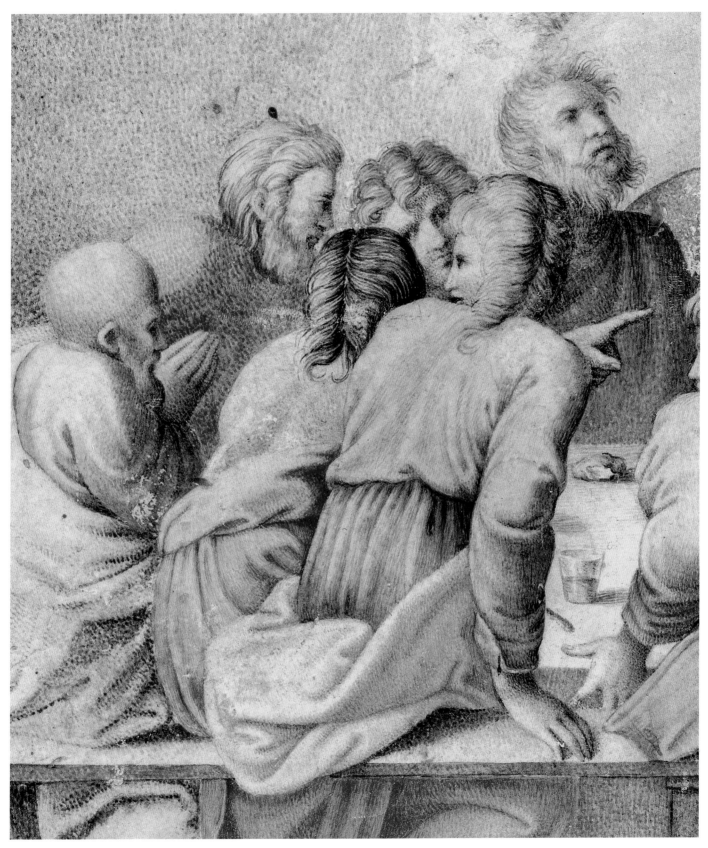

FIG. 26 Detail of fig. 25, showing Bisi's dot technique

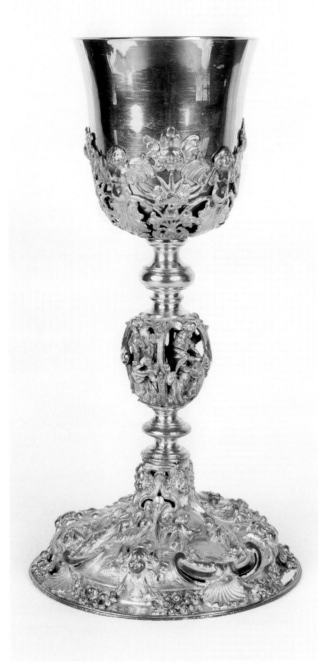

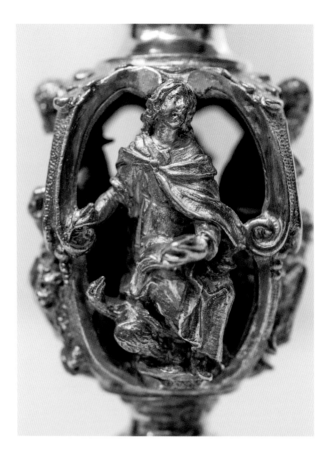

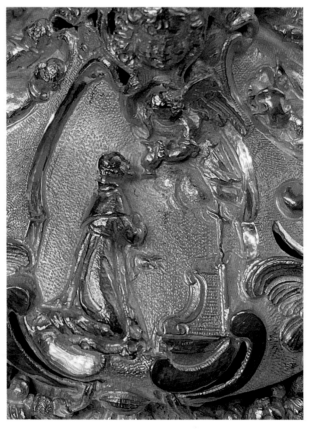

FIG. 27 Anonymous Bolognese silversmith, Chalice, 1644. Silver, 25.5 × 13.5 cm. Museo del Tesoro, Basilica di San Francesco, Assisi; inv. 1447

FIG. 28 Anonymous Bolognese silversmith, Chalice (detail), *St. John the Evangelist*

FIG. 29 Anonymous Bolognese silversmith, Chalice (detail on foot), *Angel Appearing to St. Francis with a Pitcher of Clear Liquid*

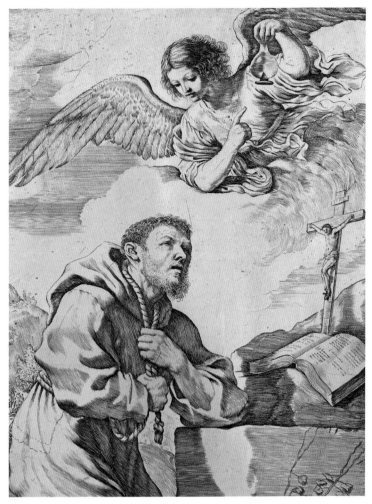

FIG. 30 Giovanni Battista Pasqualini after Guercino, *Angel Appearing to St. Francis with an Ampoule of Clear Liquid* (detail), 1629. Engraving, 350 × 240 mm. Metropolitan Museum of Art, New York; inv. 53.600.2312

AN ICONOGRAPHIC RARITY: THE CLEAREST WATER

This unusual subject is based on the influential book, written in Portuguese, by Mark of Lisbon, the *Chronicle of the Orders Instituted by St. Francis* (1557–62).[51] It soon appeared in a widely distributed Italian translation by the Bolognese scholar, active in Parma, Orazio Diola: *Croniche degli Ordini*.[52] The *Croniche* mentions Francis's zeal to become a priest and how he prayed to God to show him the path. But suddenly, as Diola says:

An Angel appeared to Francis holding in his hand an ampoule [glass flask] filled with the clearest liquid ["chiarissimo liquore"]; and he said: "look, Francis, this is how pure you need to be to administer the holy Sacrament." With these words, this humble servant of Christ decided there was nothing wrong with remaining a deacon, given the great purity required to be a priest, and he no longer wanted to be ordained.[53]

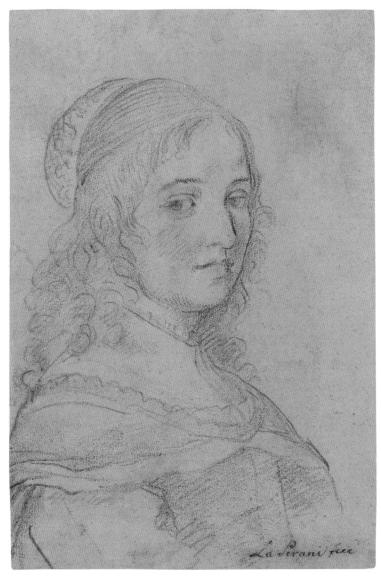

FIG. 31 Elisabetta Sirani, *Self-Portrait*, ca. 1658. Red and black chalk on paper, 229 × 154 mm. Smith College Museum of Art, Northampton, MA; inv. SC 2020.7.1

That "the clearest liquid" should be understood as water seems self-evident, given the iconological theme of purity. Diola's analytical index (under *Revelationi*), spells this out: "The priests need to be like an ampoule of the clearest water." Important images of this narrative include Guercino's design engraved by Pasqualini in 1629–30 (fig. 30),[54]

which, unlike the Assisi parchment and chalice, shows an actual ampoule.[55]

FRA BISI AND ELISABETTA SIRANI

Bisi the adviser-dealer often collaborated with Reni's student Giovanni Andrea Sirani (1610–1670), a gifted connoisseur. Bisi was one of the

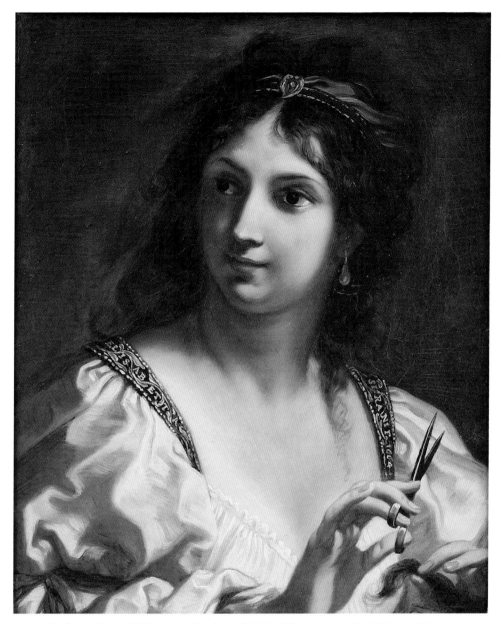

FIG. 32 Elisabetta Sirani, *Delilah*, signed and dated 1664. Oil on canvas, 55 × 44.5 cm. Private collection, CT (courtesy Robert Simon Fine Art, New York)

first to write an appreciation of Sirani's daughter and pupil Elisabetta Sirani (1638–1665), seen here in a rare self-portrait of about 1658 in red and black chalk (fig. 31),[56] who would go on to become, arguably, the greatest female painter in Bologna.

In a letter of January 22, 1658, introducing her to Leopoldo de' Medici (1617–1675), Bisi writes: "Perhaps Your Most Serene Highness will like to see this little sketch by the hand of a most talented girl, and she is the daughter of our Sirani of Bologna, around 19 years old or so, and she paints like a man with great ability and invention."[57] This presentation would greatly benefit the young artist, as one scholar noted: Elisabetta would soon receive several commissions from Leopoldo and others in Florence.[58] Her paintings, such as *Delilah*, signed and dated 1664 (fig. 32),[59] are today, like those by

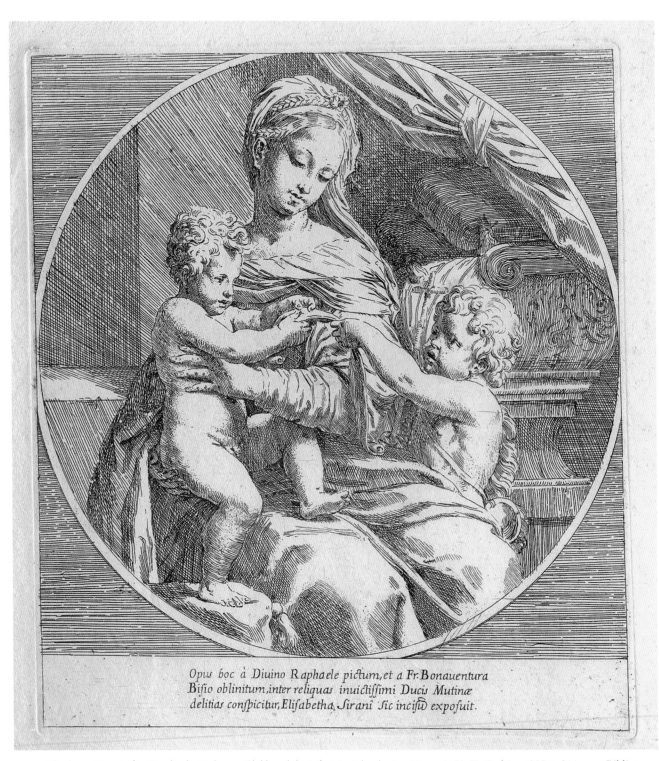

Opus hoc à Diuino Raphaele pictum, et a Fr. Bonauentura
Bifio oblinitum, inter reliquas inuictiffimi Ducis Mutinæ
delitias conspicitur, Elisabetha Sirani Jic incifu expofuit.

FIG. 33 Elisabetta Sirani after Raphael, *Madonna, Child, and the Infant St. John the Baptist*, ca. 1659 (?). Etching, 235 × 214 mm. Biblioteca Comunale dell'Archiginnasio, Bologna; inv. SAV1420

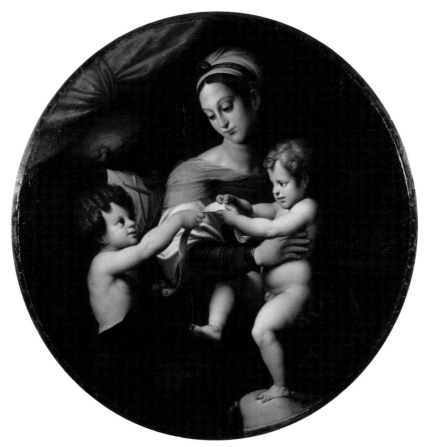

FIG. 34 Anonymous after Raphael, *Madonna, Child, and the Infant St. John the Baptist*, first half of 16th century. Oil on poplar, 83.5 cm (diam.). Staatliche Kunstsammlungen, Dresden; inv. 98

Artemisia Gentileschi, icons in the reappraisal of the role of women in Seicento art.

In an undated, silvery etching (ca. 1659?) of the *Madonna, Child, and the Infant St. John the Baptist* (fig. 33),[60] Elisabetta mentions Bisi in the inscription: "Opus boc à Diuino Raphaele pictum, et a Fr. Bonauentura Bisio oblinitum, inter reliquas inuictissimi Ducis Mutinae delitias conspicitur, Elisabetha Sirani sic incisum exposuit" (This work, painted by the divine Raphael, and *oblinitum* [see below] by Fra Bonaventura Bisi, can be seen among the rest of the delights of the unconquered Duke of Modena, [but] Elisabetta Sirani [has] depicted it thus in an etching).[61] The

work by "the divine Raphael," a tondo on poplar formerly in the Galleria Estense (fig. 34), considered an original in the Seicento but long since downgraded, is based on the Prado's *Madonna della Rosa*.[62]

Scholars have interpreted the inscription to mean that Bisi made a drawing of the Raphael for Elisabetta, but this is not what the text states. Rather, it contrasts three "media" or processes: painting (Raphael); "daubing" or "dabbing" (*oblinitum*, Bisi); and etching (Sirani). The text does not imply that Elisabetta used Bisi's miniature to make her print so much as it claims she was following in his footsteps by copying the Raphael.

FIG. 35 Fra Bonaventura Bisi after Raphael, *Madonna, Child, and the Infant St. John the Baptist*, after 1645 (?). Tempera on parchment, 23 × 21 cm. Galleria Estense, Modena; inv. R.C.G.E. 2295

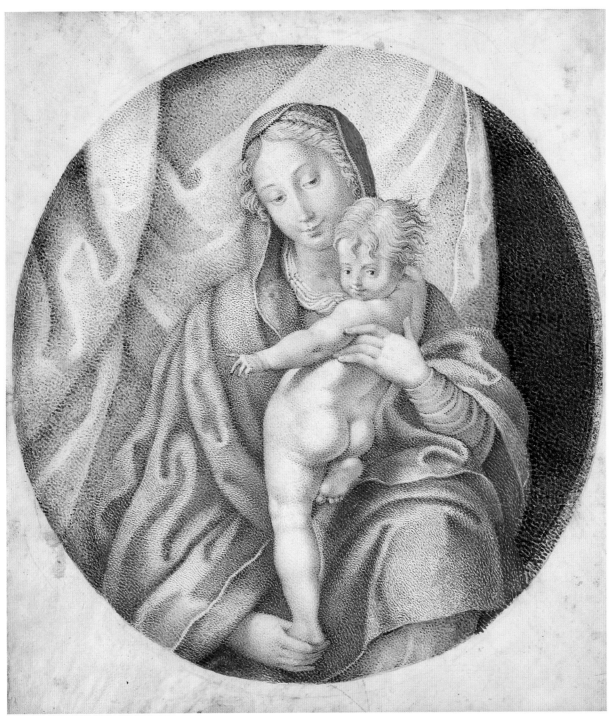

FIG. 36 Fra Bonaventura Bisi after Parmigianino, *Madonna and Child,* after 1645 (?). Tempera on parchment, 23 × 21 cm. Galleria Estense, Modena; inv. R.C.G.E. 2294

FIG. 37 Parmigianino, *Madonna and Child with Three Female Figures*, ca. 1524–27. Red chalk, white heightening, 176 × 171 mm. Gabinetto dei Disegni e delle Stampe, Uffizi, Florence; 1976 F.

Oblinitum (smear, daub, dab) is an odd word. I believe it is a purposeful reference to exactly what we see in Bisi's miniature copy of the tondo, a work on parchment made with dots of tempera (fig. 35).[63] Careful philological analysis of Sirani's inscription allows the Modena miniature to be confidently attributed to Bisi's hand.

There are no early inventories describing Bisi's tondo; the same is true of two similarly painted miniatures in the Galleria Estense.[64] The first is a shimmering tondo of the *Madonna and Child*, perhaps a pendant to the other, of identical size (fig. 36).[65] The elongated, twisted pose of the Child is unabashedly Parmigianesque, and, indeed, the composition is likely based on a red chalk Parmigianino sketch in the Uffizi,[66] although Bisi considerably varied the draperies and background, and eliminated the figures on the right (fig. 37). The second is a magnificent, free, and expansive reproduction (fig. 38)[67] of Guido Reni's *Angel*

Appearing to St. Jerome of about 1634–35 (fig. 39).[68] The attributions of these two works to Bisi can now be firmly established thanks to the Assisi *Last Supper* and the Modena *Madonna, Child, and the Infant St. John the Baptist*.[69] The dating of the three Modena paintings, in my opinion, should be placed some years after the 1645 *Last Supper*, though function and size could account for differences in approach. The Galleria Estense works seem far more daring and masterful in execution, especially the amazingly luminous area of the sky and landscape near the angel in Bisi's copy after Reni, where the dots are so conspicuously spread apart.

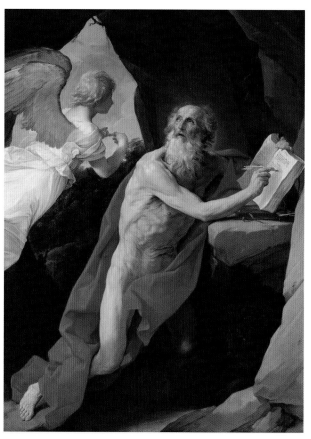

FIG. 39 Guido Reni, *Angel Appearing to St. Jerome*, ca. 1634–35. Oil on canvas, 237.5 × 178.5 cm. Kunsthistorisches Museum, Vienna; inv. 9124

FIG. 38 Fra Bonaventura Bisi after Guido Reni, *Angel Appearing to St. Jerome*, after 1645 (?). Tempera on parchment, 43 × 37 cm. Galleria Estense, Modena; inv. R.C.G.E. 1372

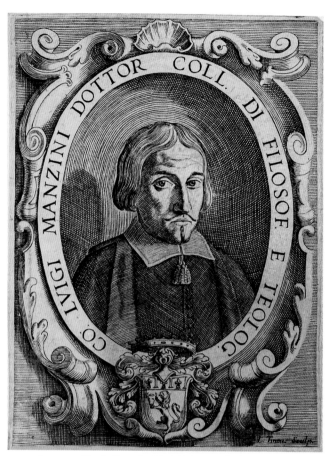

FIG. 40 Lorenzo Tinti, *Portrait of Luigi Manzini*, before 1672. Engraving, 146 × 108 mm. Biblioteca Comunale dell'Archiginnasio, Bologna; Collez. Ritratti, b. 36, fasc. 35, n. 1

FIG. 41 Luigi Manzini, Title Page to *Il Punto* (Bologna, 1654), 226 × 169 mm. Biblioteca Comunale dell'Archiginnasio, Bologna; 17. Scritt. Bol. Filol. Poesie Ital. caps II, n. 61

IN PRAISE OF BISI'S *PUNTI* AND THE THEORY OF THE *INDIVISIBILI*

Bisi's pointillist technique was greatly admired by his intellectual contemporaries, not least the prolific Bolognese poet and professor of theology Luigi Manzini (1604–1657), a member of the Accademia dei Gelati. His older brother—one of Guercino's closest friends—was the even more famous writer Giovanni Battista Manzini (1599–1664),[70] and another sibling was Carlo Antonio Manzini (1600–1677), a prominent astronomer who wrote one of the first treatises on grinding lenses for telescopes. Carlo was informed about Bisi and mentions him (eight years after the friar's

death) in a letter dated October 25, 1667, to Leopoldo de' Medici, in which he explains how Bisi's art applied the geometric theory of the "indivisibili" (a precursor of integral calculus) promoted by Galileo's disciples Evangelista Torricelli and Bonaventura Cavalieri.[71] Carlo also gave Leopoldo a Madonna on parchment by Bisi as a gift.[72] The Manzini were an extraordinary Bolognese family, connecting art, literature, and science.

Luigi Manzini, shown in a portrait by Lorenzo Tinti (fig. 40),[73] published a witty, inventive poem, *Il Punto*, in celebration of Bisi in 1654 (fig. 41): "The Dot: for . . . Bonaventura Bisi . . . Most Famous Painter, Because he paints all of his Works

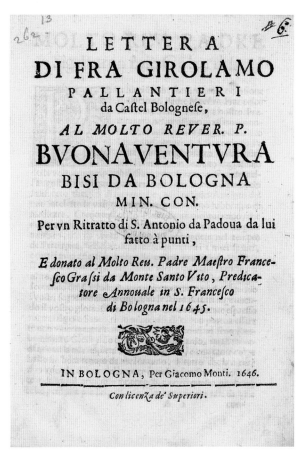

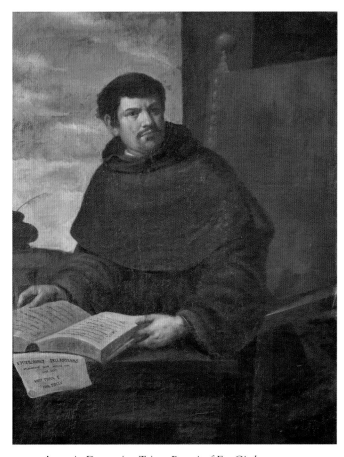

FIG. 42 Girolamo Pallantieri, Title Page to *Lettera . . . Buonaventura Bisi* (Bologna, 1646), 196 × 141 mm. Biblioteca Comunale dell'Archiginnasio, Bologna; 17. Scritt. Bol. Filol. Belle Arti, caps. II, n. 65

FIG. 43 Antonio Domenico Triva, *Portrait of Fra Girolamo Pallantieri*, signed and dated 1655. Oil on canvas, 129 × 100 cm. Palazzo Mengoni, Comune di Castel Bolognese (RA)

with Dots alone; On the occasion of his donation to the Sacristy of San Francesco in Bologna of a Most Expensive Holy Ornament." Perhaps unique in Italian Baroque literature in dedicating an entire poem to the painting technique of an artist, the *canzone* is full of marvelous conceits relating to Bisi's "attomi colorati" (colored atoms):[74] "Tu, dal tuo Punto immenso / Cavi il Ciel, formi il suol, scopri l'inferno" (You, with your immense Dot, represent the heavens, form the earth, reveal hell). And "Può co' punti formar sfere novelle" (with dots [your illustrious brush] can form new spheres). Finally, in what seems an appreciation of Bisi's economy of color: "E se pingi, ogn'imago /

Sol de' suoi punti avara, / Quanto è povera più, tanto è più cara" (And if you paint, every image, / Greedy only for its dots, / The poorer it [the image] gets, the more precious it becomes).[75]

Our "Seurat of Bologna" was lauded in yet another publication, a "lettera" printed in 1646 (fig. 42). It was written by a Minor Conventual in Castel Bolognese, Fra Girolamo Pallantieri (1623–ca. 1685), who is portrayed in a commanding picture of 1655, signed and dated by Antonio Domenico Triva (1626–1699), possibly a pupil of Guercino (fig. 43).

The title page of the pamphlet is not dissimilar to Manzini's *Il Punto* in that it heralds Bisi's

"punto-ism" and thanks him for a generous gift—in this case, one of his miniatures, a *St. Anthony of Padua* ("da lui [Bisi] fatto à punti")—donated in 1645 to a visiting preacher at San Francesco di Bologna named Padre Francesco Grassi.

BISI'S GENEROSITY

Malvasia said that "everything Bisi earned—which was a lot—he used to benefit the Church."[76] The "ricchissima suppellettile sacra" for the sacristy of San Francesco in Bologna mentioned in Manzini's title page to *Il Punto* was, according to Malvasia, "a massive silver tabernacle of great quality, and a 'raggio' (rays), which came to more than two thousand scudi."[77] The object was lost by the time of Napoleon's invasions, but Oretti, who describes the tabernacle's iconography, notes that the famous silversmith Virgilio Fanelli (ca. 1600/1604–1678) made the work for Bisi.[78]

Guercino's portrait of Bisi provides important clues as to how this generous and talented miniature painter earned so much money: serving powerful rulers as an art dealer. And it is precisely to this fascinating topic we now turn our attention in the next chapter.

Guercino, *Portrait of Fra Bonaventura Bisi* (detail), ca. 1658–59

NOTES

1. Parts of this essay are based on Stone 2020. I have made corrections or updated interpretations below as space permitted. All translations are mine unless otherwise noted.

2. This format, with occupation-related books as a backdrop, was first used by Guercino in *Portrait of Francesco Righetti* (ca. 1626–28; Ferrara, Fondazione Cavallini-Sgarbi). Stone 1991a, 135, no. 111; and Turner 2017, 438, no. 151.

3. The book at center on the top shelf is cut off and shows only "nav. opa [opera]." I suspect this means [Bo]nav. opera.

4. See Forlivesi 2002. I thank Marco Forlivesi for his assistance.

5. Numismatica Ars Classica (Zurich-London), Auction 32, January 23, 2006, 40, lot 68.

6. Sotheby's, London, December 9, 1992, 74, lot 44 (with research by S. Stagni); illus. on p. 75; purchased by Damon Mezzacappa (1936–2015), New York and Palm Beach. His sale: Sotheby's, New York, January 31, 2013, lot 57, bought in (entry by D. M. Stone, unsigned); sold Christie's, London, December 9, 2015, lot 168, where purchased by The Ringling and catalogued in Brilliant 2017, 141–44, no. I.81 (based mainly on the 2013 entry and information supplied by the present author). Cf. also Negro, Pirondini, and Roio 2004, 137, fig. 252: "Ritratto di frate collezionista di disegni" (as Benedetto Gennari).

7. For Bisi's biography, see Galleni 1979.

8. Translation by Joseph Farrell. Listed by De Vesme 1906, the engraving was first illustrated in Stone 2020, 58, fig. 2.

9. Oretti MS B. 126, 76: "In Bologna vedesi il suo ritratto fatto di sua mano mezza figura del naturale in atto di tenere una Carta con una testa à lapis rosso, è posto in una Camera contigua alla Sagrestia di S. Francesco nello stesso Convento: Il suo Ritratto vedesi in mezza figura al naturale da lui dipinto nella Sagrestia dei R.R. PP. di S. Francesco di Bologna pubblicato alle stampe da Domenico Maria Muratori, once 6 x once 4.5 gagliarde."

10. Aldrovandi 1827, 12, no. 57 (errors in Sotheby's 1992 citation); Aldrovandi 1869, 6, no. 9. Two unpublished Aldrovandi inventories, one of 1764 the other of 1782, might refer to The Ringling painting (cf. Stone 2020, 68 nn. 5–6). See also Atti 1861, 132; and Stone 2020, 57–58, 68 n. 7.

11. But the friar could be critical of Guercino. Their relationship is too complex to examine here, but see D. M. Stone, "Entry for Guercino's *Ercole che brandisce la clava*," in Dotti 2020, 18–20.

12. E.g., Stone 2020, 66–67, 70 n. 50. (Correction: the "compagno" sent to Florence was not Guercino's painting *Putto con stromenti della passione*, but his red chalk drawing for the *Putto con teschio*.)

13. Turner and Plazzotta 1991, 222–23, no. 206; and Stone 2020, 65–66, fig. 12.

14. Gibbons 1977, 1:106, no. 294; Stone 1991b, 217, suppl. no. 77; Turner and Plazzotta 1991, 222, under no. 206; and Stone 2020, 65–66, fig. 13. Ann Harris informs me that the sitter is not wearing a Conventual habit.

15. Potito 1975, 91–92, no. 64; CdA III, c. 338 (see Chapter 2, n. 1, in this volume, regarding these sources). On February 19, 1658, writing to Leopoldo de' Medici, Bisi says he has been in bed for several days unable to urinate, and asks the prince if he has any remedies in the Medici *fonderia* he could send.

16. Potito 1975, 139–40, no. 22.

17. Malvasia 1678, 1:560: "Dilettossi di disegni, e n'ebbe uno studio famoso, che poi ridotto in età, e decimato."

18. Turner 2017, 722–23, no. 436. For Guercino as a portraitist, see Spear 2020.

19. Gozzi et al. 2013, 21–22, fig. 5. Sold Sotheby's, New York, January 31, 2019, lot 164.

20. Masini 1666, 617.

21. Malvasia 1678, 1:559.

22. Bisi may have done a few full-scale paintings: perhaps the copy after Reni's *St. Francis in Prayer* (Bologna, sacristy of San Francesco); and a lost work in Lugo of the *Stigmatization of St. Francis* (Bonoli 1732, book 2, ch. 8, 277). See Stone 2020, 68 n. 19.

23. Galleni 1979, 177.

24. Galleni 1979, 176; and Malvasia 1678, 1:559–60.

25. Piccinini and Stefani 2009, 54–55 (entry by D. Benati).

26. Di Natale 2020, 18–23 (entry by A. Brogi).

27. Sgarbi 2015, 212–13, no. 65 (entry by T. Pasquali).

28. Stone 1991a, 64, no. 44; Turner 2017, 315, no. 56. Bisi's admiration for Guercino's early style is evinced throughout his correspondence.

29. Stone 1991a, 75–77, no. 54; Turner 2017, 333, no. 76.

30. Sotheby's, New York, January 31, 2018, lot 143.

31. There is no evidence of such a trip. See Stone 2020, 60.

32. Stone 1991a, 99–101, no. 78; Turner 2017, 369–74, no. 108.3.

33. Stone 1991a, 140, no. 116; Turner 2017, 452, no. 163. For Guercino's style change, see Stone 1989.
34. Pepper 1984, 259, no. 119, pl. 148.
35. Stone 2020, 60, fig. 6; see also De Vesme 1906, 334–35.
36. For Oselli's print, see Streliotto 2000, 26–27, no. 8.
37. See Turčič 1985–86, 210–11, fig. 7; and Härb 2015, 41, 45, fig. 33, and 247, no. 103. My thanks to David Ekserdjian for pointing this out.
38. McDonald 2019, 2:477, no. 2540. Cf. also Zanotti 2013, 223. There is, however, a crudely cut up impression, collaged to another sheet: BCABo, Inv. SCG 51. Collocazione: Goz.23 175. Bisi's inscription is cut off.
39. Cueto 2006, 101, 417 n. 464.
40. Morselli 1998, 443: a *Madonna*, a *Concettione*, *Quattro quadretti Vasi di Fiori*, and a *Groppo di Puttini* (after Reni); also pp. 189, 219 ("fatta con miniatura à punti"), 407. See also Fileti Mazza 1993, 1:358–62, with descriptions of several lost works, including a "Testa di femmina" wearing a turban with a jewel (doc. 514) recorded in several Medici inventories.
41. Giorgi 2008, 29–30.
42. Marioli 1985, esp. 18–19; and Zanotti 2013, 220–24. Mentioned in Papini Tartagni 1824, 321–22. The *cartagloria* (inv. 1200) with a *Communion of St. Bonaventure* in a tortoise frame (Marioli 1985, 19, ill. on p. 17) is not, in my opinion, by Bisi; inventories give the donor as Mons. Catalano and list no author.
43. The parchments for the lateral sections are each backed by a wooden panel, now eaten away by insects that have damaged the text and paintings. Though the central section has some losses due to flaking, its copper-plate backing provided protection against the bugs. All three parchments are faded.
44. Assisi, Archivio Sacro Convento, Fondo Demaniato, Registri, vol. 44, "Inventario della Sagrestia (1624–1723)": "Una carta di Gloria d'ebano con miniature fatta dal Padre Pittorino da Bologna, quale si serra et è senza In Principio et Lavabo" (c. 138v; inventory 1671); and "Una Carta di Gloria . . . fatte à punta di Pennello dal P. Bon.ra Bigi." (c. 167v; inv. August 20, 1686; updated April 25, 1694); also: c. 186r (1694); c. 206r (1707); and vol. 47: c. 228r (1758). My thanks to Cristina Roccaforte for her assistance.
45. Dacos 1986, 205–6, no. XXXI.4; pl. LII. Attributed to Vincenzo Tamagni based on drawings by Perino del Vaga.
46. British Museum, inv. 1871,0812.5540.
47. Translation by Joseph Farrell.
48. Dal Poggetto 1980, 132–33, no. 61.
49. See García Zapata 2019, 285, fig. 133, for a similar chalice.
50. Assisi vol. 44 (see above), c. 79r, June 3, 1646 (addition to inventory of June 15, 1644): "Uno tutto di Argento bello con diverse figurine di rilievo intagliate con la sua Patena donato dal padre Pittorino da Bologna." And c. 187r (1697): "5. Un calice d'argento con piede di getto con quattro statuette nel pomo e anco quattro historie nel piede donato dal padre Pittorini da Bologna di peso libre due." See also c. 207v (1707); c. 212v (1711); c. 238r (1715). My thanks to Beatrice Gallo and Cristina Roccaforte for these previously unpublished references.
51. See Porto 2002.
52. *Croniche* 1581. For Diola, see Dallasta 2015. For his impact on Ludovico Carracci, see Bull 2012.
53. *Croniche* 1581, 89.
54. Bagni 1988, 76–77, nos. 109 (1629), 110 (1630).
55. Dzik 2015 for further examples.
56. Bohn 2021, 194, fig. 116.
57. Potito 1975, 86–87, no. 59; CdA III, c. 328. Fileti Mazza 1993, 2:787–88, doc. 1287. Stone 2020, 68–69 n. 22. Sirani's sketch was meant to give Leopoldo a preview of a so-called portrait by Correggio.
58. Modesti 2001, 170.
59. Straussman-Pflanzer and Tostmann 2021, 140–41, no. 42 (as representing Berenice; entry by E. Straussman-Pflanzer); Bohn 2021, 71, fig. 35 (as Delilah).
60. Modesti 2001, 166–73, fig. 14; Stone 2020, 59–60; and Bohn 2021, 205.
61. Translation by Joseph Farrell.
62. Prado; inv. P000302. By Giulio Romano?
63. First published in Stone 2020, 59–60, fig. 5.
64. Bisi's parchments are not individually noted in the early Estense inventories.
65. Stone 2020, 59–60, fig. 4.
66. I thank David Ekserdjian for this suggestion.
67. Stone 2020, 58–59, fig. 3.
68. Pepper 1984, 271–72, pl. 179.
69. See Stone 2020, 68 n. 19, regarding an *Adam and Eve* (Galleria Borghese, inv. 528) after Giuseppe Cesari, il Cavalier d'Arpino, long ago attributed to Bisi. I have since examined this parchment; its technique is wholly unlike Bisi's. My thanks to Francesca Cappelletti and Marina Minozzi for graciously allowing me access to this beautiful miniature.
70. Unglaub 1998–99.

71. "[The box I am sending] custode di un quadretto di pittura che per essere di un'emolo di Guido Reni, non posso chiamarla di Guido: ella è del Frate Franciscano detto il Pittorino, il quale pochi Anni sono morì; praticava questi la Dottrina degl'Indivisibili, componendone infiniti per Imagini più belle del naturale. È picciol dono per un Principe par suo: ma che? È povero ancora il Donatore: non è però picciola la fama di chi lo fece: l'opera loderà il Maestro. Questi sarà à mio nome presentato à Vostra Serenissima Altezza dal Signore" ASF Medici del Principato, vol. 5543, fol. 453. The quotation is based on notes and a transcription (Medici Archive Project doc. 24883) by Sheila Barker, whom I thank for this reference. Cf. Barker 2020, 21, 29 n. 44.

72. MdP, vol. 5543, fol. 452 (see MAP doc. 24883).

73. From Zani 1672.

74. *Attomi* are the smallest unit in linear measurements: an *oncia* is made up of 12 *punti*; and 1 *punto* is made up of 12 *attomi*.

75. For the full text, see Pieri and Varini 2006, 3–13. My sincere thanks to Christopher Nissen for help in translating this challenging poem. For an insightful discussion in the context of art theory of Luigi Manzini's 1643 text on the Book of Esther, *Il Dragone di Macedonia*, see Unglaub 2003, who also notes Manzini's correspondence with Cassiano dal Pozzo. Perhaps Bisi, who dedicated his Holy Family print to Cassiano, was introduced to the great antiquarian by Manzini (though there would have been other luminaries in Bologna positioned to do so).

76. Malvasia 1678, 1:559–60.

77. Malvasia 1678, 1:559–60.

78. Oretti MS. B. 133, 174. García Zapata 2020.

Bisi as Art Adviser and Dealer to the Estensi and Medici

David M. Stone

Bisi's letters tell the story of his passion in life: chasing down great drawings (but also paintings and the occasional ancient sculpture); consulting with his clients about purchasing his finds; and haggling with the seller to make a deal.[1] He sometimes gained access to a cache of objects by making a gift of one of his precious miniature paintings, and he traveled frequently to investigate promising leads. Often in a follow-up letter, after congratulating everyone (including himself, though humbly) on a notable acquisition or ensuring that the new owner was happy, he would turn to practical matters: how a work should be framed, in which album a sheet should be mounted, or in what room some ancient marbles should be placed so as to make the best impression.

Logistics mattered to Bisi and his clients. Many of his letters deal with the timing of shipments, so as to take advantage of couriers coming and going from Bologna or, when Florence was involved, from Pianoro (fig. 1). The church of San Benedetto di Pianoro (or Guzzano) was much loved by Bisi, who served as its rector for many years.[2] He frequently took refuge there from the distractions of the city to paint his miniatures (fig. 2).[3] Located in the Apennine hills in the valley of the Savena River, some ten miles south of Bologna, and near an important rest stop along the "Via di Toscana" connecting Emilia and Tuscany, this

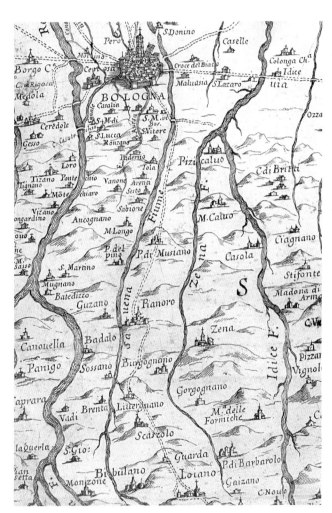

FIG. 1 Camillo Sacenti, *Geografia del Territorio Bolognese. . .* (detail, with Pianoro and Guzzano), ca. 1699–1760. Engraving. Collezione BolognArt di Francesco Bonetti, Bologna

Pordenone, *Ballo di Putti (Dancing Putti)* (detail), ca. 1532–36

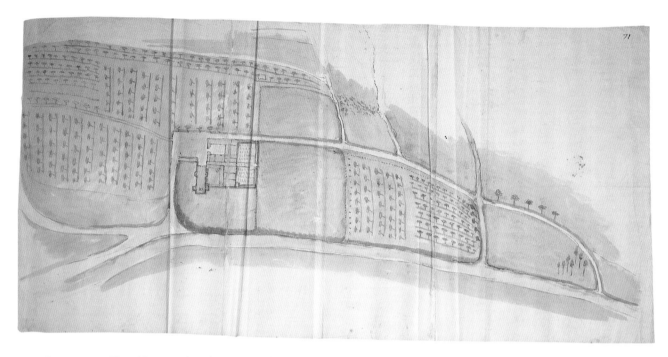

small church, convent, and hospital complex is now a ruin (fig. 3).[4]

Pianoro's strategic location was useful for other reasons, namely, to avoid huge customs fees. For example, Bisi told his client in Florence that if he has to send works back to Bologna and wishes to avoid customs ("sfuggire che siano contati in Dogana"), he should leave things with Frizzi the driver (elsewhere called "il mulatiere"). Frizzi will turn them over to the owners of the Hosteria at Pianoro (Bisi's friends), who will bring the objects to Bologna.[5]

Secrecy was Bisi's specialty. Many families, especially those of the nobility, were embarrassed to be selling their art collections, and the friar was expected to be discreet. Bisi also wanted to protect his sources and the names of middlemen,[6] and sought to avoid anyone cutting into his trans-actions. He was highly competitive, and there is some evidence of a temper.

Bisi's hyperbole is one of his most consistent and amusing traits. A drawing is not just good or great, but "the best this master has ever done, and all the painters say so." He could be sharply critical when discovering that a group of drawings did not match his expectations or had inflated attributions. He was jealous of other dealers, especially if they showed good drawings to his clients. And he made sarcastic remarks when people who should know better grossly overpaid for things (no doubt because it made it that much more difficult for him, in turn, to offer low sums for similar items). For example, on seeing some "beautiful drawings" owned by the Conte di Novellara (Alfonso II Gonzaga) in 1659, Bisi says: "he buys by chance, and I don't know about his intelligence because he pays for drawings without any guidelines; he gave 50 scudi for a single sheet by Annibale Carracci representing a theatre scene. To me it seems like buying 'Disegni senza Disegno' [buying drawings without discipline]."[7]

Bisi served two courts, the Estense in Modena and the Medici in Florence.[8] His clients in the former were Duke Francesco I d'Este, along with his son, Prince Alfonso, the future Duke Alfonso IV, who ruled for only a few years.[9] We see their majestic presences in a pair of graceful silver medals attributed to Elia Teseo (active 1648–1669), the Jewish goldsmith and "zecchiere" of the ducal mint in Modena (figs. 4 and 5).[10]

Francesco was a powerful, ambitious ruler whose commissions and collecting were meant to reflect his grandness.[11] His self-fashioned glory is evident in Gian Lorenzo Bernini's (1598–1680) incomparable marble portrait, completed in 1650–51 and still in Modena.[12] The famous bust of the duke was remembered some time later, probably after

his death, in the brilliant, genre-bending *Allegorical Still Life with Bernini's Bust of Duke Francesco I d'Este*, attributed to Francesco Stringa (1635–1709; fig. 6). Possibly painted in about 1660, this large and challenging image is replete with conceits related to the *paragone*, the poetic/theoretical duel between painting and sculpture. The picture was recently analyzed in an incisive study with several intriguing theories about its meaning, including the idea that the painting represents the continuity of the Estense dynasty with the succession of Alfonso IV.[13]

In Florence, Bisi advised Prince Leopoldo de' Medici, shown here in a print by Adriaen Haelwegh (1637–ca. 1696) that captures something of his imposing presence (fig. 7). Leopoldo's interests ranged from the natural sciences and

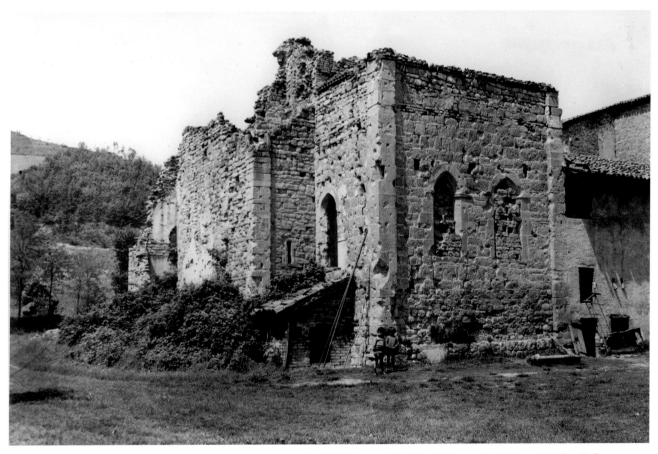

FIG. 3 Luigi Fantini, *Church of San Benedetto di Pianoro (Guzzano)*, 1950. Photograph, 180 × 240 mm. Fondazione Carisbo, Bologna; inv. FANT 0324

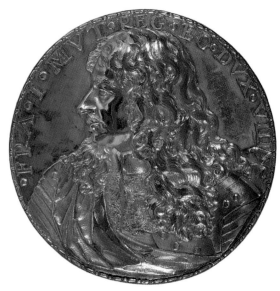

FIG. 4 Attributed to Elia Teseo, *Portrait Medal of Duke Francesco I d'Este of Modena*. Cast and chased silver, 89 mm (diam.). Fitzwilliam Museum, Cambridge; inv. CM.30-1967

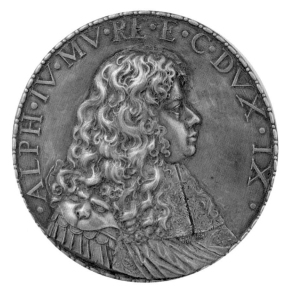

FIG. 5 Attributed to Elia Teseo, *Portrait Medal of Duke Alfonso IV d'Este of Modena*. Cast and chased silver, 88.9 mm (diam.). Minneapolis Institute of Art; inv. 67.55.2

astronomy to clocks and ancient gems and sculpture, to paintings and drawings of every region and time period.[14] He apparently could paint—and fairly well, if the *Portrait of the Musician Simone Martelli* (ca. 1660; Uffizi, Florence) is properly attributed.[15] A supporter of Galileo's experimentalism and avid collector of his telescopes and other instruments, Leopoldo founded, with his brother Ferdinando II (1610–1670), the Accademia del Cimento (1657–67), devoted to the new empirical methods of scientific inquiry. The future cardinal was also, early in his career, a member and protector of the Accademia della Crusca, one of the most important academies in Italy, which brought together luminaries in literature and philology to investigate and purify the Italian language.

It is simply impossible—when reading Bisi's letters, which imply such an extensive back and forth with Leopoldo about hundreds of works of art—to imagine how many other endeavors Leopoldo was undertaking simultaneously. The drawings collection in the Uffizi would be greatly diminished had it not been for Leopoldo and to an important degree his "agente" (adviser-dealer) in Bologna, Fra Bonaventura Bisi.

The friar did not travel to Florence very often. Especially in his later years, his health

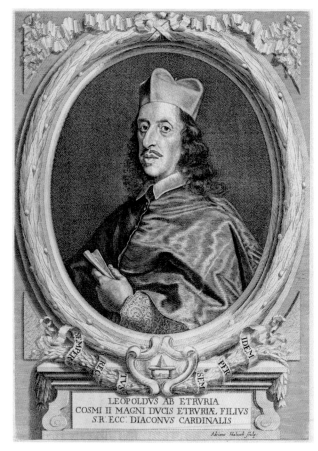

FIG. 7 Adriaen Haelwegh, *Portrait of Cardinal Leopoldo de' Medici*, ca. 1680–99. Engraving, 344 × 244 mm. The John & Mable Ringling Museum of Art, Sarasota, Gift of Miss Bertha H. Wiles, 1970; inv. SN8563

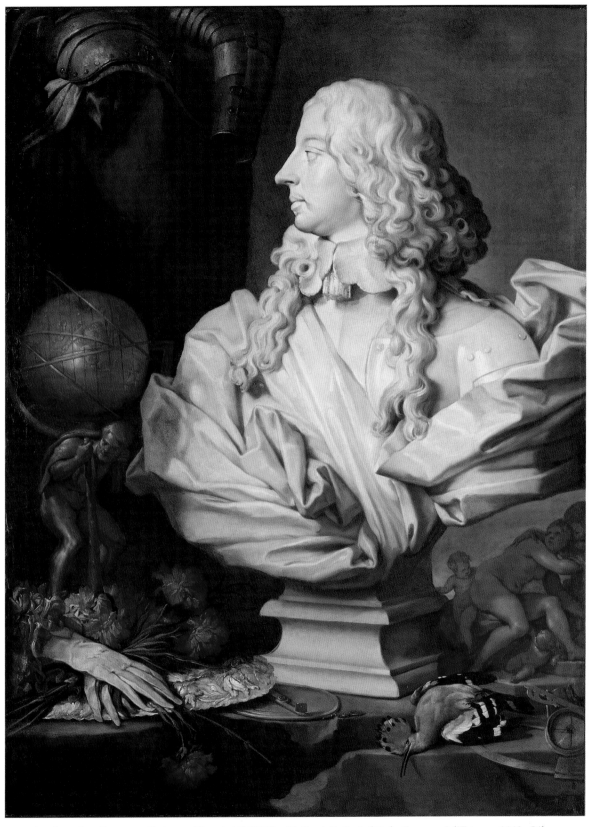

FIG. 6 Attributed to Francesco Stringa, *Allegorical Still Life with Bernini's Bust of Duke Francesco I d'Este*, ca. 1660. Oil on canvas, 135.89 × 101.92 cm. Minneapolis Institute of Art; inv. 38.38

FIG. 8 Adriaen Haelwegh after Sustermans, *Portrait of Marchese Ferdinando Cospi,* from L. Legati, *Museo Cospiano . . .* (Bologna, 1677). Engraving, approx. 307 × 204 mm. Getty Research Institute, Special Collections, Los Angeles; inv. 85-B1671

seems to have been an impediment; nonetheless, in his dispatches he consistently mentions plans to visit Leopoldo to bring him recent finds and see his collection. Bisi relied on Leopoldo's letters (which do not survive) for information on the artists the Medici prince hoped to collect and for decisions on proposals. And the friar was also briefed on a regular basis in Bologna about Leopoldo's wishes by their mutual friend Marchese Ferdinando Cospi (1606–1686), who helped Bisi, in turn, communicate and complete transactions with Florence.

Cospi, who shuttled between the two cities with ease, was the representative of the Grand Duke of Tuscany to Bologna (his mother was a Medici), and he was a senior member of the Cavalieri di Santo Stefano, as he is shown here in a print (fig. 8). A local Bolognese dignitary, influential collector, and founder of a world-famous natural history museum in Bologna, the Museo Cospiano, the marchese had the connections to help the friar gain access to the homes of reclusive noble families in Emilia, and he seems to have intervened in certain cases in which Bisi's negotiations had come to a standstill.[16] Given his intense interest in natural history, Cospi must have been enthusiastic about Bisi's 1654 purchase for Leopoldo of a large group of richly colored drawings, forty-three in total, of birds (and one snail), attributed at the time to Pordenone (ca. 1484–1539). The most beautiful of them is the huge sheet of a *Black Crowned Night Heron (Ardea Nycticorax)* (fig. 9).[17]

Because Bisi visited nearby Modena frequently, many of his transactions were conducted in person. This situation may partially account for the fact that only thirty or so letters from Fra Bonaventura to the Estense court have survived. He probably did not write to Modena nearly as often as he did to Leopoldo in Florence (about one hundred of these letters are preserved). The Modena letters do not have the rich detail and personal character of his missives to Florence, with the exception of the tragicomic series he wrote to Francesco I in 1653 recounting his misadventures in the futile attempt to buy for the duke's *galleria* the *Madonna di Foligno* altarpiece by Raphael (fig. 10). Bisi's humiliation is palpable as he reports: "that fellow from Fano who was supposed to take me to Pesaro for the Raphael

FIG. 9 Anonymous Venetian, *Black Crowned Night Heron (Ardea Nycticorax)*, 16th century. Various colored washes, gouache, traces of black chalk, 581 × 420 mm. Gabinetto dei Disegni e delle Stampe, Uffizi, Florence; inv. 2132 Orn.

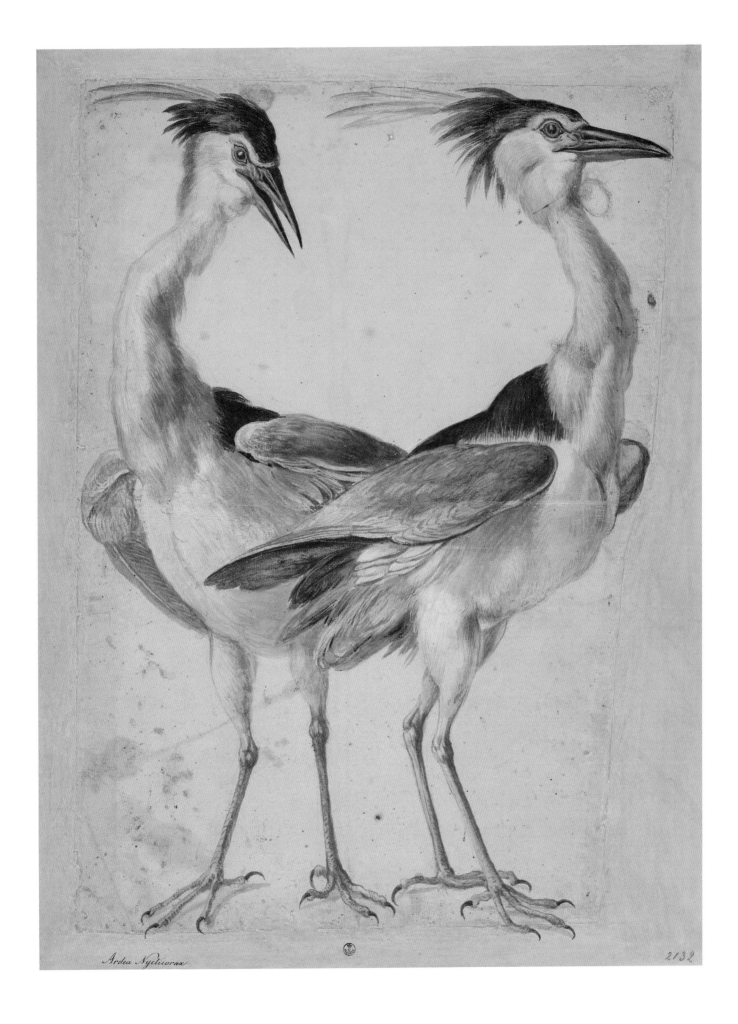

Ardea Nycticorax

2132

FIG. 10 Raphael, *Madonna di Foligno*, 1511–12. Tempera grassa on panel transferred to canvas, 308 × 198 cm. Pinacoteca Vaticana; inv. MV.40329.0.0

painting has thus far just kept me dangling with beautiful words and false promises, and he's dragged me from today into tomorrow . . . and I cannot go by myself since I don't know my way around this area, and I do not know who actually has the painting."[18]

It is miraculous, given the obvious pitfalls, that Bisi managed to serve two powerful masters at the same time. He was careful in his letters to one patron not to boast too much about purchases made for the other. In this period, the

Estensi and Medici had good relations, making Bisi's work much easier. Indeed, letters suggest that Alfonso and Leopoldo may occasionally have traded drawings.[19]

Bisi's extant correspondence, which must be only a fragment of the letters he wrote during his lifetime, mentions hundreds of drawings and dozens of paintings. Some of these works have been identified, and here I discuss a few of the more important drawings acquisitions in depth. These cases were also selected because the related correspondence is rich enough to provide insight into Bisi's taste, knowledge, personality, and style of his interactions with patrons.

Bisi, Coccapani, and Twelve Roman Emperors

For more than four and half years, Bisi was obsessed with a particular set of drawings, writing in a letter of June 16, 1654, "I live with an inexplicable passion for the Modena drawings."[20] Indeed, a significant number of his extant letters speak to his enthusiasm for the large collection left by Marchese Paolo Coccapani (1584–1650),[21] the bishop of Reggio Emilia, depicted in a fine but little-known portrait (fig. 11).[22] Called by Giuseppe Campori "among the most fervent collectors of art of his time,"[23] Coccapani—as known from two inventories Campori published in 1870[24]—was an ardent purchaser of paintings by all the major Emilian and Venetian artists. The paintings list (in Coccapani's hand), which Campori dates, without explanation, to 1640, includes a staggering 215 works. Among them was almost certainly Guercino's striking *St. John the Baptist in Prison Visited by Salome* of about 1620 (fig. 12), an influential representation of this rare subject, which likely had belonged previously to the Reggio banker, merchant and savvy collector Stefano Scaruffi.[25]

In a legal act of December 3, 1647, a large group of the paintings (86 in total) was given by the bishop (perhaps feeling the end was near)

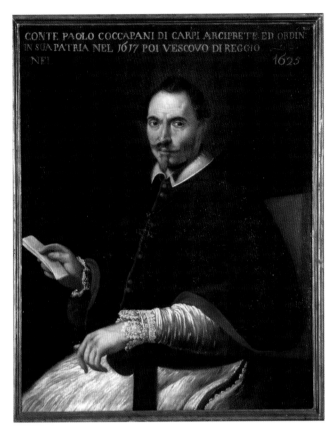

FIG. 11 Anonymous Emilian, *Portrait of Bishop Paolo Coccapani*, ca. 1640s (?). Oil on canvas, 117 × 90 cm. Musei di Palazzo dei Pio, Carpi (MO); inv. A/234

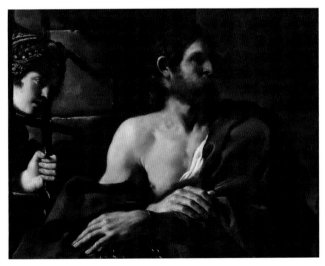

FIG. 12 Guercino, *St. John the Baptist in Prison Visited by Salome*, ca. 1620. Oil on canvas, 78 × 100 cm. Private collection, New York (courtesy Sotheby's)

to his nephew and heir in Modena, Marchese Alfonso Coccapani (son of Paolo's older brother Guido II).[26] At some point, Alfonso also took possession of Paolo's impressive collection of drawings (perhaps after the bishop's death in 1650), which numbered some 241 sheets, as recorded in the second inventory, dedicated solely to drawings (and written in a different hand), published by Campori.[27] This document, which unlike the paintings list includes prices, was also dated by the scholar to 1640, but there are reasons to think it was compiled much later.[28]

Bisi's infallible "drawings radar" must have lit up a few years later when rumors began to circulate about the nephew's failing health. On August 4, 1653, Bisi wrote from Bologna to his client Leopoldo de' Medici in Florence to report that Marchese Coccapani, resident in Modena, was about to die and this major group of drawings would soon be sold.[29]

A mere three weeks later, on August 23, Bisi wrote to Florence to say that the marchese has died and that he now hopes—through the intervention of a Jesuit priest—to acquire some of the best drawings for Leopoldo. The unnamed priest wants one of Bisi's miniature paintings (as a reward), but Bisi tells the Medici prince that he's not going to give the cleric one until he first comes up with some drawings.[30]

In this same letter, Bisi suggests, knowing how much Leopoldo (like the friar himself) is infatuated with Parmigianino drawings, that he wants something ("qualche cosa") by this master's hand for the future Medici cardinal. Perhaps he had in mind a drawing like *Study of Eight Putti Carrying Foliage*, a superb sheet by Parmigianino that came from the Coccapani collection and is easily identified in the inventory (fig. 13).[31] But the next sentence is surprising, as it is the only mention of specific sheets in all of Bisi's correspondence concerning the Coccapani drawings: "But above all what I'd really cherish (if it's possible to get it) is a

FIG. 13 Parmigianino, *Study of Eight Putti Carrying Foliage*, ca. 1523. Pen and brown ink, brown wash, traces of black chalk, 155 × 147 mm. Musée du Louvre, Paris; inv. 6439 recto

book containing Twelve Emperors in pen and ink by Annibale Carracci, done in imitation of Titian. These are beautiful in the superlative."[32] He mentions the book of drawings again on September 13, 1653 (though now with a more general attribution to "the Carracci"), but seems to telegraph to Leopoldo that the game is up, and it will no longer be easy to quietly acquire some drawings from the collection: "I was in Modena to see if I could get a few drawings from the late Marchese Coccapani, but I found that they have [in the meantime] opened their eyes; there is still real hope [I think] of getting a book with 12 Emperors in pen by the Carracci in imitation of Titian, which are exquisite."[33]

Bisi's hopes were not realistic. In the end, the drawings collection, as might have been predicted given their location in the shadow of the Palazzo

Ducale at Modena, wound up being purchased by Francesco I d'Este and his son Alfonso, Bisi's other principal clients.

Until recently, it was not clear exactly how or when the Coccapani drawings found their way into the Galleria Estense. The fact that many of the sheets formerly in Modena, like the Parmigianino *Putti*, were taken to France by Napoleon's troops and are now in the Louvre has made the investigation even more complicated. But thanks to research by Elisa Montecchi, we now know that the marchese's widow, Isabella Molza Coccapani, received 1,040 lire, in a formal record ("ristretto contabile") of debt cancellation dated January 15, 1656, from the court of Duke Francesco I d'Este, for "drawings and books."[34] (The Coccapani had borrowed large sums from the Estensi.) Simone Sirocchi has also published important payment documents pertaining not just to the deceased bishop's drawings but also his statues and paintings.[35] Nearly a year later, a document dated December 1, 1656, records the "invio" (the shipment) of the drawings from the Coccapani to "Serenissimo Signor Principe," which surely refers to Alfonso d'Este.[36] Bisi's correspondence with the latter consistently demonstrates the young prince's great love of drawings and his interest in enriching the court's collections. Francesco was often away at war, so Alfonso may have been especially active.[37]

It turns out that a year and a half before the January 1656 sale of the drawings, Bisi had taken on a serious role in their dispersal. Now, as an insider, he had to give Leopoldo some sobering news. As relayed to the Medici prince on April 14, 1654,[38] Bisi's "Padre Superiore" at the Convento di San Francesco in Bologna had just sent him to Modena, following a request by a certain Abbate Carlo Campori, to appraise the collection drawing by drawing ("pezzo per pezzo"). In the same letter, Bisi reports: "They say the Duke [Francesco I] wants to buy them [the drawings], which just gutted me." Years later, at the end of 1657, and surely still smarting from his failure to please Leopoldo, Bisi wrote to Florence to say that he had been in the Palace at Modena and seen Alfonso's drawings collection, including the Coccapani sheets (about which, so as not to arouse jealousy, he tactfully skipped his customary hyperbole).[39]

As affirmed by Alessandra Bigi Iotti,[40] the "album" of emperor portraits today in the Galleria Estense (now mounted as separate sheets) is the one listed in the Coccapani drawings inventory, where it is given specifically to Ludovico: "Un libro con dodeci Imperatori di penna di Ludovico Carraccia D. 20" [the "D" = "Ducatoni"].[41] Two of the sheets are illustrated here: *Julius Caesar* (fig. 14) and a particularly compelling drawing (far from the usual models) that probably represents the emperor *Galba* (fig. 15). Still in reasonable condition despite, centuries ago, having been hung in a gallery and exposed to light, the sheets are squared for transfer in white chalk, as if preparatory for a set of paintings (or prints).

Most scholars agree that the series of drawings should be attributed to School of Passerotti, although Catherine Loisel believes they are by an unidentified member of the Carracci School,[42] and that idea makes sense, especially when it comes to the Carraccesque frontispiece, which has a Coccapani provenance (fig. 16).[43] This sheet—and perhaps even the *Imperatori*—might be by Francesco Brizio (1574–1623).[44] Early in his career, Brizio was a pupil of Passerotti; he later moved on to the Carracci Academy. Entitled *Effigie delli XII Cesari*, the frontispiece shows Fame—as if depicted in the sky above—astride a globe, blowing one of her two trumpets. In the corners (emblematically representing the heavens), imperial laurel crowns hover and flicker like stars—a nice touch, the Caesars' fame is not just global but universal.

In 1536–40, Titian (ca. 1488–1576) executed a series of paintings portraying eleven Caesars (he left out Domitian, which was supplied, many believe, by Giulio Romano [1492–1546]) for Duke

FIG. 14 School of Bartolomeo Passerotti, *Julius Caesar*, ca. 1600–1610 (?). Pen and brown ink, squared in white chalk, 317 × 214 mm. Galleria Estense, Modena; inv. 849

FIG. 15 School of Bartolomeo Passerotti, *Galba*, ca. 1600–1610 (?). Pen and brown ink, squared in white chalk, 311 × 214 mm. Galleria Estense, Modena; inv. 850

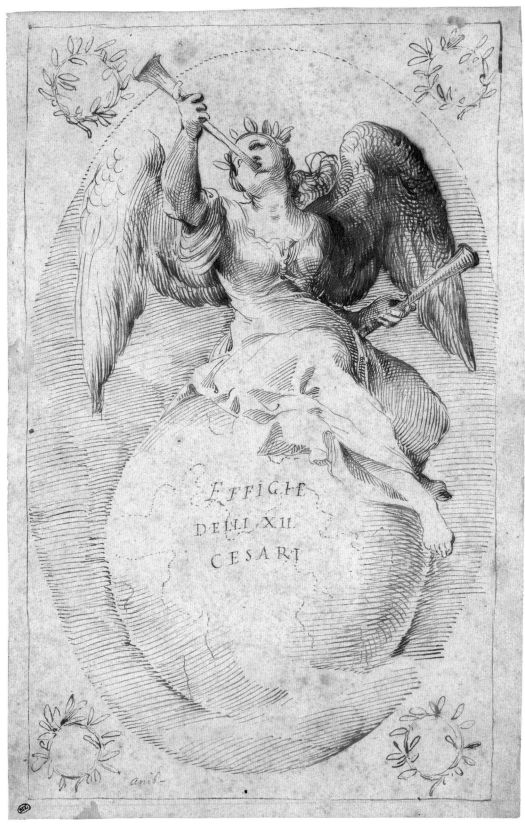

FIG. 16 School of Bartolomeo Passerotti, *Fame*, Frontispiece to *Effigie delli XII Cesari*, ca. 1600–1610 (?). Pen and brown ink, 326 × 215 mm. Musée du Louvre, Paris; inv. 8016 recto

FIG. 17 Bernardino Campi after Titian, *Julius Caesar*, 1562. Oil on canvas, 138 × 110 cm. Museo di Capodimonte, Naples; inv. Q1161

FIG. 18 Bernardino Campi after Titian, *Galba*, 1562. Oil on canvas, 138 × 110 cm. Museo di Capodimonte, Naples; inv. Q1157

Federico II Gonzaga's Gabinetto dei Cesari in the Palazzo Ducale in Mantua. The portraits were sold to Charles I of England in 1628, but by 1651 they were in Madrid in the collection of Philip IV of Spain. Destroyed in the famous Alcázar fire in 1734, the series is known today principally by the copies painted in 1562 by Bernardino Campi (1522–1595), now in Naples.[45]

A 1751 inventory by Pietro Zerbini of the Galleria delle Medaglie at the palace in Modena records all twelve drawings of the Roman emperors, framed and hanging six on the west wall, with the other six opposite.[46] Later (certainly by 1854),[47] two had disappeared: only ten drawings remain in the Galleria Estense collection. Titus and Claudius are probably the sheets missing, though the

identifications of the extant portraits are difficult to ascertain in a few cases.[48]

Indeed, the set is highly innovative and more intellectual than most. In the *Julius Caesar* (fig. 14), the emperor addresses the spectator in a powerful, psychologically engaging way. The viewing point is very low, as if we are kneeling before him. To increase the effect of his dominance, the body is elongated and the head is relatively small. The massive hands and broad, flowing drapery folds are more sculptural and austere than their counterparts in the principal copies after Titian (compare Campi's *Julius Caesar*; fig. 17). The portrait drawing in the Galleria Estense traditionally called *Domitian* (fig. 15) is more likely to be Galba, for two reasons. First, it represents an old man (Galba became

FIG. 19 Anonymous (Giovanni Francesco Cassioni?), *Portrait of Giovanni Andrea Sirani*, before 1678. Woodcut, from Malvasia, *Felsina Pittrice* (Bologna, 1678). Library, National Gallery of Art, Washington, DC

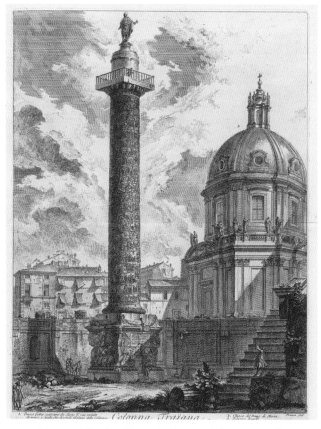

FIG. 20 Giovanni Battista Piranesi, *Trajan's Column*, 1758 (from *Vedute di Roma*). Etching, 530 × 400 mm. Yale University Art Gallery, New Haven; inv. 2012.159.11.18

emperor, following Nero's suicide, when he was in his seventies, whereas Domitian died at the age of forty-four). Second, the drawn composition has a column in the background, placed adjacent to the head in a scheme similar to Titian's *Galba* portrait but to none of the Venetian's other emperors (compare Campi's *Galba*; fig. 18). With its sophisticated network of hatching, strong diagonals, and moving facial expression, this is the most exceptional of the ten sheets at Modena. It anticipates the blend of melancholy, philosophical soulfulness, and *all'antica* poetics of Salvator Rosa (1615–1673).

Bisi, Francesco I, and Trajan's Column

Before turning to some examples of works that actually did make the journey south to an eager Leopoldo, it should be noted that Francesco I d'Este's love of drawings depicting ancient Roman

history would be satisfied again, two years later—and this time on a massive scale. As Federico Fischetti has shown,[49] in 1658 Bisi was able, through his friendship with the Bolognese painter, connoisseur, and dealer Giovanni Andrea Sirani (fig. 19), to arrange for the sale to Francesco of an artistic marvel of the sixteenth century: an incredibly long "scroll" of joined sheets in pen and wash reproducing the entire series of carved reliefs depicting the Dacian Wars on Trajan's Column. The scroll is more than half the length of an NFL football field: 187 feet.

The 128-foot-tall monument (dedicated 113 CE), shown in a stirring etching by Giovanni Battista Piranesi (1720–1778) of 1758 (fig. 20), was an important source for classical narrative style, military costume, and architecture. The sculptures consist of some 2,500 figures carved in relief on

FIGS. 21–22 Attributed to Circle of Pirro Ligorio, *Scenes from the Dacian Wars* (after reliefs on Trajan's Column), second half of 16th century (?). Pen and brown ink, wash, each sheet approx. 28 × 44 cm. Galleria Estense, Modena; two details from inv. 8129

a spiral of marble panels that winds around the shaft twenty-three times, for a combined length of approximately 656 feet.

Bisi recommended the drawings (figs. 21–24) to Francesco as the work of Raphael's pupil and assistant Polidoro da Caravaggio (ca. 1499–ca. 1543). The attribution, probably made by Giovanni Andrea, makes a certain amount of sense given Polidoro's devotion to imitating ancient Roman friezes in his frescoes. But the style of his drawings is only superficially similar to that of the Modena sheets. Another Raphael collaborator, Giulio Romano, has also been suggested as the author. More recent scholarship has pointed to the circle of Pirro Ligorio (ca. 1500–1583).[50]

Most draftsmen in the Quattrocento just depicted the lowest band on the column, as it was immediately accessible,[51] but the Bolognese artist Jacopo Ripanda (active ca. 1500–1516) is credited with having produced, shortly before 1506, the first drawing of the entire frieze. He reportedly climbed the column's internal staircase and then slowly descended the exterior in a basket.

In a letter to the duke of June 18, 1658,[52] Bisi documents the beginning of the transaction that brought this incomparable frieze of drawings to the collection of Francesco I:

And I visited with Giovan Andrea Sirani whom I invited, as directed by V.A.S. [Vostra Altezza Serenissima; "Your Most Serene Highness"], along with his daughter-painter ["la sua pitrice"—Elisabetta Sirani], to see the beautiful drawings in your Camerino; and if he hadn't been laid up with gout, he would have come flying to you. And to please V.A.S., and to give pleasure to me too, he has passed on to me a beautiful acquisition opportunity which he himself had hoped to act on quickly; and it will be easier for V.A.S. to get it than anyone else: this is a most superb drawing by Polidoro da Caravaggio, five or six [*sic*] braccia in length.[53] Part of it is done with white highlights; and some with wash; and one could break it up into several pieces ["e se ne potrano far più pezzi"]. The drawing is in Correggio, and it is in the hands of a Spanish painter named Diego, and he wants 50 scudi for it.[54]

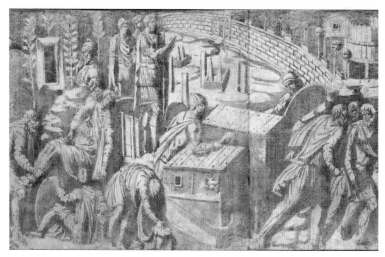

FIGS. 23–24 Attributed to Circle of Pirro Ligorio, *Scenes from the Dacian Wars* (after reliefs on Trajan's Column), second half of 16th century (?). Pen and brown ink, wash, each sheet approx. 28 × 44 cm. Galleria Estense, Modena; two details from inv. 8133

Francesco purchased it almost immediately. Just eleven days later, on June 29, a certain Costa in Correggio wrote to the duke: "I'm sending V.A.S. the drawing by Polidoro da Caravaggio which was in the possession of Diego, a painter here in Correggio. . . . [It's a good thing] that the order of V.A.S. did not come much later, since the drawing was about to be sent to the painter Sirano of Bologna."[55]

The drawings consist of 124 sheets—11 inches (28 cm) in height and of varied width (averaging about 17 inches across; 43–44 cm)—each slightly overlapping and glued to its neighbor. At some point (near the end of the nineteenth century), they were divided into twelve friezes backed by wooden boards. By the early twentieth century, if not earlier, they were framed and glazed. The combined length of the twelve *pannelli*, as noted earlier, is 187 feet (57 m) or roughly one-third the length of the original marble reliefs.[56]

The "Polidoro" frieze is one of the treasures of the graphic collection in the Galleria Estense. It was Bisi who had the passion, agility, and the perfect network in Bologna (with Sirani) to effect this acquisition. Francesco—and his son Alfonso, who would become duke in a few months, after

his father's unexpected death—trusted Bisi's judgment. As Malvasia said about Bisi's service to the Estensi, "Without the advice of the friar, Duke Francesco would not buy a single painting or drawing in Bologna."[57]

Leopoldo de' Medici and Bisi: The Making of a Collection

Bisi had long lists of desiderata from Leopoldo, and he worked indefatigably to satisfy him.[58] The two men loved many of the same artists, and to judge from Bisi's side of the correspondence, they understood each other to a surprising degree (figs. 25, 26). The future cardinal had agents throughout Italy searching for the best examples, but for Emilian art—Correggio (ca. 1489–1534), Parmigianino, Francesco Primaticcio (1504–1570), the Carracci, Reni, Guercino—he relied mainly on Bisi. After the friar's death, in 1659, his nephew Fra Giuseppe Maria Casarenghi (1639–after 1675) (fig. 27),[59] whom he had trained as a miniature painter and drawings connoisseur, continued in Bisi's role with great energy until Leopoldo's own passing in 1675.[60] For Bisi, the first two names were his clear favorites. Concerning two paintings

FIG. 25 Domenico Maria Muratori after Guercino, *Portrait of Fra Bonaventura Bisi* (detail)

FIG. 26 Adriaen Haelwegh, *Portrait of Cardinal Leopoldo de' Medici* (detail)

of heads, one by Correggio and the other by Parmigianino, Bisi says: "I cannot rest; in fact I always wished for your Gallery some paintings by these authors who are my idols in this profession."[61]

PARMIGIANINO AND PRIMATICCIO: ELEGANCE AND EXTRAVAGANCE

One documented Parmigianino that Bisi purchased for Leopoldo was this diminutive *Suicide of Dido*, which the friar recommended in 1654 (fig. 28).[62] In his letter of August 25, Bisi seems in rapture: "Marchese Cospi is informed of the great find I made with regard to a drawing by Parmigianino no bigger than a folded letter; it's of such exquisiteness that it drives the painters who see it crazy. I hope to get it; it's a *Dido* made of I don't know what. It is so meticulous that it seems to be made of air ["fatta d'Aria"]—you just have to see it."[63]

FIG. 27 Attributed to Fra Giuseppe Maria Casarenghi, *Self-Portrait*, ca. 1665–70. Tempera on parchment, 106 × 80 mm. Uffizi, Florence; inv. 8783

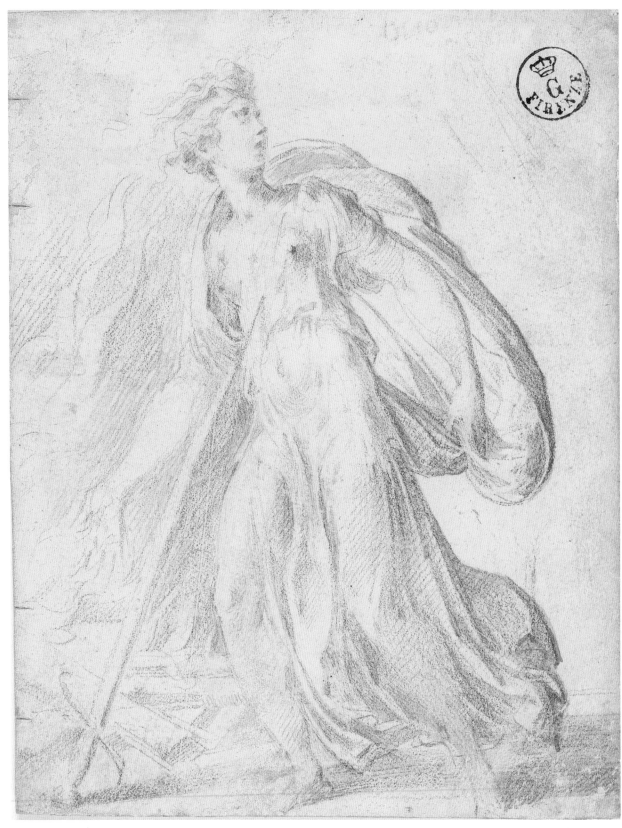

FIG. 28 Parmigianino, *Suicide of Dido*, ca. 1525–40. Metalpoint on prepared parchment, 95 × 73 mm. Gabinetto dei Disegni e delle Stampe, Uffizi, Florence; inv. 13610 F

FIG. 29 Francesco Primaticcio. *Juno Invoking Somnus to Put Jupiter to Sleep*, ca. 1541–44. Pen and brown ink, red wash, traces of black chalk and stylus, white highlights, 221 × 333 mm. Gabinetto dei Disegni e delle Stampe, Uffizi, Florence; inv. 695 E

Of a similar refinement and virtuosity are three marvelous sheets Bisi purchased for Leopoldo created by the Bolognese painter-architect Primaticcio. After studying with Giulio Romano at Mantua, Primaticcio was called in 1532 by King Francis I to work in France at the Château de Fontainebleau, where he excelled in delicate, erotic representations of sometimes arcane mythological, literary, and allegorical scenes.

In 1654, Bisi was responsible for Leopoldo's acquisition of this hyper-elegant and inventive drawing by Primaticcio, made for a fresco of ca. 1541–44 in the vestibule of the Porte Dorée at Fontainebleau. It represents a rarely depicted scene from Homer's *Iliad*: Juno Invoking Somnus to Put Jupiter to Sleep (fig. 29).[64] The story relates how Juno, who favored the Greeks (Danaans), created a scheme to keep her husband Jupiter, ruler of all the gods, from helping the Trojans in the Trojan War. She convinces the reluctant Somnus (Greek: Hypnos) to put Jupiter, who is always awake, into a deep slumber so that Neptune can secretly help the Greeks.[65]

The other two drawings Bisi sold to Leopoldo are a daring, erotic pair of images almost certainly made before Primaticcio went to France, as they so deeply reflect his youthful period at Mantua under the spell of Giulio's *di sotto in su* ceiling frescoes in the Palazzo Te. They probably date to about 1526–28. These are a *Carro del Sole (Chariot of the*

FIG. 30 Francesco Primaticcio, *Carro del Sole (Chariot of the Sun preceded by Aurora)*, ca. 1526–28. Black chalk, pen and ink, brush and wash, white highlights, 317 × 497 mm. Gabinetto dei Disegni e delle Stampe, Uffizi, Florence; inv. 13332 F

FIG. 31 Francesco Primaticcio, *Carro della Luna (Chariot of the Moon with Two Gods of Sleep)*, ca. 1526–28. Black chalk, pen and ink, brush and wash, white highlights, 285 × 490 mm. Gabinetto dei Disegni e delle Stampe, Uffizi, Florence; inv. 13335 F

Sun preceded by Aurora) (fig. 30)[66] and the *Carro della Luna (Chariot of the Moon with Two Gods of Sleep)* (fig. 31)[67]—together, allegories of the passage of time. Bisi, as a Franciscan, gave a moral warning about the *Aurora*: "ma per essere veduta di sotto insu è un poco lascivetta" (but because of the steep perspective, seen from below looking up, it's a bit risqué).[68]

The friar was also consistently on the lookout for works by major Venetian and Florentine painters of the sixteenth century: Veronese (1528–1588), Titian, Raphael, Michelangelo (1475–1564).[69] For Leopoldo, Bisi was able to buy masterpieces such as the vibrant 1552 portrait of the Bolognese prelate *Bishop Ludovico Beccadelli* by Titian (fig. 32),[70] and a superlative red chalk drawing by Raphael of *St. Paul Preaching at Athens*,[71] a key study for one of the Vatican Tapestries of 1514–16.

Bisi seems not to have been very active in getting works from Genoa (or, for that matter, Cremona).[72] But he certainly appreciated the Genoese painter Bernardo Strozzi (1581–1644) and noted his Caravaggesque sources.[73] And when it came to drawings, he had his eyes peeled at all times for sheets by Luca Cambiaso (1527–1585), one of the Cinquecento's most prolific and dynamic draftsmen. A fine example of this Genoese master's excited, nervous penwork and atmospheric use of wash is his *St. Sebastian with the Madonna and Child, Sts. Mark and John the Baptist*, likely a preparatory study for an altarpiece (fig. 33).[74]

Bisi was simply enthralled with Cambiaso drawings. In a 1657 letter to Leopoldo, he reports: "I bought some beautiful landscapes by Titian carried back from Paris by a Bolognese painter and many pieces by Cambiaso brought from Genoa, and to me these are so beautiful that all day long I enjoy looking at them and poring over them: I have no greater pleasure than beautiful drawings."[75]

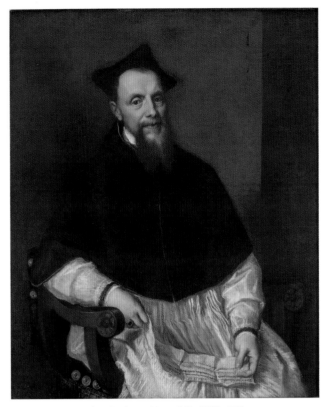

FIG. 32 Titian, *Bishop Ludovico Beccadelli*, 1552. Oil on canvas, 117.5 × 97 cm. Uffizi, Florence; inv. 1890, n. 1457

Puttomania: Pordenone's "Ballo di Putti," David Beck, and a Gift for Queen Christina of Sweden

An artist from Friuli much influenced by Correggio and Titian yet always his own brilliant, idiosyncratic self, Giovanni Antonio de' Sacchis, better known as il Pordenone, was much appreciated in Emilia because of his illusionistic frescoes in Piacenza and Cortemaggiore. In 1654, Bisi was involved in acquiring for Leopoldo four stunning Pordenone drawings: a *Ballo di Putti*, as well as the *Martyrdom of St. Peter Martyr*,[76] *Birth of the Virgin*,[77] and *Joachim Chased from the Temple*.[78]

One could make the case, based on a protracted narrative told in many letters over several years, that the first of the four Pordenone sheets, a *Ballo di Putti* (Dancing Putti), dateable to ca. 1532–36,

FIG. 33 Luca Cambiaso, *St. Sebastian with the Madonna and Child, Sts. Mark and John the Baptist*, early 1560s. Pen and brown ink, with brush and brown wash, 543 × 351 mm. The John & Mable Ringling Museum of Art, Sarasota, Museum purchase, 1977; inv. SN958

became one of Bisi's favorite acquisitions (figs. 34, 35).[79] It is a work of incomparable charm and persistent energy, but manifesting, too, a highly sophisticated synthesizing of sources, not only Correggio and Raphael but also Michelangelo.

On January 3, 1654, Bisi wrote: "There are four very beautiful [drawings] of Pordenone, that is: a 'Ballo di Puttini' on blue paper. Eleven of them are dancing; three play music; and three are playing with a small dog. This is such a beautiful

drawing that if they were to sell it separately I would pay 25 even 30 scudi." The friar then mentions the *St. Peter Martyr*, which he says is large and "più fornito che una miniatura" (more densely painted or colored than a miniature—a phrase Bisi uses frequently): "But [the *Peter Martyr* is] not as exquisitely pleasing as the 'Puttini.' "[80] From Bisi's letter of April 28, 1654, we learn that the friar has by now already purchased the Pordenone drawings for Leopoldo.[81] It is not clear when they arrived in Florence.

Renaissance artists such as Donatello created joyous, even raucous friezes of frolicking, dancing, carousing, wrestling, drinking, and music-making putti, based on antique sources.[82] By the Seicento, one could argue for a true "Puttomania" resurgence, partly inspired by Titian's 1519 painting for Alfonso I d'Este of the *Worship of Venus* (Prado, Madrid). The picture, with dozens of putti—having been taken from Ferrara to Rome in 1598 by the Aldobrandini, and then given in 1621 to Guercino's patrons there, the Ludovisi—was a sensation. The context for Bisi's appreciation of Pordenone's *Ballo di Putti* was also filled with works of playful babies created by dozens of the friar's contemporaries, including Reni, Guercino, and especially Francesco Albani (1578–1660), for whom they were practically a brand.

Bisi's admiration for the *Ballo di Putti* took on material form when he decided to reproduce it in one of his miniatures as a gift for Leopoldo (now unfortunately lost). This work must have been well advanced by November 30, 1655, when, as we know from Bisi's letter of that date, Queen Christina of Sweden (1626–1689), having abdicated the throne in 1654 and now touring Italy, had already arrived in Bologna and seen the miniature.[83]

A brilliant, highly cultured, engaging person, Christina was always on the lookout to meet artists and collect great works (fig. 36). Bisi, as he reported rather breathlessly to Leopoldo, was starstruck:

FIG. 34 Pordenone, *Ballo di Putti (Dancing Putti)*, ca. 1532–36. Black chalk with white highlights on oxidized blue paper (now turned brown), 202 × 357 mm. Gabinetto dei Disegni e delle Stampe, Uffizi, Florence; inv. 729 E

I have to tell V.A.S. how the Queen of Sweden wanted to meet me and see my work and most of all she liked the *Ballo de' Puttini* similar to your drawing by Pordenone; and she was so infatuated with it that she said "no matter what, I want it." But because I had said I was making it [the miniature] for V.A.S. (which was truly what I had intended), the Queen replied: "well what shall we say to Signor Principe Leopoldo? What can be done?"

I replied that V.A.S. would be honored to serve Her Majesty in this small thing.

And she just repeated that she would like to have it. I said it will be ready. . . . So I thought it a good idea to share with you now what happened. So if you think you would like to make her a gift, then in the meantime one could prepare a beautiful frame while I complete the miniature as best I can. And then I will send it to V.A.S., to whom I will also say that this great lady has the most elevated mind ["spiriti"] and in no way shows herself to be a woman; and she knows drawings better than her painter [Beck].

FIG. 35 Pordenone, *Ballo di Putti (Dancing Putti)* (detail)

The festivals that were done here [in Bologna for the Queen's welcome] were of no great moment, but her greatest pleasure was having seen some paintings. Before leaving, she wanted to meet Guercino of Cento and Albani. And with everyone she comported herself with utmost politeness.[84]

Christina was often accompanied in Italy by her official portraitist and art adviser, the Dutch painter David Beck (1621–1656) (fig. 37). Born in Delft, Beck had trained in London with Van Dyck and become an important assistant. He left England after his teacher's death in 1641, and then worked in Paris and Copenhagen for a few years. In 1647 he landed an official appointment at the court in Stockholm. An amusing biography of Beck, who in Rome was a member of the Bent-veughels (Birds of a Feather) artists group, with the nickname "Golden Sceptre," was penned by the Dutch artist and biographer Arnold Houbraken (1660–1719). He reports rumors that Beck died of poisoning while on a visit to The Hague in 1656.[85] Beck was an ambitious drawings dealer. Based on

FIG. 36 David Beck, *Portrait of Queen Christina of Sweden*, 1650. Oil on canvas, 110 × 92 cm. Nationalmuseum, Stockholm; inv. NM 308

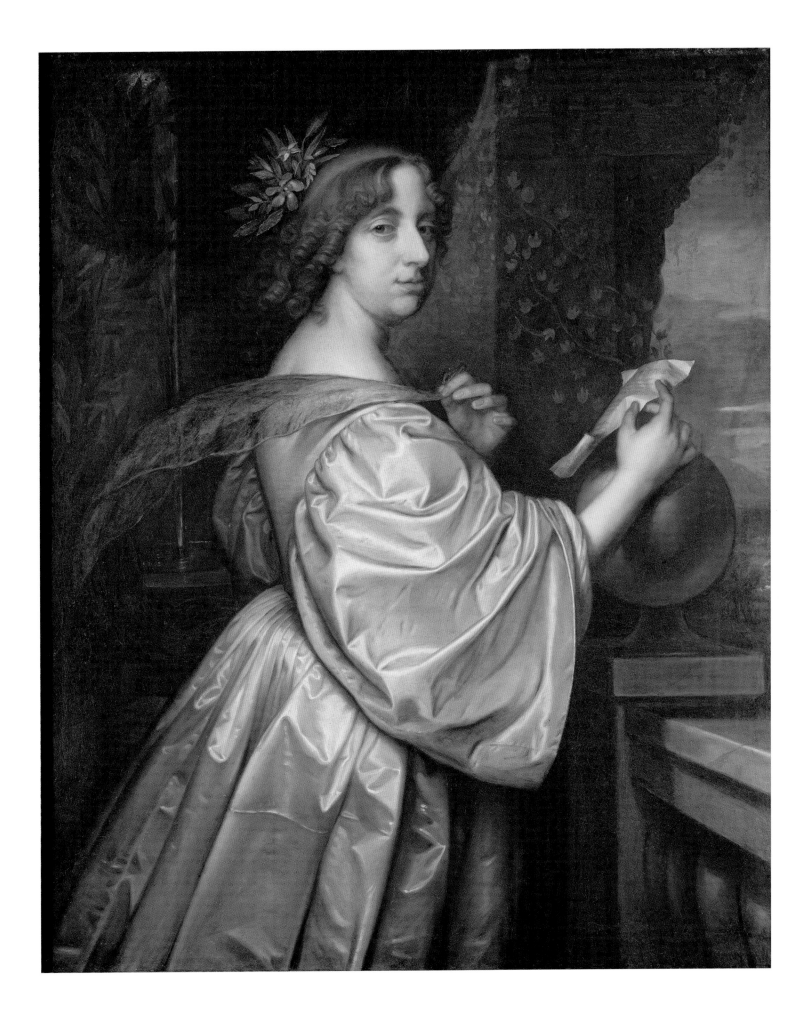

dozens of Bisi's letters from this period, we know that in Italy, Beck was constantly ill—though not enough to slow down what to Bisi was a perpetual invasion of the friar's territory.

Wherever the "Pittore della Regina" went, sometimes with official arrangements to paint portraits, he looked at important collections and showed off his recent discoveries. To Bisi, Beck was guarded, conceited, and not nearly as knowledgeable a connoisseur as he claimed (note Bisi's snide comments in the letter quoted above). On January 26, 1655, Bisi wrote Leopoldo to say that he intends to go to Venice to visit a certain Flemish merchant named Signor Gualtiero who had invited him to see his great collection of drawings. "But it's made me rather jealous to learn that that painter of the Queen of Sweden got there first." And it probably did not help matters that, as Bisi relates in the same letter, Beck had just been to Florence while Leopoldo was absent and was shown the future cardinal's drawings collection by Prince Mattias, Leopoldo's brother.[86]

On August 12, 1655, Bisi wrote that Beck, who had been in Modena, was in Bologna "male da morto" (deathly ill), and that he would soon be in Florence to paint the portrait of Principe Mattias. "I think [Beck] has beautiful drawings with him but he's so paranoid ["tanto sospettoso"] that it's difficult to get him to show you things."[87] Nearly two weeks later, on August 24, Bisi wrote to Leopoldo to say that he's heard that Beck has seen the drawings collection in Florence (and the implication Bisi wants to telegraph is that Beck has said some nasty things about them): "he's an opinionated man, who is pretty knowledgeable, but not as much as V.A.S., because the taste of the Flemish [including the Dutch] is not as elevated as those of Italians."[88]

Things got heated when Bisi learned that in Modena the Dutchman had supposedly struck a deal with the Marchesa Coccapani to buy the late bishop's drawings collection for 100 doble—100 scudi less than what the friar had already offered

DAVIT BECK
Peintre, et Valet, de Chambre de la Serenissime Reyne de Sweede, enuoié de Sa Ma: pour peindre les personnes Illustres de la Chrestienté, natif de Delft en Hollande.

Dauit Beck pinxit. *Ant. Cosset sculpsit.* *Ioan. Meyssens exc.*

FIG. 37 Joseph Antoine Couchet after David Beck, *Self-Portrait*, 1662. Engraving, approx. 172 × 117 mm. From Cornelis De Bie, *Het Gulden Cabinet . . .* (Antwerp 1662). Sterling and Francine Clark Art Institute Library, Williamstown, MA

her (presumably with Leopoldo's blessing). Bisi was incensed and protested in a (now missing) letter to Marchese (Abbate) Carlo Campori. He received an apologetic reply from Campori, dated August 24, 1655.[89] A week later, on August 31,[90] Bisi, now feeling embarrassed at the aggressive tone of his complaint, explained the Beck fiasco to Leopoldo and attached Campori's letter. The marchese said that in Modena Beck was nearly dead from illness and must have lost his mind, as he was obviously not remembering things clearly: no such deal had been made.

The saga of Queen Christina and the *Ballo de' Puttini* continued. By December 13, 1655, some two weeks after Bisi informed the Medici prince of the queen's desire to intercept his (Leopoldo's) miniature of the *Dancing Putti*, and after hearing back from Florence that Leopoldo (we can infer) is willing to part with it, the friar says he will finish the painting as soon as he can and then send it to the prince so he can in turn send it to the queen. If Leopoldo wants Bisi to provide a frame, he will do so; but if Leopoldo wishes to make one in Florence, the friar will send him the measurements.[91]

Two weeks later, in a letter of December 28, Bisi sent the measurements for a frame to be made by Leopoldo's craftsmen, but whether it should be in gold leaf or tortoiseshell is entirely up to the prince's "prudenza." But immediately Bisi inserts his belief: "I think, however, that the gold contrasts too much" ("ma l'oro sbata troppo"). The friar promises, once again, to send to Leopoldo "quanto prima" (as soon as possible) the miniature of the *Puttini*.[92]

The story comes to its conclusion three weeks later with Bisi's funny but confusing letter to Leopoldo of January 18, 1656.[93] The text has sometimes been misunderstood. The friar says: "I am sending you these four Frogs ["quattro Rane"] which emerged from the weakness of my paintbrush guided by ["sotto la scorta del"] the beautiful drawing by Pordenone."[94]

Bisi has not painted an image of four frogs.[95] He is simply using one of his ironic "Bisi-isms."[96] We know from a passage later in the letter (which, alarmingly, repeats content Bisi seems to have forgotten he had told Leopoldo just six weeks earlier) that he is sending the miniature of the *Ballo di Putti* for the queen and that the Medici prince is expected to send it to her in due course: "I would really appreciate knowing, down the road, how the Queen liked them [the *Putti*], because I cannot tell V.A.S. the desire that she demonstrated; and after showing her some of my works in the presence of Cardinal Lomellino and other Lords, when she saw these Putti ["questi Putti"], she screamed, and said 'I want them.'"[97]

No proof exists to indicate that Leopoldo actually sent Bisi's *Dancing Putti* to Queen Christina. The huge gap in the surviving correspondence (between February 19, 1656, and January 25, 1657) makes it difficult to understand the precise outcome. But from what follows, it would seem Leopoldo, for a time, kept the original miniature for himself. (If Bisi made a replica for the queen it is undocumented.)

LAST DANCE:
BISI'S *BALLO DI PUTTI* AND MODENA

On January 25, 1657, a full year after the "four frogs" letter, Bisi tells Leopoldo that he's in a jam and obligated himself to make another miniature of the *Ballo di Putti*, but has no way of doing so without a model to copy. He suggests the prince lend him the miniature, as shipping the actual drawing from Florence to Bologna would be too big an ask: "I wouldn't dare request the drawing by Pordenone because it is 'cosa troppo zelosa' [something too fragile]."[98]

Another year passes, and a letter to Modena of February 2, 1658, almost certainly reveals the intended recipient of the miniature Bisi had needed Leopoldo's help to produce: Duke Francesco I d'Este, recently returned to Modena from a victory on the battlefield.

The gift was arranged by his son Alfonso. Bisi, in his letter to the duke, turns the *Ballo di Putti* into an allegory: "From him [Alfonso] you will kindly receive the expression of my happiness through some Putti who dance to applaud your glories."[99] A letter to Alfonso, written the same day, provides instructions: "I beg you [when it arrives] to arrange to open the box I am sending you, wherein you will find a 'Ballo de' Putti' by my hand. Please present it, as coming from me, to my Lord the Most Serene Duke. The putti dance, and make

FIG. 38 Anonymous after Pordenone (or Bisi?), *Ballo di Putti (Dancing Putti)*, late 17th century (?). Tempera on parchment, 215 × 330 mm. Musée du Louvre, Paris; inv. RF 4254 recto

applause on my behalf for the happy return of S.A.S. [Sua Altezza Serenissima, "His Most Serene Highness"] and for his glorious actions."[100]

Nothing with Bisi is easy. If my interpretation is correct, he spoke too soon. He wrote to Leopoldo eight days later (February 10, 1658) to say that he is awaiting the arrival of Marchese Cospi [in Bologna] to receive the favor of "quelli benedetti Puttini." It seems Leopoldo has decided, in the end, to give a desperate Bisi the chance to make a gift to Duke Francesco of the prince's miniature still in Florence. Bisi is tremendously grateful, adding: "And I assure you that you are relieving me of a great vexation and whatever you spent on the frame I will repay immediately, either in money or in drawings or paintings—in whatever manner you please."[101]

Bisi's joyful *Ballo di Putti*—admired by some of the most powerful nobles in Europe—may be lost forever, but a miniature painting on parchment (fig. 38), reproducing Pordenone's drawing in Florence, has been suggested tentatively by Giovanni Agosti as by the hand of the friar.[102] Its dimensions, taking into account that it omits the musical group on the left, are not dramatically different from those of the Uffizi sheet. While the parchment (which I know only from photographs and needs restoration) seems far below the level of Bisi's accepted miniatures and does not employ his renowned dot technique, it would not be surprising if it turned out to be a copy (late seventeenth century?) after the friar's lost original. Perhaps this discussion will lead to the discovery of Bisi's miniature, which was fit for a prince, a queen, and a duke.

NOTES

1. For this section, I have been guided by Galleni 1979 and Fileti Mazza 1993, 1:3–33; esp. 7–21. Bisi's letters to Leopoldo in the Archivio di Stato, Florence [ASF], are located in the Carteggio d'Artisti, III, inserto 30 (hereafter CdA III). Many letters seem to be missing, as there are none between February 19, 1656, and January 25, 1657. (The gaps are even larger for the letters preserved in the Archivio di Stato, Modena [ASMo], which are not numbered: none exists for 1656 or 1657.) The pages in the Bisi *carteggio* in Florence have two numbering systems: one (clearly older) is in pen and ink; the other consists of numbers stamped in ink. I cite only the latter, following Fileti Mazza (although in her introduction she uses only the pen numbers). Strangely, she does not cite Potito's 1975 work on Bisi. Although he missed several important letters (in the archives of both Florence and Modena), and his transcriptions contain numerous mistakes and must be checked against the originals (and I have done this, as time permitted), his contribution is nevertheless worthy of recognition. Some of the letters have since been transcribed in Barocchi and Bertelà 2007, which also contains a useful index: see esp. 2:974–75; and *ad indicem*, Bisi and Cospi. There are a few references to Bisi's paintings (all unfortunately lost) in Barocchi and Bertelà 2011. Many of Bisi's letters appear here for the first time in English. Translations are mine unless otherwise noted.

2. Giordani 1835, esp. 146, 164–65 n. 22, who, on the basis of documents he inspected, describes a drawing (untraced) by Bisi of a now-lost medieval tomb at San Benedetto. The inscription on the drawing calls Bisi "Rettore di essa chiesa e pittore eccelente." Cf. also Rivani 1968, 94–97.

3. Carpani 1975, ill. pp. 46–47. For one of dozens of statements regarding retreating to Pianoro, see CdA III, c. 298 (December 13, 1655; Bisi to Leopoldo de' Medici), letter not in Potito 1975; cf. Fileti Mazza 1993, 1:16, 362: "mi ritrovo fuori della città alla mia Chiesa di San Benedetto di Pianoro ove sto lavorando un poco, cosa che alla città malamente posso fare per le molte occupationi della Chiesa et altre facende."

4. For the history of the church, see Rivani 1968; Carpani 1975, 40–49; and Fabbri 2017.

5. Potito 1975, 71–72, no. 43; CdA III, carta (hereafter "c.") 280 (Bisi to Leopoldo; August 24, 1655).

6. He often refers to one of his best sources simply as "Il Prete delli Disegni."

7. "A me pare un comprare Disegni senza Disegno." Potito 1975, 116, no. 88; CdA, III, c. 383 (Bologna, March 11, 1659).

8. Malvasia 1678, 1:560, says the Estensi paid Bisi a stipend: "una provisione di due doble il mese fine che vivesse." For Bisi's stipend under Alfonso IV, see Sirocchi 2015, 74, 81 n. 13. It is mentioned as "36 doble" a year in the record of the dispute between the Convento di San Francesco in Bologna and Alfonso IV over Bisi's estate. See Potito 1975, 157.

9. Recent studies of Estense patronage and collecting include Bentini 1998b; Cavicchioli 2010; Fumagalli and Signorotto 2012; Casciu, Cavicchioli, and Fumagalli 2013; Sirocchi 2015; and Sirocchi 2018. For Bisi and Modena, see esp. Bentini 1989, 18; and Sueur 1998, 21–22.

10. For *Francesco I*: Boccolari 1987, 183–84, no. 166; Weston-Lewis 1998, 190, no. 169 (entry by T. Clifford). For *Alfonso IV*: Boccolari 1987, 188, no. 167. For Teseo, see Crespellani 1884, esp. 105; 119–20.

11. Because of the calamitous 1746 "Vendita di Dresda," in which Francesco III d'Este (1698–1780), because of war-related debt with the Elector of Saxony, sold off to Dresden what were arguably the one hundred most important works in the collection, many acquired by Francesco I, the Galleria Estense today is a much reduced version of its former self. Bisi would hardly have recognized it. See Winkler 1989.

12. See Lavin 1998.

13. Ostrow 2011.

14. Conticelli, Gennaioli, and Sframeli 2017, for Leopoldo as a collector. See also Goldberg 1983; and Goldberg 1988.

15. Conticelli, Gennaioli, and Sframeli 2017, 244–45, no. 11.

16. For Cospi, see also Fileti Mazza 1993, 1:20–33. Cospi took a role in trying to acquire the Coccapani drawings for Leopoldo (discussed below). Potito 1975, 50, no. 18; CdA III, c. 234 (last day of February 1654).

17. Forlani Tempesti and Petrioli Tofani 1976, 71–72, no. 45, fig. 42 (entry by A. M. Petrioli Tofani). For the documents, see Potito 1975, 53, no. 21; CdA III, c. 237 (April 28, 1654); and Potito 1975, 53–54, no. 22; CdA III, c. 238 (May 5, 1654). There is no convincing attribution of these drawings of birds (nos. 2088 Orn.–2136 Orn.), which Bisi purchased as 43 original works by Pordenone (the Uffizi catalogues 49 in this group). Giovanni da Udine (1487–1564) has been one of the

names proposed as their author. They seem to me to be by several different hands.

18. Potito 1975, 126–28, no. 9 (ASMo, Archivio per materie, Arti belle, b. 13/1, Bisi Bonaventura: Bologna, August 14, 1653); Galleni 1979, 182–83.

19. Bisi makes a general statement to Leopoldo about trading drawings: "et il barattare in simile materia è gusto indicibile perchè molte volte vengono a tedio alcuni Disegni anche belli per haverli tenuti longo tempo." Potito 1975, 90–91, no. 63; CdA III, c. 332 (February 10, 1658). And see Sueur 1998, 22.

20. Potito 1975, 54–55, no. 23; CdA III, c. 246r-v (June 16, 1654).

21. There are more than fifteen letters to Leopoldo wherein Bisi makes some reference (a few times in detail) to the Coccapani drawings collection: Potito 1975, nos. 10–12, 15, 18, 20, 23–25, 37–38, 40, 45 (and its attachment, 42), 50, and 58. They span August 4, 1653, to December 18, 1657. Fileti Mazza 1993, 1:12–15, provides a summary. Cf. also Sueur 1998, 21–22.

22. Rossi 2010, 110–11, no. 15 (entry by M. Rossi).

23. Campori 1870, 142.

24. Campori 1870, 145–53 (paintings); 153–59 (drawings). Bentini 1989, Documento III, 37–38.

25. Stone 1991a, 83, no. 61; Mazza 2011, 15; and Turner 2017, 357, no. 99.II. There are many other versions of this composition, some of them perhaps "authorized" replicas made under Guercino's supervision in his *bottega*. It is possible (though unlikely) that Scaruffi and Coccapani each owned an autograph version in Reggio. An exhibition is needed to sort out the question of autograph replicas (or, indeed, of *bozzettoni*, full-size preparatory bozzetti) in Guercino's studio. See Stone 2019.

26. Montecchi 2017, 37. I thank Elisa Montecchi for her insights regarding the Coccapani drawings inventory and sale.

27. Montecchi 2017, 44 n. 1.

28. Montecchi 2017, 42, rightly concludes that the drawings inventory published by Campori, though not in Bisi's hand, is based on his appraisal of 1654 (discussed below). Thus, the document published by Campori as dating to 1640 is probably from after April 1654.

29. Potito 1975, 42, no. 10; CdA III, c. 222r-v (August 4, 1653).

30. Potito 1975, 43–44, no. 11; CdA III, c. 223r-v (August 23, 1653). Potito has the wrong date.

31. The Coccapani *Disegni* inventory lists "Otto puttini di penna e acquarella, del Parmegiano D. 4." Campori 1870, 156.

32. Potito 1975, 44, no. 11; CdA III, c. 223 (August 23, 1653); Sueur 1998, 21.

33. Potito 1975, 47, no. 15; CdA III, c. 230 (September 13, 1653).

34. Montecchi 2017, 42.

35. Sirocchi 2015, esp. p. 74.

36. Montecchi 2017, 42.

37. E.g., Sirocchi 2015, 74, references an otherwise unpublished letter (not related to the Coccapani affair) from Bisi to Alfonso of May 22, 1658. (My thanks to Enrico Ghetti for finding and photographing this letter, which is preserved at ASMo, Arti Belle Pittori: Ludovico Carracci.) As Sirocchi notes, Bisi is sending Alfonso a large drawing by Ludovico Carracci and meanwhile is trying to liberate from the Bolognese quadraturist Angelo Michele Colonna (1600/1604–1687) a drawing (no subject) by Raphael. Bisi was successful. Though the sheet is untraced, the Estense *registri* record a payment on June 18, 1658, to Colonna for a Raphael drawing. Sirocchi has also located a huge payment to Bisi (October 5, 1659) for Alfonso's acquisition of a stunning pen and ink *Head of a Woman* by Raphael (Musée du Louvre, inv. 10963r); Sirocchi 2015, 74–75, and fig. 1.

38. Potito 1975, 51–52, no. 20; CdA III, c. 236r-v (April 14, 1654).

39. Potito, 85, no. 58; CdA III, c. 322r-v (December 18, 1657).

40. Bigi Iotti 2011.

41. Campori 1870, 155. Montecchi 2017, 51 nn. 99–101, 103.

42. Loisel Legrand 1998, 34.

43. See Loisel Legrand 1998, 34; and Loisel 2004, 143, no. 165.

44. I thank Daniele Benati for this suggestion.

45. A set of drawings by Campi (Archivio Borromeo), made after Titian's paintings, helped prepare his painted copies. See Coulter 2019, who also discusses the series of engravings (ca. 1620) by Aegidius Sadeler (ca. 1570–1629), which are less faithful to Titian's designs.

46. Sirocchi 2017; cf. also Bentini 1989, Documento VIII, 42, no. 174; 43, no. 305; and with more detail, Bentini and Curti 1990, 74, no. 174; 80, no. 305. In another context, Fischetti 2018, 515, notes the gaps in the documentation regarding the layout of these rooms before 1751.

47. Bigi Iotti 2011, 170.

48. I thank Frances Coulter for help with the Modena *Caesars*.

49. Fischetti 2018, with previous bibliography.

50. Fischetti 2018, 514.

51. My summary follows Fischetti 2018, 511.

52. Fischetti 2018, 514 n. 15. See also Venturi 1882, 273–74; and Bentini 1989, 18. The document is not in Potito 1975.

53. The Bolognese braccio is 64 cm in length. Obviously Bisi made an error in saying the drawing, which at this time was in the form of a scroll, was only five or six braccia in length: "longo cinque o sei braccia" (my transcription). That would be approximately 12½ feet (384 cm). The combined length of the twelve panels today is 187 feet. He may have intended to write "cinquantasei" braccia (as in Fischetti's transcription), though even that is far short. I suspect Bisi relied on a description by Sirani, and that the friar had not yet seen the scroll in person.

54. The letter, which is very difficult to read, begins by saying Bisi had hurt his hand. He returns to the subject at the end: "I don't know if you can understand my chicken scratch ["questi quattro scarabocchi"—four squiggles], because I can't control my hand."

55. Fischetti 2018, 514–15 n. 15 (letter not in Potito 1975).

56. Some or all of the "scroll" may have been framed in some fashion already in Bisi's time, as evinced by a letter of December 12, 1658, discussing a recently purchased drawings frieze by "Palma" (one assumes, Palma Giovane, 1544–1628) being sent to Modena. Potito 1975, 135–36, no. 17; Bentini 1989, 18.

57. Malvasia 1678, 1:560.

58. Fileti Mazza 1993, 1:3–33; esp. pp. 7–21. Cf. also Conticelli, Gennaioli, and Sframeli 2017. For Leopoldo's lists and network of agents (Paolo del Sera in Venice being the most important), see the fundamental four-volume (six tome) series, *Archivio del Collezionismo Mediceo: Il Cardinal Leopoldo* (of which Fileti Mazza 1993 deals with agents serving Emilia). For Bolognese paintings and the agents who sought them for the Medici, see Fumagalli 2019a, esp. p. 144, who notes Bisi's interest in two famous works by Ludovico Carracci, the Amsterdam *Vision of St. Francis* and the Douai *Flagellation*.

59. Conticelli, Gennaioli, and Sframeli 2017, 565, no. 400.

60. For Giuseppe [or Gioseffo] Maria Casarenghi (son of Bisi's sister Fulvia), see Galleni 1979, 176; Fileti Mazza 1993, 2:1050 *ad indicem*. A few times, his brother Fra Antonio Maria Casarenghi served Leopoldo. Both of Bisi's nephews are mentioned in his correspondence. He was constantly worried about their being placed in good positions and used his contacts in Modena and Florence to help them. See, e.g., Potito 1975, 103–5, no. 76; CdA III, c. 360 (July 26, 1658), which probably refers to Giuseppe Maria: "il mio Nipote frate . . . un fratello Prete d'anni 15, che tra l'altre virtù attende anche a quella del Disegno." G. M. Casarenghi's notes on acquisitions and lists are preserved in ASF CdA XX.

61. Potito 1975, 60, no. 31; CdA III, c. 260 (Bisi to Leopoldo, December 19, 1654). An unpublished letter sent from Florence by Bisi on July 3, 1658, to Alfonso (cf. Venturi 1882, 272–73), notes that the friar has met Marchese Guidoni, who has a "superbissimo" Parmigianino drawing in pen, wash, and gouache of the fable of Daphne ("with other figures"), which he would like to present to the Estense prince as a gift. Bisi instructs Alfonso what to write to Guidoni to secure the "dono." Here Bisi affectionately calls the artist "nostro Parmigianino." ASMo, Archivi per Materie, Arti Belle: cartella 14/2, Parmigianino. My thanks to E. Ghetti for his help; this is perhaps the only known Bisi letter sent from Florence. David Ekserdjian has suggested to me Albertina, inv. 2667 (pen, wash, white highlights, on brown paper; 260 × 220 mm) as a possible match with the sheet Bisi described.

62. Conticelli, Gennaioli, and Sframeli 2017, 500–501, no. 153 (entry by L. Bettina).

63. Potito 1975, 56–57, no. 26; CdA III, c. 249 (August 25, 1654). Fileti Mazza 1993, 2:662, doc. 1062.

64. Potito 1975, 48–49, no. 17; CdA III, c. 233r-v (Bologna, January 3, 1654). Fileti Mazza 1993, 2:705–6, doc. 1144. Bisi thought the scene came from the *Aeneid* (but was not far off).

65. For a full discussion, including the iconography, which involves not only the *Illiad* but also Ovid's *Metamorphoses* and Virgil's *Aeneid*, see Cordellier 2004, 162, no. 50 (entry by D. Cordellier).

66. Potito 1975, 100–102, no. 74; CdA III, c. 358r-v (July 16, 1658); and Potito 1975, 103–5, no. 76; CdA III, c. 360r-v (July 26, 1658). See Fileti Mazza 1993, 2:703, doc. 1140, pl. 30; and Conticelli, Gennaioli, and Sframeli 2017, 506–7, no. 156 (entry by M. Grasso).

67. For the documents, see above and Fileti Mazza 1993, 2:704, doc. 1141, pl. 31. For both drawings, cf. Cordellier 2005, 73, under no. 2.

68. Potito 1975, 100–102, no. 74; CdA III, c. 358r-v (July 16, 1658).

69. Bisi rarely mentions Michelangelo drawings. He was enthusiastic about the purchase of a Samaritan Woman

by the master done completely in wash without edges ("senza contorno"), which Bisi tells Leopoldo is currently being engraved ("che ci a alla stampa"). Potito 1975, 81, no. 53; CdA III, c. 312 (Bologna, May 1, 1657).

70. Agostini 1978, 216–22, no. 56. For related letters, all from 1653, see Potito 1975, 37–38, no 5; CdA III, c. 212 (June 10); Potito 1975, 38, no. 6; CdA III, c. 213 (June 12); Potito 1975, 39, no. 7; CdA III, c. 214 (June 19); Potito 1975, 39–40, no. 8; CdA III, c. 220 (June 24); and Potito 1975, 41, no. 9; CdA III, c. 221 (July 1). Fileti Mazza 1993, 2:823–25, doc. 1356.

71. Inv. 540 E. Forlani Tempesti and Petrioli Tofani 1976, 77, no. 53, fig. 51 (entry by A. Forlani Tempesti). Potito 1975, 100–102, no. 74; CdA III, c. 358r-v (July 16, 1658); and 103–5, no. 76; CdA III, c. 360 (July 16, 1658). Fileti Mazza 1993, 2:730, doc. 1186, pl. 36.

72. From a letter written in Bologna on August 13, 1658, to Florence (Potito 1975, 107–8, no. 79; CdA III, c. 368), it can be inferred that Leopoldo has asked Bisi to find him some works by Cremonese artists (or by artists who had worked in Cremona), but some of the names of these painters, the friar admits, are unknown ("incogniti") in Bologna. He would otherwise go to Cremona, but, as he writes on September 28, 1658, even though he has now heard about a secret cache of drawings there owned by the son of Padovanino, he will not risk the journey because of the wars ("queste guerre"). Sensibly, Bisi asks Leopoldo if he has an agent living near Cremona. Potito 1975, 108–11, no. 81; CdA III, c. 370r-v.

73. Potito 1975, 45, no. 13; CdA III, c. 224v, postscript to the signed and dated recto (August 13, 1653). Fileti Mazza 1993, 2:800–801, doc. 1311.

74. According to Jonathan Bober, whom I thank for his help, this drawing is dateable to the early 1560s. Its design has much in common with Cambiaso's San Benedetto altar, now in the Duomo (Cattedrale di San Lorenzo) in Genoa, which represents Sts. Benedict, John the Baptist, and Luke (dated 1563).

75. "Io non provo maggior gusto che li belli Disegni." Potito 1975, 81, no. 53; CdA III, c. 312 (May 1, 1657). For a Cambiaso drawing of Samson that Bisi sent to Leopoldo, see Potito 1975, 113–14, no. 85; CdA III, c. 380 (December 24, 1658); and Fileti Mazza 1993, 1:386–87, doc. 565.

76. Inv. 725 E. For all four Pordenone drawings, see Giglioli 1936, 318; Potito 1975, 48–50, no. 17; CdA III, c. 233r-v (January 3, 1654). For *St. Peter Martyr* see Fileti Mazza 1993, 2:699–700, doc. 1133, pl. 29. See

also Forlani Tempesti and Petrioli Tofani 1976, 70, no. 44, fig. 40.

77. Inv. 730 E. Fileti Mazza 1993, 2:699, doc. 1132, pl. 28. Conticelli, Gennaioli, and Sframeli 2017, 498–99. no. 152.

78. Inv. 731 E. Fileti Mazza 1993, 2: 693–94, doc. 1122, pl. 27. Conticelli, Gennaioli, and Sframeli 2017, 499, under no. 152.

79. Filetti Mazza 1993, 2:695, doc. 1125. See Agosti 2001, 441–48, for a thorough examination of the style, function, dating, and context of this unique drawing in Pordenone's career. There seems to be little agreement on the dating. Agosti (p. 446) mentions a drawn copy (black chalk, white highlights, on gray-green paper) of this sheet in the Louvre (inv. 11936), 204 × 359 mm.

80. Potito 1975, 48–50, no. 17; CdA III, c. 233r-v (January 3, 1654).

81. Potito 1975, 53 no. 21; CdA III, c. 237 (April 28, 1654).

82. Dempsey 2001.

83. Queen Christina's visit and Bisi's miniature of the *Ballo di Putti* are discussed in Fileti Mazza 1993, 1:15–16. The most useful summary, however, is Agosti 2001, 442. Bisi had already mentioned Christina's visit a week earlier: Potito 1975, 75–76, no. 47; CdA III, c. 290 (November 23, 1655). He says he was in Pianoro working on the "Testa di miniatura" (also discussed in the next letter, dated November 30), and missed the chance to come to Bologna, where he imagined Leopoldo had been to celebrate the queen.

84. Letter missing from Potito 1975. CdA III, c. 296r-v (November 30, 1655). See also Fileti Mazza 1993, 1:15–16; 361–62 for partial transcriptions. The text begins by saying that Bisi is sending Leopoldo a miniature of "a head." He uses the word "talco" twice below. A *talco* (talc in English) is a transparent stone that can be easily broken into extremely thin sheets. It was used by artists to make tracings. Bisi also used it for covering his miniatures, giving them a glass-like, transparent protection. He tells Leopoldo that he is sending his miniature of a head without a *talco*, because he could not find one big enough to cover it. In the second mention of *talco* (the "talco de' Puttini"), he simply means "a copy" (in any medium) made after doing a tracing with a *talco*. Bisi replaces the word *talco* with *miniatura* toward the end of his missive, making it clear that he is using the words in this context interchangeably. Many of Bisi's letters ask Leopoldo to buy him supplies of large *talchi*, especially those sold in Livorno, which seems to have had the best ones. "Le mando per questo Proccacio la

Testa di miniatura, e prego N. Signore a concedermi gratia che sia di gusto di V.A.S.; io la potevo fornire molto più ma ho procurato di farla di maniera più tosto pittoresca che da miniatura, et quando ella la volesse più fornita io lo farò ogni volta me lo accennarà; non ho trovato un Talco tanto grande per poterla coprire; in tanto gli rendo vivissime gratie dell'honore m'ha fatto in comandarmi questa poca cosa. Devo poi insinuare a V.A.S. come la Regina di Svetia ha volsuto conoscermi e vedere delle mie cose, e sopra tutte gl'è piaciuto il talco de' Puttini simile al Disegno del Pordonone di V.A.S., et se ne è invaghita tanto che ha detto che per ogni modo lo vorebbe, ma perché io havevo detto farlo per V.A.S. (come veramente era il mio pensiero) essa m'ha soggiunto, e che ne dirà il Sig. Prencipe Leopoldo? E come si potrebbe fare? Io ho replicato che V.A.S. havrà per gloria di servire a Sua Maestà in questa poca cosa et essa ha pur replicato che lo vorrebbe; io ho detto che ne sarà pronta, e che per tanto darò compimento a certe cosette che non sono ben fornite e poi farò quanto comandarà; et hora ho giudicato bene dar à parte di quanto passa acciò se ella giudicasse bene fargliela un dono, si potrebbe intanto preparare una bella cornice et io andarei perfetionando la miniatura al meglio sapessi, e poi la mandarei a V.A.S. alla quale dico di più che questa gran Dama ha spiriti ellevatissimi ne in niuna parte si mostra donna, e conosce meglio li Disegni che non fa il suo Pittore. Le feste che si sono fatte sono state cose di poco momento, ma il suo maggior gusto è stato in vedere alcune Pitture; ha volsuto prima di partire conoscere il Guerzino da Cento e l'Albano, et con tutti si è mostrata cortesissima; mi scusi se ardisco troppo in contarle queste minuciole perché tutto faccio per non mancare del debito mio, e qui resto."

85. See Houbraken 1718–21, 2:83–87.
86. Potito 1975, 63–64, no. 35; CdA III, c. 268 (January 26, 1655).
87. Potito 1975, 68–69, no. 40; CdA III, c. 278r-v (August 12, 1655). See also the subsequent letter of August 14, 1655: Potito 1975, 69–70, no. 41; CdA III, c. 279, wherein Bisi says Beck is still sick but has a great drawing that he found in Modena by Correggio for the cupola of San Giovanni in Parma.
88. Potito 1975, 72, no. 44; CdA III, c. 286r-v (August 24, 1655).
89. Potito 1975, 70–71, no. 42; CdA III, c. 287 (August, 24 1655).
90. Potito 1975, 73–74, no. 45; CdA III, c. 288r-v (August 31, 1655).
91. Letter missing in Potito 1975; CdA III, c. 298 (December 13, 1655). See Fileti Mazza 1993, 1:16, 362. The "quel scartaffaccio che le ho mandato" at the beginning of this missive refers to the *Testa* sent on November 30 (see above).
92. Letter missing in Potito 1975. CdA III, c. 300 (December 28, 1655). See Fileti Mazza 1993, 1:16, 359.
93. Potito 1975, 76–77, no. 48; CdA III, c. 307 (January 18, 1656).
94. "Sotto la scorta del" could also mean, literally, "accompanied by" the Pordenone drawing, but I think Leopoldo had already been sent the sheet much earlier, and that Bisi is using the words figuratively.
95. Fileti Mazza 1993, 1:358, doc. 509 ("soggetto: animali: quattro rane").
96. In many of his letters, the friar uses terms, some of them self-deprecating, involving the number four: "quattro scarabocchi" (four squiggles); or "le mando quattro bagatelle di niun momento" (four trifles); or even the conclusion to this letter (January 18), "dico queste quattro ciarle" (I'm telling you these four rambles).
97. Potito 1975, 76–77, no. 48; CdA III, c. 307 (January 18, 1656).
98. Potito 1975, 78–79, no. 50; CdA III, c. 309 r-v (January 25, 1657). The letter is a bit ambiguous. Bisi requests the prince "prestarmi quelli [the putti] già fatti acciò ne faccia una coppia, o vero gli cambiarò in altra miniatura." It probably means Bisi will make an exact copy of, or make a variation from, Leopoldo's picture. It could mean Bisi will give Leopoldo a new, different miniature in exchange, though I doubt it.
99. Potito 1975, 132, no. 13 (February 2, 1658). ASMo, Archivi per Materie, Arti Belle Pittori, cassetta n. 13/1 (letters not numbered).
100. Potito 1975, 133, no. 14 (February 2, 1658). ASMo, Archivi per Materie, Arti Belle Pittori, cassetta n. 13/1 (letters not numbered).
101. Potito 1975, 90–91, no. 63; CdA III, c. 332 (February 10, 1658).
102. Agosti 2001, 446.

Men with Earrings in the Sixteenth and Seventeenth Centuries

Sarah Cartwright

Surely the most surprising element of Guercino's portrait of Fra Bonaventura Bisi is the glinting gold hoop in his left ear (fig. 1). As seventeenth-century fashion goes, it is discreet: small and slender, it tightly hugs the lower half of the lobe. But once seen, the hoop commands attention and strikes an incongruous note. Why is the friar, whose religious order renounces worldly goods and adopts the humble wool habit of St. Francis, wearing a gold earring? It is especially difficult to comprehend because, in all other respects, Bisi's appearance is in keeping with the austere requirements of the Franciscan Order.[1] Although many sixteenth- and seventeenth-century portraits of secular clergy show them with finger rings,[2] and even a small number of regular clergy (i.e., monks and friars), I am not aware of any other portrait of a religious man wearing an earring.[3]

There is no reason to think that Bisi's earring is not original to the painting. The hoop clearly appears in Domenico Maria Muratori's engraved reproduction of the work, produced a few decades later (see p. 15).[4] More important, this area of the painting strongly indicates Guercino's hand (fig. 2). The complex sculptural form of Bisi's ear is created with just a few strokes of paint, in a display of virtuosic mastery consistent with Guercino's late technique. The painter has created the illusion of a three-dimensional hoop using two lines: one for

the actual earring, a dark mustard color topped with a yellow-white highlight; and the other, to its left, in semitransparent brown, indicating the shadow cast onto the lower part of the lobe. The careful depiction of Bisi's ear is consistent with Guercino's abiding interest in this part of the head, evident in an early drawing (fig. 3) and throughout his painted and graphic work.[5]

No other evidence, apart from the portrait (and Muratori's engraving after it), indicates that Bisi wore an earring. It is not shown in Guercino's humorous drawing of the friar from about thirty years earlier (in which Bisi appears much younger and heavier) (see p. 16),[6] suggesting that Bisi adopted it later in life. The painted portrait is not mentioned in Guercino's account book[7] or by any contemporary writers, and it was not in Bisi's rooms in the monastery of San Francesco in Bologna at the time of his death.[8] With the painting's earliest history entirely undocumented,[9] we are left without contemporary reaction to what would seem to have been an extraordinary thing: an image of a Franciscan friar wearing a gold earring.

The fashion of men wearing earrings in sixteenth- and seventeenth-century Western Europe has not been well investigated.[10] The largest body of evidence for the phenomenon is found in portraiture, but as that genre overwhelmingly represents wealthy elites, the fashion among men

FIG. 1 Guercino, *Portrait of Fra Bonaventura Bisi* (detail)

FIG. 2 Guercino, *Portrait of Fra Bonaventura Bisi* (detail)

FIG. 3 Guercino, *Six Studies of Ears*, 1618. Pen and brown ink on laid paper, 149 × 210 mm. The Morgan Library and Museum, New York, Purchased on the Gordon Ray Fund and the Fellows Endowment Fund; inv. 2016.17:2

of lesser social rank is not well reflected there. Little documentary evidence is available to explain why men wore earrings. We do not know why Charles I of England, probably the most famous earring-wearing man of his day, was so attached to his large pearl drop (figs. 4, 5) that he even wore it to his execution in 1649.[11] This essay provides a brief exploration of the fashion in the period before, and contemporary with, Bisi's gold hoop. As portraits of men with earrings were most common in France, England, and Italy, examples from these countries dominate this overview.

In modern sources it is sometimes claimed that the Renaissance fashion for men to wear earrings originated in Italy or Spain.[12] In the fourteenth century, earrings were not worn by either sex in much of Europe, but they were fashionable among women in south Italy and in Sicily, as attested by inventories.[13] In the mid-sixteenth century,

FIG. 4 Isaac Oliver, *Charles I as a Child, King of England, Scotland and Ireland*, ca. 1612. Watercolor on vellum, 6.8 × 4.5 cm. Nationalmuseum, Stockholm; inv. NMB 978

FIG. 5 Anthony van Dyck, *Charles I*, 1635–36. Oil on canvas, 84.4 × 99.4 cm. Royal Collection Trust © His Majesty King Charles III 2022; inv. RCIN 404420

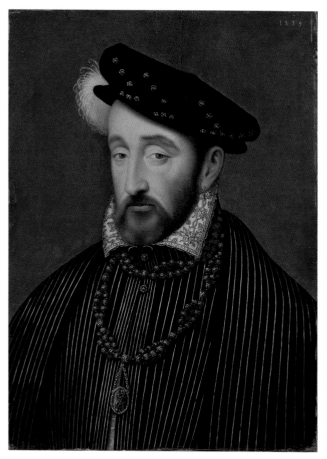

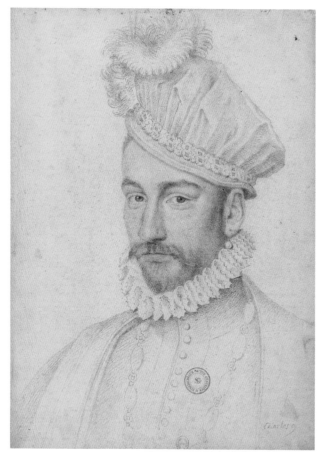

FIG. 6 Studio of François Clouet, *Henry II, King of France*, 1559. Oil on panel, 39.6 × 28.7 cm. Royal Collection Trust © His Majesty King Charles III 2022; inv. RCIN 403430

FIG. 7 François Clouet, *Charles IX of France*, ca. 1572. Black and red chalk on paper, 352 × 260 mm. Bibliothèque nationale de France, Paris

French kings began to be depicted with an earring and the custom seems to have been adopted soon after by courtiers in England.[14] From quite early on, male portraits show a marked preference for pendant earrings, in particular a drop-shaped pearl—sometimes quite large—dangling from a small gold hoop.[15] Famous adopters of this look were the sixteenth-century Valois kings of France Henry II (r. 1547–59), Charles IX (r. 1560–74),[16] and Henry III (r. 1574–89) (figs. 6–8). Given the rarity and cost of large pearls, such an earring was an excellent means of flaunting one's wealth, but pearls were also thought to be beneficial for the

complexion[17] and may have held symbolic religious associations for the French kings.[18]

The pearl pendant earring continued to be popular for men into the seventeenth century, as seen in the case of Charles I. Before him, earrings in England were associated with "lusty courtiers . . . and gentlemen of courage,"[19] the latter category referring to sixteenth-century explorers such as Walter Raleigh (fig. 9) and Thomas Cavendish, both of whom wear a single pearl pendant earring in portraits. By the mid-seventeenth century, the fashion was still seen among French noblemen, notably Henri di Lorraine, Count of Harcourt,

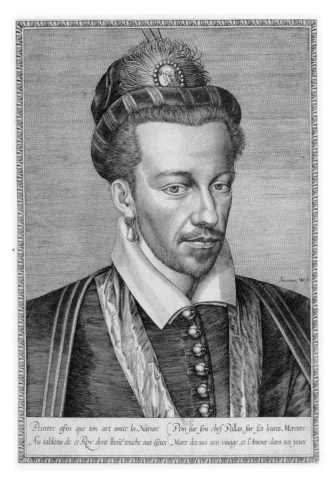

FIG. 8 Jérôme Wierix, *Henri III of France*, 1588–89. Engraving, 355 × 249 mm. Bibliothèque nationale de France, Paris, Dép. Estampes et photographie, Reserve FOL-QB-201 (9)

FIG. 9 Unknown English artist, *Sir Walter Raleigh*, 1588. Oil on panel, 914 × 746 mm. National Portrait Gallery, London; inv. NPG 7

who was known as the "Cadet de la Perle" from his prominent pearl earring, but it is also seen on men of lesser rank, such as the gold- and silversmith Louis Roupert (fig. 10).

From surviving portraits, it appears that Italian men were less inclined to wear earrings than their French and English counterparts. Many Italian cities in the sixteenth and seventeenth centuries enforced severe restrictions on the wearing of jewelry (by both women and men) through sumptuary laws, which sometimes made specific reference to earrings.[20] Men's choices about earrings may also relate to prevailing attitudes in

Italy that gender should be reflected in dress and appearance. In his famous guide to behavior for gentlemen, known as *Galateo* (1558), Giovanni della Casa condemns over-embellished men who look too much like women, but does not address the wearing of jewelry.[21] Further evidence of the Italian mindset is seen in the account given to the Venetian senate in 1572 by the Republic's ambassador to France, Giovanni Michiel, who described the twenty-year-old Duke of Anjou (the future Henri III of France) as having lost the respect he formerly commanded as a military leader since giving himself over to a "voluptuous life,"

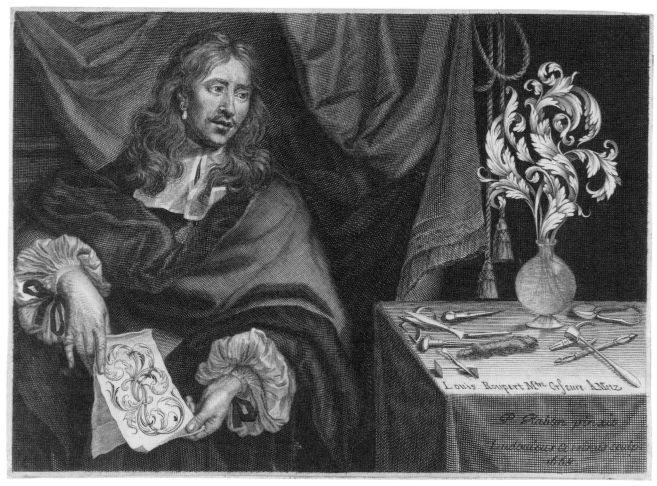

FIG. 10 Louis Cossin after Pierre Rabon, *Portrait of Louis Roupert*, 1668. Engraving, 148 × 212 mm. Rijksmuseum, Amsterdam; inv. RP-P-1953-313

concerned above all with perfume, hair, fancy clothing, and women, and "always wearing in his ears two or three kinds of pendants or 'earrings,' as they are called."[22]

Late in the sixteenth and into the seventeenth century, we find two prominent Italian men with equally prominent pearl pendant earrings: Don Antonio de' Medici (1576–1621) (fig. 11), the legitimated son of Francesco I, Grand Duke of Tuscany; and the Roman intellectual, composer, author, and world traveler Pietro della Valle.[23] The same type of earring is worn by the unknown dandy, with modish hat and enormous white ruff,

in a painting from about 1625, *Portrait of a Man with a Sword* (fig. 12).[24] Such ostentatious pearl earrings, though contemporary with Bisi, are a long way from the friar's modest gold hoop.

The gold hoop deserves its own study. It is associated in parts of Western Europe in the fifteenth century with groups who suffered exclusion from Christian society, specifically Black Africans, prostitutes, and Jews.[25] In art, a hoop

FIG. 11 Unknown painter, *Don Antonio de' Medici*, ca. 1610. Oil on canvas, 70 × 58 cm. Museo Storico della Caccia e del Territorio, Cerreto Guidi (Florence); inv. Poggio a Caiano no. 209

· ANTONIO · MEDICI ·

FIG. 12 Follower of Caravaggio, *Portrait of a Man with a Sword*, ca. 1625. Oil on canvas, 65 × 52.5 cm. Uffizi, Florence; inv. 1890 n. 1814

earring is often worn by the Black African magus who begins appearing in mid-fifteenth-century Flemish paintings of the Adoration of the Magi (fig. 13).[26] Penny Howell Jolly has argued that in these paintings, the earring (which she notes is sometimes also worn by men whose turbans identify them as Jews) functions as a "signifier of difference," clearly marking the figures as outsiders and further underscoring the power of the Christian message to convert even people of distant faiths.[27] Diane Owen Hughes has shown that in the fifteenth century some north Italian cities—spurred on in some cases by the preaching of Observant Franciscans such as Bernardino of Siena—enacted laws requiring Jewish women (though not men) to wear gold hoop earrings as an outwardly distinguishing mark of their faith.[28] Hughes notes that it took time in Italy for the hoop earring to shed this association, which thus may explain the preference among women for pendant styles as they begin adopting earrings more widely in the sixteenth century.[29]

FIG. 13 Gerard David, *Adoration of the Magi* (copy after Hugo van der Goes), ca. 1495–1505. Oil on wood, 123.7 × 166.1 cm. Alte Pinakothek, Munich; inv. 715

The situation in France seems to have been different, as the Valois kings (and some of their followers), while most often seen with a pearl, sometimes also wore small gold hoops (figs. 14, 15). Their reasons for choosing simple hoops rather than a pendant style are not clearly understood, but the hoop seems to appear more frequently in earlier portraits of Charles IX and Henri III. The fashion was taken up by at least one visitor to the French court, Petru Cercel (ca. 1545–1590), a prince of Wallachia, whose name means "Peter

Earring." Sent from his home in Romania to Constantinople as a child, Petru's later travels eventually brought him to Italy in search of support in reclaiming his kingdom. In 1579 Pope Gregory XIII (1502–1585) sent him to the court of Henri III, where he remained for two years and adopted the hoop earring.[30]

The hoop is also traditionally associated with mariners (and pirates), explorers, and military men. Though many reasons have been offered for seafaring men to have pierced their ears, few

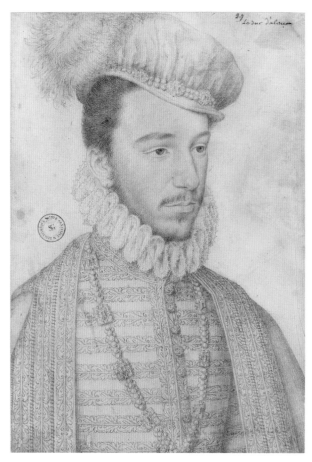

FIG. 14 François Clouet, *Charles IX, King of France*, 1563. Oil on wood, 33 × 25.1 cm. Châteaux de Versailles et de Trianon, Versailles; inv. MV3239

FIG. 15 Jean de Court, *The Future Henry III as Duke of Anjou*, 1573. Black and red chalk on paper, 33 × 22.7 cm. Bibliothèque nationale de France, Paris

are supported with documentary evidence; these include contact with native populations, for use as payment for burial if they died at sea, to improve eyesight or hearing, or to protect from evil.[31] One object discussed by Natasha Awais-Dean supports the notion that Renaissance sailors did in fact wear earrings: a late sixteenth-century pendant inscribed with a poem notes that it is made from the gold earring of a Spanish sailor who died in the Armada campaign of 1588.[32] Portraits of well-to-do English seafarers and travelers show them wearing gold hoops, including the naval commander, slave trader, and privateer (who was also

accused of piracy) John Hawkins, and the naturalist, gardener, collector, and traveler John Tradescant the Elder (fig. 16).[33]

One of the best-known images of a man with a hoop earring from this period is William Shakespeare, whose likeness in the "Chandos portrait" (fig. 17) shows a small hoop very similar to that of Fra Bisi.[34] Aside from this image, no other documentation of Shakespeare wearing an earring exists, but several men in his circle are depicted with earrings, including the brothers William and Philip Herbert,[35] to whom Shakespeare dedicated his First Folio in 1623, and

FIG. 16 Possibly Alexander Marshal, *John Tradescant the Elder*, 1638–65. Oil on canvas, 79 × 62 cm. Ashmolean Museum, Oxford; inv. WA1898.8

MEN WITH EARRINGS 97

FIG. 17 Associated with John Taylor, *William Shakespeare* ("Chandos portrait"), ca. 1610. Oil on canvas, 55.2 × 43.8 cm. National Portrait Gallery, London; inv. NPG 1

FIG. 18 Jusepe de Ribera, *The Sense of Taste*, ca. 1614–16. Oil on canvas, 113.8 × 88.3 cm. Wadsworth Atheneum Museum of Art, Hartford, CT, The Ella Gallup Sumner and Mary Catlin Sumner Collection Fund; inv. 1963.194

the actor and playwright Nathan Field.[36] However, these men are seen not in the simple gold hoop of the Chandos portrait but with more elaborate pendant styles.

In Italy, portraits of men with hoop earrings from the sixteenth and seventeenth centuries are rare. Whether or not this is the result of lingering association with the fifteenth-century Italian laws is difficult to determine. Sadly, no Italian portrait survives of Petru Cercel, who was presumably wearing his earring in 1581 when he stopped in Turin and Venice on his way from Paris back to Constantinople. The rather scruffy eater representing the *Sense of Taste* in one of

Jusepe de Ribera's (1591–1652) early Roman paintings (fig. 18) wears two large gold hoops, though not, apparently, to impress. And a bit later on, at least one (adopted) Italian artist paints himself with a hoop earring: the Dutch painter Pieter Mulier the Younger (1637–1701), known as Il Cavalier Tempesta (fig. 19).[37] Tempesta, whose Italian moniker came from his specialty in painting stormy seascapes, worked in Rome and north Italy for most of his career, and served prison

FIG. 19 Pieter Mulier (Il Cavalier Tempesta), *Self-Portrait*, 1685–86. Oil on canvas, 69 × 52 cm. Palazzo Borromeo, Isola Bella

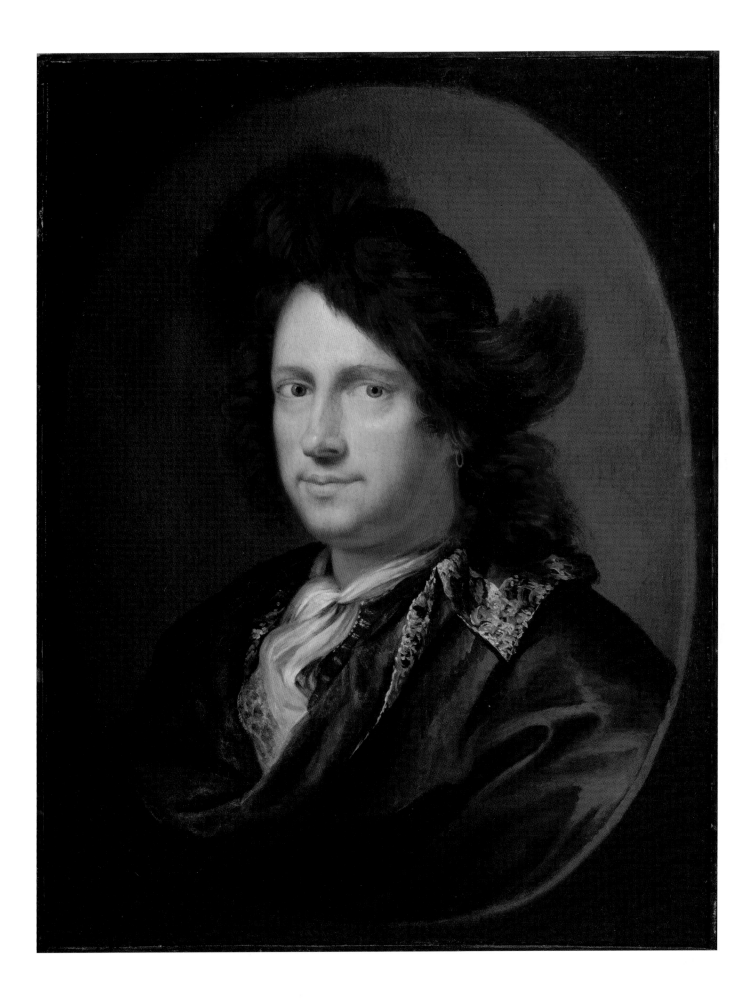

time in Genoa for having arranged the murder of his first wife.

Given this limited evidence, how are we to interpret the case of Bisi, a Bolognese Franciscan friar? Does it seem likely that he "fancied himself as having an unconventional, adventurous disposition"?[38] Nothing in Bisi's published letters suggests this in the slightest; on the contrary, he hews closely to his humble religious identity,[39] does not travel very far from home, and is happiest in the rural solitude of the small convent of San Benedetto in Pianoro, where he could devote himself to his miniature painting.[40] Nor does Bisi have anything in common with English seafarers like Raleigh and Cavendish, or the intrepid traveler Tradescant. That Bisi was a Franciscan Conventual, and thus a person whose lifestyle, dress, and personal income were all subject to severe restrictions by his religious order, sets him well apart from the men we have seen thus far.

There is another possible explanation for Bisi's earring: problems with his eyesight. In Italy, a popular belief held that a gold earring was beneficial for the eyes, and the use of an earring as an eye treatment persisted into the late nineteenth and early twentieth centuries in parts of south Italy.[41] A twentieth-century authority on the history of medicine in Italy reports that earrings were used to ward off eye disease, as well as to brighten and refresh a person's vision, and notes that this explains why men historically adopted the fashion.[42] Bisi, in a letter of 1652 to Leopoldo de' Medici, mentions difficulty with his eyes after working on his miniature painting, and in a more cryptic letter, from 1657, seems to also refer to eye trouble.[43] Eye strain was a known problem for miniature painters, as it required close-up, detailed work.[44] Could an eye problem explain Bisi's earring?

Don Antonio de' Medici may have worn earrings as treatment for his eye disease. During a severe bout of illness in 1596–97, which caused him terrible eye pain,[45] one of the treatments his doctors recommended was, according to his nineteenth-century biographer, the wearing of earrings.[46] Don Antonio's passion was chemical arts, medicine, and alchemy, which he pursued by directing experiments and study at the Casino di San Marco in Florence, where he also resided.[47] Recent studies have focused on his compilations of medical "secrets" (recipes for medical treatments),[48] though nothing has yet emerged about earrings.[49] Another earring-wearing man already discussed, the painter known as Cavalier Tempesta, also suffered from eye problems; his letters from prison in Genoa convey a state of utter desperation about his failing eyesight.[50] Tempesta's self-portrait with the gold hoop was painted shortly after his release from prison.[51] Though there is no mention of an earring in any of his published letters, one wonders if he might have adopted it in an attempt to treat his eyes.

For now, the notion that Fra Bisi's earring was for a therapeutic purpose must remain conjectural. But if Bisi did adopt an earring for this reason—and if the earring itself came from a high-ranking patron—then it could explain why he was permitted to wear it despite its obvious violation of the Franciscan codes of dress. It is hoped that additional study will shed further light on this intriguing and puzzling element of Fra Bisi's appearance.

NOTES

1. On the dress of Franciscans in this period, see Rocca 2000, 319–47; and Levi Pisetzky 1966, 473ff.

2. For the history of finger rings among European clerics, see Lightbown 1992, 92–95.

3. Parisciani 1984, 417–21, cites widespread violations of restrictions of dress and the accumulation of property among Conventual friars in the seventeenth century, though nothing relating to earrings until the end of the eighteenth (p. 421).

4. Stone 2020 dates it 1680–89. Though the original context of the engraving is unknown, the oval format, framing elements, and inscription suggest that it was executed for a book. Muratori's portrait engravings of four Conventual Franciscans (three men and one woman), which appear in Argenti 1711, are less detailed than the one of Bisi but have similar framing elements and inscriptions. I am grateful to Sheila Santilli at the Biblioteca Comunale of Terni for providing study images of this rare volume.

5. On the drawing, see Marciari 2019, 34–37 (nos. 3a–3b, J. Marciari). On Guercino and ears, see Turner 2017, 133.

6. See Galleni 1975; Turner and Plazzotta 1991, 22 (no. 306); Stone 2020, 65–66, and Chapter 1 in this volume.

7. Not unusual if it was a gift from the artist to the sitter. On the painting's provenance, see Brilliant 2017, 141, 143, 144 n. 1, and Chapter 1 in this volume.

8. Potito 1975, 155–60, transcribes the detailed record of discussions that took place after Bisi's death among the friars of San Francesco in Bologna about how to dispose of the works of art that remained in his room, all of which went to the Duke of Modena; the portrait is not mentioned.

9. Bisi may have given away the painting before his death, perhaps to his nephew, pupil, and fellow Franciscan (Capuchin) friar, Giuseppe Maria Casarenghi. On Casarenghi, see Galleni 1979, 176; Fileti Mazza 1993, 1:7 (n. 2 with previous bibliography); and Chapter 2 of this volume. Galleni 1979, 188 n. 68, transcribes a letter from the Medici archives of May 19, 1660 (five months after Bisi's death), from Fra' Agostino Giorgi, Inquisitor of Belluno, to Leopoldo de' Medici, in which Giorgi informs the cardinal of the involvement of Bisi's nephews (one of whom was Casarenghi) in a dispute between the Convent of San Francesco and the Duke of Modena over the ownership of a painting left behind by Fra Bisi, referred to as a "Mortorio" ("un quadro adomandato il Mortorio"); as the word *mortorio* could refer to any scene from Christ's Passion, it leaves the exact subject of the painting unclear. The ownership of a different "quadro" left behind in Bisi's rooms, a Mystic Marriage of St. Catherine, is discussed at length by the friars at San Francesco (see note 8 above) as being in their possession but claimed by the Duke of Modena; according to them, in his will Bisi left the duke only the drawings in his possession, but made no such provision for the paintings or miniatures he had (Potito 1975, 159–60). If Casarenghi had possession of the Guercino portrait of his uncle, he may have kept it hidden to avoid it also being claimed by the duke.

10. Brief discussions of the fashion for men's earrings in the Renaissance can be found in Fontenay 1887, 125; Steinbach 1995, 228–44; Robbiani 2001, 114–24; Bruna 2001 (more focused on Middle Ages); Chevallier 2012, 298–300; and Awais-Dean 2017, 3. Levi Pisetzky 1966, 173, notes that the sumptuary laws banning the wearing of earrings indicate the fashion was widespread among the elite.

11. The earring survives to this day in private hands; see Chadour-Sampson and Bari 2013, 76, 80.

12. Fontenay 1887, 125, says that the fashion came from Spain, where it was common for both sexes, and was brought to France by the Spanish ambassadors and their entourage. Lightbown 1992, 294, notes that women in Spain continued to wear earrings in the Middle Ages and fifteenth century. Chevallier 2012, 300, speculates that it was an Italian custom brought to France by Catherine de' Medici.

13. For Naples, see Owen Hughes 1986, 10–11. For Sicily, see Lanza di Scalea 1892, 99–100, 176–78; and Levi Pisetzky 1964, 309. McCall 2022, 60–62, speculates that Galeazzo Maria Sforza (1444–1476), Duke of Milan, may have worn earrings, citing documentary evidence of earrings having been made "for the lord's use"; see also Venturelli 1999, 97.

14. Phillips 1996, 89, notes that "Portraits from the court of Elizabeth I indicate a fashion for earrings from the 1580s onwards, where they were worn by the men . . . as well as the ladies of the court," while Cooper 2012, 191, notes that the earring "becomes generally popular for courtiers c. 1616–20 but appears to be worn by maritime explorers, those with literary associations and others from the mid-1590s."

15. The painting in the Milwaukee Art Museum entitled *The Minions of Henri III* (inv. M1966.55), dated to the

1570s, shows a range of pendant styles worn in France. English portraits of men from the late sixteenth and early seventeenth centuries show a similar variety, including interlocking hoops, pendant crosses, and tassels (for examples, see Cooper 2012, ills. 198 and 206). On pearls in Renaissance Europe, see Chadour-Sampson and Bari 2013, esp. 62–76.

16. Champion 1941, 1:279, relates the 1570 account of the Spanish ambassador in Paris, Don Francés de Álava, who described the enormous emerald earrings worn by the Duke of Anjou (the future Henry III) and a similar one worn by Charles IX; he also notes that the king forced fifty or sixty of his men to pierce their ears. See also Haquet 2011, 85.

17. Black 1974, 178.

18. Haquet 2011, 85–86.

19. From William Harrison's 1577 *Description of England*, quoted by Awais-Dean 2017, 3.

20. Levi Pisetzky 1966, 173, 376 (with bibliography of the laws on 280–84, 462–66).

21. Della Casa 2013, 70: "Thus, a man must not embellish himself in the guise of a girl, for his adornments will be one thing, himself another; I see many men who have their hair and beards all curled with a hot iron, and have their faces, necks, and hands so shiny smooth and soft that it would be unsuitable for any young wench, even for a tart more anxious to hawk her wares at a discount than sell them for a decent price."

22. Albèri 1860, 305 ("come ha del tutto perduto quella grande opinione di guerriero, che aveva data di sè per gli alti principj suoi . . . si è talmente dato all'ozio e alla vita voluttuosa . . . che fa maravigliar ognuno; stando per il più fra donne . . . tutto pieno di odori e di profumi, col farsi i ricci, e aver all'orecchie sempre due o tre sorte di pendenti od orecchini, come si dice. . ."). Translations here and in the next essay are mine.

23. On Pietro della Valle, see Venetucci 2010.

24. Long thought to be a self-portrait of the painter Lionello Spada (1576–1622) because of the sword, that identification was withdrawn after a 1974 restoration revealed that the palette and thumb were added much later. Kawase and Watanabe 2016, 124–25 (no. 22) gives it (again) to Antiveduto Gramatica (1571–1626), while in Papi 2010, 264–65 (no. 73, entry by G. Papi), it bears a tentative attribution to Lo Spadarino (1585–1651/53) ca. 1625.

25. See Bruna 2001.

26. See Koerner 2010.

27. "Signifiers of difference" is used by Howell Jolly 2002, 197. It should be noted that most of the hoop earrings depicted in these Flemish paintings are much larger and more prominent than the one worn by Bisi. By the seventeenth century, although Black individuals (both male and female) depicted in portraits—most of whom are shown as servants and were thus presumably enslaved—still often wear earrings, the style of their dress and jewelry now matches that of their wealthy owners; a range of examples is reproduced in Bindman and Gates 2010.

28. See Owen Hughes 1986, who also notes the similarity between the treatment of Jewish women and prostitutes under these laws.

29. Owen Hughes 1986, 46–55.

30. See Vranceanu Pagliardini 2017; and Vranceanu Pagliardini 2020, esp. 13–14.

31. Steinbach 1995, 47. Robbiani 2001, 120, notes that it was in vogue among sailors until the eighteenth century and asserts (with no evidence) that military seafarers wore one in the right ear, while merchant sailors did so in the left.

32. Awais-Dean 2017, 6.

33. Tradescant (whose reason for wearing an earring is unknown) collected plants and curiosities from around the world and eventually opened a museum in his London home. After his death, the collection was purchased by Elias Ashmole and later became the foundational collection of the Ashmolean Museum at Oxford. On Tradescant's life, see Potter 2008.

34. Cooper 2012, 180–81, notes that the Chandos portrait has been considered a likeness of Shakespeare since the middle of the seventeenth century and is the only painted image that has a convincing claim to being a lifetime portrait of him.

35. William Herbert, 3rd Earl of Pembroke, wears a pendant earring in portraits by Paul van Somer (c. 1577–1621) and Daniel Mijtens (c. 1590–1647/48); Philip, 4th Earl of Pembroke, wears two interlocking hoops in an engraving by Robert van Voerst (1597–1635/36) of 1630 after a painting by Mijtens.

36. It has been argued that the painting thought to be of Field in the Dulwich Picture Gallery may show him in costume for a role. See Cooper 2012, 185.

37. This is the original portrait dated 1685–86, which he painted along with one of his second wife (whom he married while in prison). An identical copy of the self-portrait is in the Uffizi. See Roethlisberger-Bianco 1970, 103–4; and Morandotti and Natale 2020, 173–74 (nos. 28–29).

38. Brilliant 2017, 143.

39. To cite one example, Bisi declines Leopoldo de' Medici's invitation to celebrations in May 1658, saying that he does not belong among such esteemed company and that it would embarrass him as a religious man (Potito 1975, 96). Parisciani 1992, 559, cites Nuti 1678, 510, in which St. Joseph of Copertino is quoted as praising Bisi as one who is concerned for the needs of the religion as opposed to any personal agenda, when the two men met in Assisi ("Sia lodato S.D.M. che hò trovato una volta, uno che non hà interesse, e che pensa al bisogno della Religione, & io per corrispondenza non mi scordarò più di pregar Dio per lui").

40. On Pianoro, which was founded in 1290 and became attached to San Francesco in Bologna in 1511, see Parisciani 1992, 557 and 564; he also cites a document on p. 572 (date unclear) stating that in March 1653, when the convents were ordered by the Procuratore Generale to remove their members and install a secular priest in their "grancie" (small rural properties attached to larger houses), Bisi had been overseeing Pianoro for many years ("e vi hanno abitato di quando in quando, massime a S. Benedetto in Pianoro fra Bonaventura Bisi che sono anni e anni che padronizza in tal luogo"). Bisi is listed as being there still in 1655 (Parisciani 1992, 573). See also Chapter 2 in this volume.

41. Pitrè 1896, 275, discusses the piercing of the ear and use of an earring as a preservative and curative ophthalmic practice in Sicily, noting that the hole clears up eyesight and cures conjunctivitis and other eye problems. He further notes that it is said that some people with chronic eye problems got better only after adding or removing the earring. Levi Bianchini 1904, 691, notes the then-current practice of children in Calabria being given an earring in the left ear to prevent eye disease.

42. Pazzini 1948, 170, 209. Chevallier 2012, 301, also states (without evidence) that men wore earrings to improve eyesight.

43. On September 12, 1652 (Potito 1975, 36), Bisi says that he has arrived home in Bologna from Pianoro "in good health, but with a bit of sensitivity in my eyes from the suffering of two very hot days which followed the toil of miniature painting" ("sono . . . arrivato a casa con buona salute, se bene con un poco di sentimento negl'occhi per il patimento di due caldissimi giornate seguite dopo la fatica della Miniatura"). In the first of two letters dated March 13, 1657 (Potito 1975, 79), he notes that he cannot leave his room due to illness (though he does not specify which), and in the second (Potito 1975, 80) he states that he "cannot write by candlelight" ("non posso scrivere col lume della candela").

44. E.g., Baldinucci 1845–47, 4:470, on Giovanni Battista Stefaneschi (1582–1659), who brought a miniature to perfect completion "after an extreme effort of his body and eyes" ("dopo un estrema fatica del corpo e degli occhi"). The famed miniaturist Giulio Clovio (1498–1578) suffered from eye problems and received surgery to remove an eye growth in 1558; see Bradley 1891, 180–81, and Pelc 1998, 192, 200. The detailed nature of miniature painting is discussed further in Chapter 4.

45. Covoni 1893, 95, 99–100; and Luti 2006, 124–25.

46. Covoni 1893, 100 ("Fu da questo tempo che S. E. per uniformarsi alle prescrizioni suggeritegli dai medici, cominciò a portar agli orecchi due campanelle d'oro a guisa di orecchini con una pera di perla che vi pendeva"), and 147 ("per gli orecchini di una grossa perla, da lui costantemente portati a difesa degli occhi, pregiudizio assai invalso in quel tempo"). Luti 2006, 124, appears skeptical.

47. See Covoni 1893 and, more recently, Strocchia 2019, 167–73; Beretta 2014; Luti 2006; and Galluzzi 1982.

48. See note 47, above, and Hedesan 2021.

49. Luti 2010, 26, notes the presence of eye treatments using honey (but not an earring) in Don Antonio's manuscripts of medical secrets.

50. Roethlisberger-Bianco 1970, 18, who also publishes part of Tempesta's correspondence (64–79): p. 71, with letters of July 23, 1682 ("Di dipingere non vedo piu con il lume". . . "o perso la sanita e quasi la vista"), and December 20, 1682 ("vado perdendo la vista del tuto, e la gioventù e la forza"); p. 73, for December 17, 1683 ("divento vecchio e vade perdendo mia vista asai asai").

51. Roethlisberger-Bianco 1970, 104.

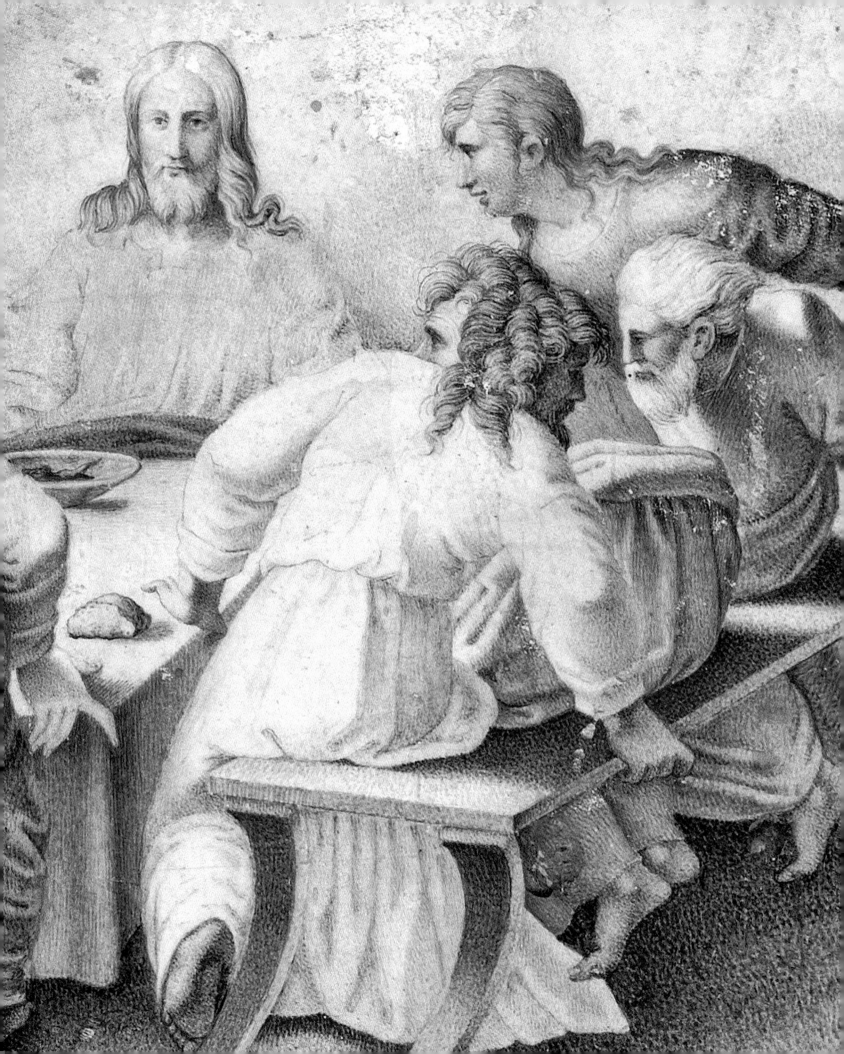

Bisi and Miniature Painting in Seventeenth-Century Italy

Sarah Cartwright

Although Guercino's portrait memorializes Fra Bonaventura Bisi in his role as an art dealer, it was the friar's work as a painter of miniatures that ensured his name would live on in the annals of art history. Bisi is named as "most famous miniature painter" in two key publications on Bolognese art that appeared soon after his death: Antonio Masini's *Bologna perlustrata* and Carlo Cesare Malvasia's *Felsina pittrice, or Lives of the Bolognese Painters*.[1] Despite such illustrious mentions in print, Bisi's miniatures were mostly forgotten, as a result of waning appreciation of Italian miniature painting in the centuries after his death.[2] That has changed in recent years, with a surge of academic interest in seventeenth-century miniature production, making it an auspicious moment to consider Bisi's miniatures within that larger framework.[3]

Miniature painting is different from other types of painting, so much so that in Italian there is a dedicated verb, *miniare* (derived from the Latin word *minium*, which denoted a red pigment) for this artistic activity.[4] Though the English word "miniature" now connotes something small in size, its origins lie in this special type of painting, which developed from the art of manuscript illumination.[5] The distinctive feature of miniature painting is its minutely detailed brushwork, executed with very fine brushes, using water-soluble pigments mixed with either gum arabic (gouache) or egg (tempera).[6] Though it was costly, parchment (a prepared animal hide) was the preferred support for miniature paintings, as it was highly durable and offered an extremely smooth, opaque surface, but specially coated paper was also used.[7] The painstaking, detailed technique of the miniature meant that such paintings were almost always small.[8] Artists applied color using tiny strokes or dots,[9] typically using the pale color of the support as the lightest tone of the painting, thus avoiding the need to add white highlights (detail at left and fig. 2).[10] Images of Italian miniature painters at work are rare, but one Flemish example from the sixteenth century, the minuscule self-portrait at age seventy-five by the celebrated painter Simon Bening (1483–1561; fig. 1), perfectly illustrates the tiny scale of this art. Here Bening holds up his eyeglasses and points to a miniature in progress on his small slanted desk, placed near a window to receive natural light.

In Bisi's day, miniature painters (also known as miniaturists) in Italy were producing work in two categories: so-called independent miniatures, which were intended as stand-alone collectible works of art, often framed; and decorated pages of luxury manuscripts, which were in much less demand than in previous centuries. The rise of the first category is tied to the decline of the second,

Fra Bonaventura Bisi after Raphael, *Last Supper* (detail)

FIG. 1 Simon Bening, *Self-Portrait*, signed and dated 1558. Tempera and gold leaf on parchment, 8.5 × 5.7 cm. Metropolitan Museum of Art, New York, Robert Lehman Collection, 1975; inv. 1975.1.2487

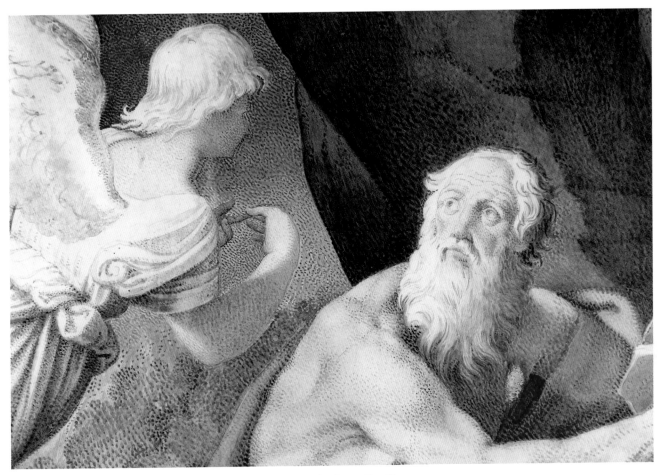

FIG. 2 Fra Bonaventura Bisi after Guido Reni, *Angel Appearing to St. Jerome* (detail)

as by the mid-sixteenth century, nearly all books were printed rather than written out and decorated by hand.[11] In certain places, however, notably the papal court in Rome, luxury manuscripts were still being commissioned in the seventeenth century, though some images in these books seem influenced by the prevailing taste for framed independent miniatures (fig. 3).[12] Most of Bisi's surviving works are independent miniatures.[13]

The artist most responsible for the rise of the independent miniature in Italy is the renowned Croatian master known as Giulio Clovio (1498–1578), sometimes called "the last great manuscript illuminator," who preceded Bisi by a hundred years.[14] Clovio, who worked principally as a manuscript painter, became famous for his elaborate compositions that translated the grand figural style of contemporaries like Michelangelo (whom he knew personally) and Raphael to the small scale of book decoration (fig. 4). He also began producing, perhaps as early as the 1520s, single works on parchment, which he often signed, as in an example for Duke Cosimo I de' Medici (1519–1574) (fig. 5).[15] By sending such works to far-flung patrons, who then shared them with other elite collectors, Clovio spread his name and talent far beyond Italy.[16] In addition to popularizing this new miniature format, Clovio was also known

FIG. 3 Attributed to Francesco Grigiotti, *All the Saints*, 1634. Full-page miniature from the Seasonal and Festal Missal of Pope Urban VIII, fol. IVv, 37.5 × 28.5 cm. Biblioteca de Castilla-La Mancha, Toledo; MS170

FIG. 4 Giulio Clovio, *Last Judgment*, ca. 1550–60. Full-page miniature from the Towneley Lectionary, fol. 23v, 49.2 × 32.5 cm. New York Public Library, New York, Rare Books and Manuscripts Division; MS91

FIG. 5 Giulio Clovio, *Crucifixion of Christ with St. Mary Magdalene*, signed and dated 1553. Tempera on parchment, 24 × 17 cm. Gabinetto dei Disegni e delle Stampe, Uffizi, Florence; inv. 812/1890

for his masterful use of the pointillist "dot" technique—the building up of an image through many fine dots of color[17]—which would prove especially popular among miniaturists of the subsequent century, including Bisi.[18]

The small scale and detailed handling of miniatures meant that they were best appreciated up close: it is easy to imagine the viewer being capitvated by their luminous surfaces and minute brushwork, and in turn being deeply moved by the religious subjects they depict. Much miniature painting in this period is devoted to religious subject matter and was used as an aid to private, domestic devotion.[19] In some cases, miniatures were incorporated into portable altarpieces with elaborate frames, as seen in examples by the long-lived, intensely religious Genoese miniaturist Giovanni Battista Castello (1547–1639).[20] Castello often borrowed and recombined elements from a wide range of compositional sources[21] to create new, deeply affecting scenes of a monumentality that belies their small size (fig. 6).[22] Like Clovio before him, Castello also gained fame as a manuscript painter, particularly for his work on the liturgical manuscripts commissioned by the king of Spain, Philip II, for the Escorial.[23]

The type of miniature that was Bisi's specialty—copies of paintings by famous masters—is another important category of religious miniature in the seventeenth century.[24] Though Malvasia's biography of the friar mentions only his copies after paintings by his Bolognese contemporary Guido Reni, Bisi also copied famous sixteenth-century artists, including Raphael and Parmigianino (see pp. 40, 41).[25] From the early part of the seventeenth century, copies in miniature of religious paintings from the High Renaissance were in demand at the Medici court in Florence, where miniature painting had been especially appreciated since Clovio's stay there in the 1550s at the behest of Cosimo I.[26] The Marchesan miniaturist Giovanna Garzoni (1600–1670), who produced many types of miniatures during an extended period in Florence under Medici patronage (1642–51), made copies of two Raphael paintings in the Grand Ducal collections and continued to try to copy paintings for the Medici after moving to Rome.[27]

That such copies were valued for religious purposes is suggested by the prevalence of this genre among miniaturists who were members of religious orders. In addition to Bisi, another specialist was his close contemporary in Florence, the Servite

FIG. 6 Giovanni Battista Castello, *Christ Giving the Keys to St. Peter*, 1598. Tempera on parchment, 38.4 × 29.2 cm. Musée du Louvre, Paris, Cabinet des dessins; inv. 3044r

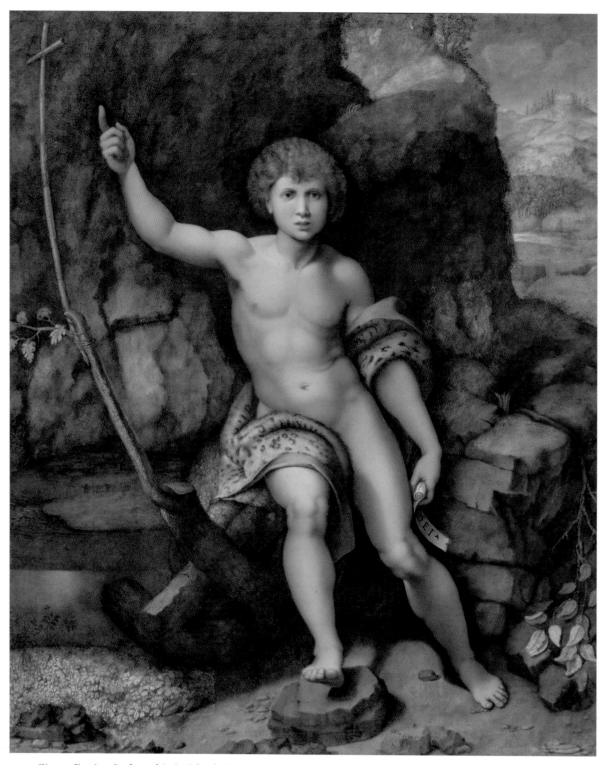

FIG. 7 Giovan Battista Stefaneschi, *St. John the Baptist in the Desert*, before 1638. Tempera on parchment laid down on copper, 44 × 37 cm. Uffizi, Florence; inv. 809/1890

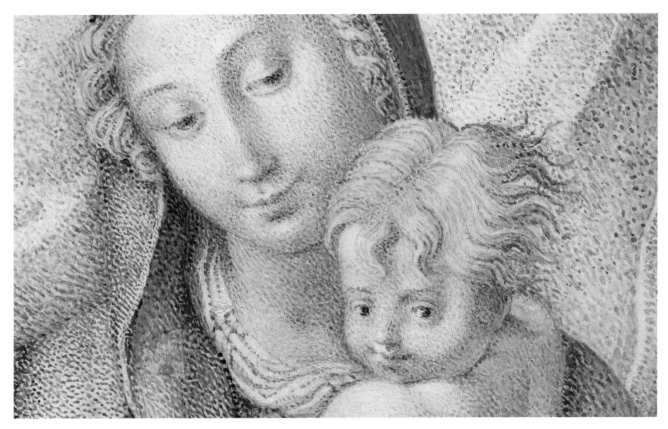

FIG. 8 Fra Bonaventura Bisi after Parmigianino, *Madonna and Child* (detail)

father Giovan Battista Stefaneschi (1582–1659; fig. 7).[28] While both men are praised by their biographers for their skill in "reducing" larger-scale paintings, it is the devoutness of their work that is most emphasized. Malvasia explains that Bisi's copies were desired above all by men of the Church, including Pope Urban VIII (1568–1644), who Malvasia says put Bisi's miniature inside one of his manuscripts,[29] while Stefaneschi's Florentine biographer Filippo Baldinucci relates that the father painted "an infinite number of most beautiful miniatures of devout small images."[30] It should be noted that these paintings, while technically "copies," often introduce important changes from the originals.[31] Some of Bisi's, in particular—where obvious dots of blue are present in flesh tones, and a significant amount of the parchment support

is left untouched, imparting a much airier, more luminous atmosphere to the whole—present quite a different picture from the oil paintings they copy (fig. 8).

At the same time, the horizons of miniature painting were expanding well beyond religious subjects, as individuals involved in scientific study, particularly natural history, found themselves in ever-greater need of detailed representations of the natural world.[32] In the 1570s, Grand Duke Francesco I de' Medici's (1541–1587) passion for science led him to bring to Florence the Veronese painter Jacopo Ligozzi (1547–1627), who executed extraordinary studies on prepared paper of plants, mammals, reptiles, and fish.[33] Ligozzi's depictions are like portraits,[34] going beyond detailed observation of the physical form of a creature (or even

FIG. 9 Jacopo Ligozzi, *A Marmot with a Branch of Plums*, signed and dated 1605. Brush with brown and black wash, point of the brush with black and brown ink and white gouache, and watercolor, over traces of graphite on burnished paper, 33 × 42.3 cm. National Gallery of Art, Washington; inv. 2007.111.121

a plant) to capture its inner spirit (fig. 9).[35] Miniaturists' involvement in scientific study continued into the seventeenth century with projects such as the enormous Paper Museum conceived by Cassiano dal Pozzo in Rome, an endeavor which sought to create a comprehensive visual record of both ancient history and the natural world.[36]

Such close observation of nature is related to the genre of still life, another category in which miniaturists of this period both concentrated and excelled. Bisi is known to have painted vases of flowers (untraced),[37] and similar works have been attributed to Stefaneschi.[38] But it is Giovanna Garzoni who is most associated with the still life miniature in the seventeenth century, due to the remarkable works she executed for the Medici in Florence:[39] parchment sheets depicting vases of flowers or bowls of fruit juxtaposed with insects, birds, and vegetables, images which seem to exist as both snapshots in time and as timeless statements

FIG. 10 Giovanna Garzoni, *Blue Bowl of Strawberries with Pears and Grasshopper Eating Grains of Wheat*, ca. 1655–62. Tempera on parchment, 25 × 33 cm. Uffizi, Florence; inv. 4758/1890

of meaning (fig. 10).[40] The Medici displayed their still life miniatures in places of honor, with examples by Ligozzi hanging in the Tribuna of the Uffizi[41] and those by Garzoni decorating Vittoria della Rovere's Stanza dell'Aurora in the Villa of Poggio Imperiale.[42]

A number of seventeenth-century miniaturists also practiced portraiture, a genre which had been part of the repertoire of manuscript painters in Italy since at least the fifteenth century.[43]

Portraits were another specialty of Garzoni, who executed several during her stay in Turin at the court of the Savoy in the 1630s.[44] Her extraordinary portrait of Zaga Christ (fig. 11)—a pretender to the Ethiopian throne whom she met during his stay at court—is the earliest known European portrait miniature to depict a Black sitter.[45] Its size (less than 3 inches high) and blue background are uncommon for an Italian miniature, but even more unusual is Garzoni's double signature on the

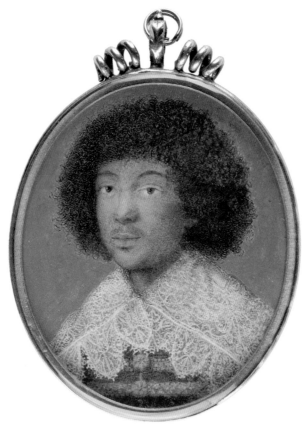

FIG. 11 Giovanna Garzoni, *Portrait of Zaga Christ (Śägga Krǝstos)*, signed and dated 1635. Watercolor and bodycolor on vellum mounted on card, 5.7 × 4.8 cm. Allen Memorial Art Museum, Oberlin College, Museum Friends Fund; inv. 2021.21

reverse, in both Italian and the Ethiopian language Amharic. Though Bisi did not, as far as we know, paint portraits, other miniaturists attached to religious orders did, including Stefaneschi,[46] as well as Bisi's nephew, pupil, and fellow Franciscan (Capuchin) Giuseppe Maria Casarenghi (1639–after 1675; for his portrait, see Chapter 2, fig. 27)[47] and another Capuchin, Ippolito Galantini (1627–1706).[48]

Having returned to the subject of miniaturists from religious orders in this period,[49] I will close by noting that these artists need further study, particularly in terms of how their vocation affected both their professional status and the appreciation of their work. Religious miniaturists like Bisi were obligated to their conventual communities and were thus not free to pursue art full-time. Bisi's

religious obligations are highlighted in Guercino's humorous drawing of him (see p. 16), in which the caption makes reference to the friar's need to wake up early the next morning to preach.[50] Malvasia, in his biography of Bisi, is even more explicit when he states that Bisi took up miniature painting "for recreation" after joining the Franciscan Order.[51] Baldinucci's biography of Stefaneschi (which is much longer and more detailed than Malvasia's treatment of Bisi) specifies how Stefaneschi found time to learn *disegno*, and eventually to study painting, in the few hours left to him after fulfilling his religious duties.[52]

Malvasia's account of Bisi's art, an especially important source for understanding how the friar's miniatures were appreciated in his own time, is short on detail and surprising in what it leaves out.[53] While the biography does note that Bisi surpassed many others who practiced the art of miniature painting due to his early training in *disegno*,[54] Malvasia reports (inaccurately) that Bisi's miniatures consisted solely of copies after paintings by Guido Reni. And though he praises Bisi's ability to preserve Reni's ideas and forms in "reducing" them to the small format of the miniature, he fails to name even one of the friar's paintings[55] and says nothing about his famed use of the "dot" technique (fig. 12).[56] As for the appreciation of Bisi's miniatures, Malvasia says that they attracted mainly men of the Church "and other lovers of these elegant little things"; the only person he names as having received one is Pope Urban VIII.[57] It is especially notable that he omits one of the major events of Bisi's artistic life, the visit he received from Queen Christina of Sweden, who fell so in love with his *Ballo di Putti*—significantly, one of Bisi's less religious subjects—that she insisted on having it for herself.[58] In the rest of the biography, Malvasia is at pains to emphasize and to detail Bisi's devout and humble conduct as a Franciscan friar, going on to explain that he gave all his earnings (which Malvasia says were "a lot") to the Church, paid for very

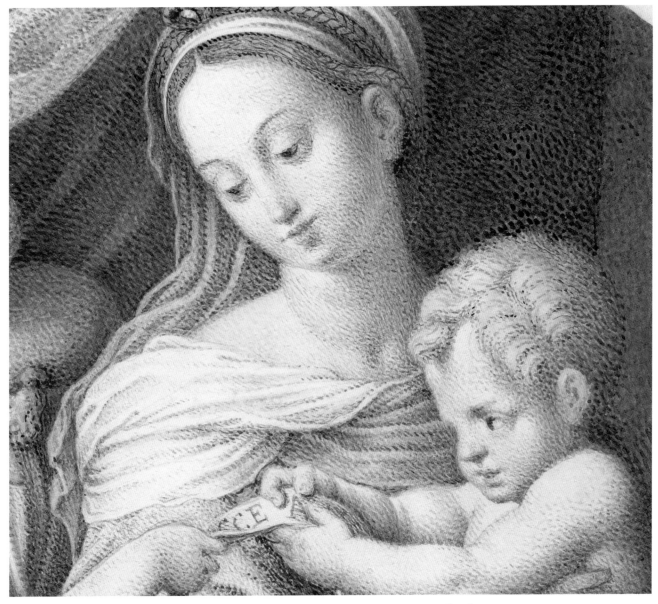

FIG. 12 Fra Bonaventura Bisi after Raphael, *Madonna, Child, and the Infant St. John the Baptist* (detail)

costly liturgical items, and, when repeatedly asked by the Duke of Modena what favor he could grant him, finally said that he wished only for a new habit to wear each year.

To understand Malvasia's elevation of Bisi's religious virtue above his artistic achievement, it is helpful to consider his attitude toward miniature painting more generally in the *Felsina pittrice*. That he had little love for the art is evident from the near-total neglect of miniature painters in the book,[59] as well as from a passage contained in the biography of the painter, engraver, and sometime miniaturist Giovanluigi Valesio (c. 1583–1633):

but it is worth noting, that as long as he was working at the *tavolino* [i.e., a small scale], few could compare, but moving with difficulty to the easel, he fell behind many others; for it is one thing to succeed at miniature painting, and engraving, where some diligence and grace are enough to satisfy; but another thing with painting, where an excellent foundation, and resoluteness, is needed and expected.[60]

Malvasia's criticism here is grave, as it rebukes the two fundamental characteristics of miniature painting we have already discussed: its detailed, painstaking technique, which he sees as less worthy than the bolder, more assured handling typical of large-scale painting; and its small size,[61] which he believes allows the miniature painter to get by without a solid artistic foundation.

In the case of Bisi, however, Malvasia seems to have allowed that the small, modest art he disdained was acceptable and appropriate when practiced by a devout Franciscan painter; that is, for a man whose ambition was only to serve the Church, and for whom humility in the eyes of God was preferable to critical acclaim. Indeed, the emphasis on the religious devotion and humility of Bisi and Stefaneschi in their contemporary biographies—both of which were composed for inclusion in larger compendia of artists' lives—strongly indicates that these qualities were seen as fundamental to their artistic output and to the appreciation of their work. Oliver Tostmann, writing about scale in relation to women's artistic production in this period, has noted that small-sized artworks carried messages about their makers: "Such works exude a sense of privacy, discretion, and to a certain degree humbleness, traits that were perfectly aligned with larger societal expectations of women in early modern Italy and beyond."[62] That similar values, particularly humility, were also expected of men belonging to religious orders probably explains, at least in part, why miniature painting was considered an appropriate pursuit for friars like Bisi, and is an important aspect to keep in mind as we continue to study contemporary reception of their work.

NOTES

1. The phrase is from Masini 1666, 1:6 ("famosissimo Miniatore") and is quoted by Malvasia 1678, 1:560 ("Miniatore Famosissimo").

2. Until the recent efforts of David Stone; see Stone 2020 and Chapter 1 in this volume. Malaguzzi Valeri 1896, 242, notes that in Italy, in contrast to other countries, particularly France, miniature painting was nearly forgotten.

3. Though there is not yet a book-length survey of seventeenth-century Italian miniature painting, this essay is much indebted to the large volume of exciting work that has been done in recent years, particularly on specific artists and centers of production. Bauman 1998, 13–76, provides an excellent overview of technical matters, especially for the sixteenth and seventeenth centuries in Italy. See also the key studies Fumagalli 2020 and Acanfora 2014.

4. Bauman 1998, 13–24, 36–37; and Colding 1953, 9–19.

5. Bauman 1998, 19–22.

6. Bauman 1998, 24–33. I am not including here small works executed in oil, which are sometimes considered to be miniatures (e.g., Agosti 2021, 84); see Tostmann 2021 for broader discussion of small works in this period.

7. Colding 1953, 111; and Acanfora 2014, 29.

8. Bauman 1998, 40–41.

9. Colding 1953, 113.

10. The use of the parchment as the lightest tone of the miniature is noted in seventeenth-century literature, including the definition of miniature painting in the *Vocabolario della Crusca* (1612) and by Filippo Baldinucci in his *Vocabolario toscano dell'arte del disegno* (1681). See Acanfora 2014, 24–25; and Fumagalli 2020, 54.

11. On the shift toward fully independent miniatures, which began in the fifteenth century in Northern Europe, see Bauman 1998, 84–88, 91; and Colding 1953, 19.

12. On the papal manuscripts of the seventeenth century, see De Laurentiis 2011a and 2011b. Another important center of manuscript production in the early seventeenth century was in Pesaro (Duchy of Urbino) under Francesco Maria II Della Rovere. See Meloni Trkulja 1981; Hermens 1990/91; Hermens 1995; and Morselli 2014.

13. Bisi is not known to have painted in manuscripts, though his *cartagloria* for Assisi (see Chapter 1 in this volume) could be considered comparable to manuscript decoration.

14. The quote is from Alexander 2016, 175; for an overview of Clovio's career, see 168–75. Though Clovio is often seen as the key figure in the shift to the independent miniature, it is worth noting that the Paduan artist Giulio Campagnola (c. 1482–c. 1515) executed single miniatures on parchment (now lost), recorded by Marcantonio Michiel in the 1520s as being in the home of Pietro Bembo. See Brooke 2018, 213–14. On Campagnola's early talent as a miniaturist, see Brown 2010, 86–87.

15. Ferber Bogdan 2017, 111, notes that Clovio had been creating single miniatures since his time in Hungary in the 1520s; Alexander 2016, 170, 345 n. 228, says that Clovio was specializing in them from the 1550s. See also Bauman 2001, 66.

16. Alexander 2016, 201, notes that it was one of these which brought Clovio to the attention of Philip II of Spain. See also De Laurentiis Accornero 2002, 158; and Bauman 2001, 66-68.

17. Also called "stippling"; see Colding 1953, 112–13. Bradley 1891, 59–60, notes that the technique was practiced in the North prior to Clovio, and quotes Francisco de Holanda's *Dialogues* (1548), which states that he and Clovio discovered the method independently of each other. In Bisi's lifetime, the Olivetan monk Secondo Lancellotti not only described the technique in detail—he called it "miniatura granita" (granulated miniature painting)—but attributed its discovery to the miniaturist Giovanni Maria Boduino (1524–1617). See Lancellotti 1636, 310 (translated by Bradley 1891, 95); and Hermens 1990/91, 96. On Boduino's (also written Bodovino) use of stippling, see Szepe 2001, 73 n. 32. The notion of Boduino having used the technique before Clovio has been discounted, as his activity is not recorded until the 1550s; see Szepe 2009, 57–60. It seems that the technique enters the northern part of the Italian peninsula first, likely through Venice, where Clovio worked when first coming to Italy, and where Giulio Campagnola had invented in about 1510 a similar stippled technique for engraving, on which see Brown 2010, 88.

18. See Stone 2020, 60–61, and Chapter 1 in this volume, on the poem *Il Punto* (1654) by Luigi Manzini, which revolves around Bisi's use of the dot ("punto") technique. For the notices about the technique by seventeenth-century writers, see Acanfora 2014 and Fumagalli 2020, 54. Baldinucci 1845–47, 4:470,

mentions it in relation to the miniaturist Giovan Battista Stefaneschi.

19. See Di Fabio 1990, 15–17.

20. Known as "Il Genovese" to distinguish him from another artist of the same name. See De Laurentiis 2012; De Laurentiis Accornero 2002; and Di Fabio 1990.

21. De Laurentiis 2012; and De Laurentiis 2014, 688–92.

22. See De Laurentiis 2012, 34; and Avril, Reynaud, and Cordellier 2011, 121–23 (no. 65, entry by C. Di Fabio).

23. Philip had tried to get Clovio to come but was unsuccessful; see Alexander 2016, 171, 345 n. 229; and De Laurentiis Accornero 2002, 158–60.

24. Fumagalli 2020, 57–59; Fumagalli 2019b; and Del Bravo 1961.

25. See D. Stone 2020, 59–60, and Chapter 1 in this volume; and Fumagalli 2020, 58.

26. On demand for such copies in Florence, see Fumagalli 2020, 57–58. On Medici interest in miniature painting, see Bauman 1998; and Acanfora 2014. On Clovio's stay in Florence, see Bauman 2001; Bauman 1998, 28ff; and Alexander 2016, 170, 345 n. 228.

27. Barker 2020, 140–41 (no. 10, entry by E. Fumagalli); and Fumagalli 2020, 57–59, who notes (p. 58) that Garzoni tried to copy a painting by Annibale Carracci in Rome.

28. Del Bravo 1961; Fumagalli 2020, 57–58; and Barker 2020, 140–41 (no. 11, entry by E. Fumagalli).

29. Malvasia 1678, 1:559. On the liturgical manuscripts commissioned by Urban VIII in the 1630s (only some of which survive), see De Laurentiis 2011a and 2011b. Interestingly, some of them do contain miniatures pasted in, though most of these seem to be excisions from much earlier manuscripts; see De Laurentiis 2011b, esp. nos. 26, 27, 37; and Talamo 2011, esp. 5–7.

30. Baldinucci 1845–47, 4:470 ("Fece . . . infinite bellissime miniature di devote immagini piccole"). The volume with Stefaneschi's biography was published posthumously; I have not been able to consult *Per Filippo Baldinucci: Storiografia e collezionismo a Firenze nel secondo Seicento*, ed. E. Fumagalli, M. Rossi, and E. Struhal (Florence, 2021).

31. Changes are noted in copies by Garzoni and Stefaneschi in Barker 2020, 138–41 (nos. 10 and 11, entries by E. De Laurentiis).

32. See Bauman 1998, 119–24.

33. On Ligozzi, see Cecchi, Conigliello, and Faietti 2014; and De Luca and Faietti 2014.

34. Tongiorgi Tomasi 2014, 33.

35. On the *Marmot with a Branch of Plums*, see Chapman, Lachenmann, and Grasselli 2011, 59.

36. On the natural history portion of this project, see McBurney et al. 2017. That both of Bisi's surviving prints have a connection to Cassiano (see Chapter 1 in this volume) is interesting, and suggestive of at least a professional acquaintance.

37. In a letter to Modena (March 30, 1654), Bisi noted "duoi Vasi di fiori" he painted for the duke; Potito 1975, 131. A painting by Bisi listed in the Museo Cospiano in Bologna (Legati 1677, 516) is described as being surrounded by floral ornament, which may have been painted on the parchment ("una Concezione con un'ornamento attorno di varii fiori al naturale").

38. Simari and Acanfora 2014, 48–51 (nos. 1 and 2, entries by E. Acanfora).

39. See, esp., Barker 2020 and Casale 1996.

40. On these, see esp. Garrard 2020.

41. Acanfora 2014, 29.

42. Focarile 2020.

43. Alexander 2016, 212ff; and Bauman 1998, 93–110.

44. On Garzoni's time in Turin, see ffolliott 2020.

45. Barker 2020, 128–29 (no. 5, entry by H. Groen); see also Allen Memorial Art Museum online catalogue entry, https://allenartcollection.oberlin.edu/objects/39335, accessed August 27, 2022.

46. Baldinucci 1845–47, 4:471; none of his portraits have been identified.

47. Casarenghi also worked as an art adviser to Leopoldo de' Medici; see Chapter 2, n. 60, in this volume; Fumagalli 2019a, 145; Fileti Mazza 1993, 1:7; Galleni 1979, 176, 185–86; and Meloni Trkulja 1975, 18. On his self-portrait, see Meloni Trkulja 1976, 46.

48. Galantini assisted Giovanna Garzoni in Florence. See Fumagalli 2020, 58; and Meloni Trkulja 1975, 27. On his self-portrait, see Forlani Tempesti and Petrioli Tofani 1976, 34.

49. The phenomenon is noted by Fumagalli 2020, 57–58.

50. It is also notable that neither Guercino's portrait of Bisi nor his caricature of him—both of which presumably depict him in his room at San Francesco in Bologna—show any evidence of painter's supplies. We know from Bisi's letters that he seems to have painted mostly (if not exclusively) when he could get away to the small convent in rural Pianoro; see also Chapter 2 in this volume.

51. Malvasia 1678, 1:559 ("si diede per diporto a miniare in carta pecora"). This language echoes Giorgio Vasari's characterization of Giulio Clovio's period with the Augustinian Canons Regular, who he says had promised

Clovio that he would have some time to paint miniatures "almost as a pastime"; Vasari 1568, 2.3:850 ("essendogli stato promesso, oltre alla quiete, e riposo della mente, e tranquill' ozio di servire a Dio, che harebbe comodità di attendere alle volte quasi per passatempo a lavorare di minio"). On this period of Clovio's life, see Alexander 2016, 168; Benozzi 2001; and Longhin 2001.

52. Baldinucci 1845–47, 4:468: "davasi, nelle poche ore che gli avanzavano dopo i divini ufizi e sante contemplazione, proprie di quell'istituto, all'esercizio del disegno"; also on p. 468: "e, fatta amicizia col molto eccellente pittore Andrea Comodi fiorentino, procurava, per quanto gli veniva permesso dall'obbligo di sua religiosa osservanza, di conferire con esso ogni studio suo."

53. It seems unlikely that Malvasia did not know Bisi personally; Bisi's letters make reference to help he received from Malvasia's cousin, Cornelio Malvasia, Marquis of Bismantova (1603–1664), in pursuing artwork for the Duke of Modena in 1653 and again in 1658; see Potito 1975, 126–29 and 136–37.

54. Bisi would have acquired this training during his time with the painter Lucio Massari; see Chapter 1 in this volume. Again, Malvasia's language here recalls Vasari, who said that Giulio Clovio had far surpassed all others who had ever practiced "this kind of painting" ("ha di gran lunga superato quanti altri mai si sono in questa maniera di pitture esercitati"; Vasari 1658, 2.3: 849).

55. In his later work, *Le Pitture di Bologna* (1686), 125, Malvasia cites one work by Bisi, a copy of a St. Francis after Guido Reni in the Church of San Francesco ("da un S. Francesco del Sig. Guido, cavò quello ch' è nell'Altare della Sagrestia").

56. See Chapter 1 in this volume.

57. See above, p. 113.

58. See Chapter 2 in this volume. The "other lovers of these elegant little things" may have been Malvasia's way of referring to the Queen.

59. Malvasia includes the first names of a few late thirteenth- and early fourteenth-century manuscript illuminators as part of his early history of Bolognese painting (Malvasia 1678, 1:14–15). Aside from Bisi, he includes only one other seventeenth-century artist who worked principally as a miniaturist, Giacomo Maria Tosi, of whom he notes (1:269) that he learned miniature painting from his father Pier Francesco, and that he drew and painted a book of caricatures of the Massari delle Arti (government representatives of the guilds), which he presented to Grand Prince Ferdinando of Tuscany; on that book see Perini Folesani 2019, 196 and n. 21. The other artists mentioned as having made miniatures—Giovanluigi Valesio, Giacomo Lodi, and Gaspare and Aurelio Passerotti—were more active in painting, engraving, or designing. Malvasia's lack of interest in miniature painting is another parallel with Vasari, who also famously neglects the art. See Acanfora 2014, 26.

60. Malvasia 1678, 2:140: "Ma vaglia il vero, che quanto operando al tavolino, ebbe pochi pari, faticando al trepiedi, restò addietro a molti; altra cosa riuscendo la miniatura, e 'l taglio, ove certa diligenza, e leggiadria basta, ed appaga; altra la pittura, ove un gran fondamento, e risoluzione si ricerca, e vi vuole." Malvasia makes special reference to this passage in the entry under Miniatures ("*Miniature*") in his "Index of Paintings and Notable Things" (2:570): "of Valesio, [whose miniatures] were as excellent as his paintings were weak, and why" ("del Valesio, altrettanto egregie, quanto deboli le sue pitture, e perche").

61. Tostmann 2021, 32, discusses the attitude that larger works were of better quality. Smith 1964 discusses Giulio Clovio's oeuvre in relation to Renaissance attitudes about the size of artworks.

62. Tostmann 2021, 39.

BIBLIOGRAPHY

Acanfora 2014
Acanfora, Elisa. "'You can draw, miniate or paint': Vellum Painting in the Contemporary Literature and Its Fortunes in 17th- and 18th-century Florence." In Simari and Acanfora 2014, 23–37.

Agosti 2001
Agosti, Giovanni, ed. *Disegni del Rinascimento in Valpadana.* Exh. cat. Gabinetto Disegni e Stampe degli Uffizi, Florence, 2001.

Agosti 2021
Agosti, Giovanni. "Miniature e ritrattini." In *Fede Galizia: Mirabile Pittoressa,* edited by Giovanni Agosti, Luciana Giacomelli, and Jacopo Stoppa, 79–87. Exh. cat. Castello del Buonconsiglio, Trent, 2021.

Agostini 1978
Agostini, Grazia, ed. *Tiziano nelle Gallerie Fiorentine.* Exh. cat. Palazzo Pitti, Florence, 1978.

Albèri 1860
Albèri, Eugenio. *Le relazioni degli ambasciatori veneti al Senato durante il secolo decimosesto.* Ser. 1. Vol. 4. Florence, 1860.

Aldrovandi 1827
Nota: Dei disegni e quadri componenti la Galleria del fu Conte Ulisse Vittorio Aldrovandi in Bologna. Bologna, 1827.

Aldrovandi 1869
Notizie de' Quadri della Collezione Aldrovandi in Bologna. Bologna, 1869.

Alexander 2016
Alexander, Jonathan J. G. *The Painted Book in Renaissance Italy 1450–1600.* New Haven, 2016.

Argenti 1711
Argenti, Felice Antonio. *Effigie: Con un breve e succinto ragguaglio della vita di alcuni religiosissimi uomini e pie donne che à tempi nostri hanno fiorito in santità e virtù nell'Ordine serafico de' Minori Conventuali di San Francesco.* Terni, 1711.

Atti 1861
Atti, Gaetano. *Intorno alla vita e alle opere di Gianfrancesco Barbieri detto il Guercino da Cento.* Rome, 1861.

Avril, Reynaud, and Cordellier 2011
Avril, François, Nicole Reynaud, and Dominique Cordellier. *Les Enluminures du Louvre: Moyen Âge et Renaissance.* Exh. cat. Musée du Louvre, Paris, 2011.

Awais-Dean 2017
Awais-Dean, Natasha. *Bejewelled: Men and Jewellery in Tudor and Jacobean England.* London, 2017.

Bagni 1988
Bagni, Prisco. *Il Guercino e i suoi incisori.* Rome, 1988.

Baldinucci 1845–47
Baldinucci, Filippo. *Notizie de' professori del disegno da Cimabue in qua.* Edited by F. Ranalli. Florence, 1845–47. First published Florence, 1681–1728.

Barker 2020
Barker, Sheila, ed. *"The Immensity of the Universe" in the Art of Giovanna Garzoni.* Exh. cat. Gallerie degli Uffizi and Palazzo Pitti, Florence, 2020.

Barocchi and Bertelà 2007
Barocchi, Paola, and Giovanna Gaeta Bertelà, eds. *Il Cardinale Giovan Carlo, Mattias e Leopoldo, 1628–1667.* Collezionismo Mediceo e Storia Artistica 3. 2 vols. Florence, 2007.

Barocchi and Bertelà 2011
Barocchi, Paola, and Giovanna Gaeta Bertelà, eds. *Il Cardinale Leopoldo e Cosimo III, 1667–1675.* Collezionismo Mediceo e Storia Artistica 4. 2 vols. Florence, 2011.

Bauman 1998
Bauman, Jennifer Marie. "Miniature Painting and Its Role at the Medici Court in Florence, 1537–1627." PhD diss., The Johns Hopkins University, 1998.

Bauman 2001
Bauman, Jennifer Marie. "Giulio Clovio and the Revitalization of Miniature Painting at the Medici Court in Florence." In Pelc 2001, 63–73.

Benati and Stone 2020
Benati, Daniele, and David M. Stone, eds. *Nuovi studi sul Guercino: Da Cento a Roma, da Piacenza a Bologna*. Piacenza, 2020.

Benozzi 2001
Benozzi, Sergio. "Don Giulio Clovio Canonico Regolare di San Salvatore." In Pelc 2001, 105–25.

Bentini 1989
Bentini, Jadranka, ed. *Disegni della Galleria Estense di Modena*. Modena, 1989.

Bentini 1998a
Bentini, Jadranka, ed. *Disegni da una grande collezione: Antiche raccolte estensi dal Louvre e dalla Galleria di Modena*. Exh. cat. Palazzo Ducale di Sassuolo, Milan, 1998.

Bentini 1998b
Bentini, Jadranka, ed. *Sovrane Passioni: Studi sul collezionismo estense*. Milan, 1998.

Bentini and Curti 1990
Bentini, Jadranka, and Patrizia Curti, eds. *Ducal Galleria Estense: Dissegni, Medaglie e altro; Gli inventari del 1669 e del 1751*. Modena, 1990.

Beretta 2014
Beretta, Marco. "Material and Temporal Powers at the Casino di San Marco (1574–1621)." In *Laboratories of Art: Alchemy and Art Technology from Antiquity to the 18th Century*, edited by Sven Dupré, 129–56. Heidelberg, 2014.

Bigi Iotti 2011
Bigi Iotti, Alessandra. Entries on *Ten Emperors* by School of Passerotti. In *Da Parmigianino a Piazzetta: Teste, animali e pensieri bizzarri nei disegni della Galleria Estense*, edited by Alessandra Bigi Iotti and Giulio Zavatta, 170–89. Exh. cat. Palazzo Ducale, Guastalla, 2011.

Bindman and Gates 2010
Bindman, David, and Henry Louis Gates, Jr., eds. *The Image of the Black in Western Art: From the "Age of Discovery" to the Age of Abolition, Artists of the Renaissance and Baroque*. Vol. 3, pt. 1. Cambridge, MA, 2010.

Black 1974
Black, J. Anderson. *A History of Jewelry*. London, 1974.

Boccolari 1987
Boccolari, Giorgio. *Le Medaglie di Casa d'Este*. Modena, 1987.

Bohn 2021
Bohn, Babette. *Women Artists, Their Patrons, and Their Publics in Early Modern Bologna*. University Park, PA, 2021.

Bohn and Morselli 2019
Bohn, Babette, and Raffaella Morselli, eds. *Reframing Seventeenth-Century Bolognese Art: Archival Discoveries*. Amsterdam, 2019.

Bonoli 1732
Bonoli, OFM Conv., Girolamo. *Storia di Lugo. . . .* Faenza, 1732.

Bradley 1891
Bradley, John W. *The Life and Works of Giorgio Giulio Clovio, Miniaturist, 1495–1578*. London, 1891.

Brilliant 2017
Brilliant, Virginia. *Italian, Spanish, and French Paintings in the Ringling Museum of Art*. Sarasota, FL, 2017.

Brooke 2018
Brooke, Irene. "'Tratta da Zorzi': Giulio Campagnola's Copies after Other Artists and His Use of Models." In *Making Copies in European Art 1400–1600*, edited by Maddalena Bellaviti, 212–60. Leiden, 2018.

Brown 2010
Brown, David Alan. "Giulio Campagnola: The Printmaker as Painter." *Artibus et Historiae* 31, no. 61 (2010): 83–97.

Bruna 2001
Bruna, Denis. *Piercing, sur les traces d'une infamie médiévale*. Paris, 2001.

Bull 2012
Bull, Duncan. "Ludovico Carracci's *Vision of St Francis*: Inspiration and Influence." *Rijksmuseum Bulletin* 60, no. 4 (2012): 282–315.

Campori 1870
Campori, Giuseppe. *Raccolta di cataloghi ed inventarii inediti. . . .* Modena, 1870.

Carpani 1975
Carpani, Giovanni. *Storia di Pianoro*. Pianoro, 1975.

Casale 1996
Casale, Gerardo, ed. *"Gli Incanti dell'Iride": Giovanna Garzoni pittrice nel Seicento*. Exh. cat. San Severino Marche, 1996.

Casciu, Cavicchioli, and Fumagalli 2013
Casciu, Stefano, Sonia Cavicchioli, and Elena Fumagalli, eds. *Modena Barocca: Opere e artisti alla corte di Francesco I d'Este (1629–1658)*. Florence, 2013.

Cavicchioli 2010
Cavicchioli, Sonia, ed. *Il principe e le cose: Studi sulla corte estense e le arti nel Seicento*. Bologna, 2010.

Cecchi, Conigliello, and Faietti 2014
Cecchi, Alessandro, Lucilla Conigliello, and Marzia Faietti, eds. *Jacopo Ligozzi "Pittore Universalissimo."* Exh. cat. Palazzo Pitti, Florence, 2014.

Chadour-Sampson and Bari 2013
Chadour-Sampson, Beatriz, and Hubert Bari, eds. *Pearls*. Exh. cat. Victoria and Albert Museum, London, 2013.

Champion 1941
Champion, Pierre. *La jeunesse de Henri III*. 2 vols. Paris, 1941.

Chapman, Lachenmann, and Grasselli 2011
Chapman, Hugo, David Lachenmann, and Margaret Morgan Grasselli. *Italian Master Drawings from the Wolfgang Ratjen Collection 1525–1835*. Exh. cat. National Gallery of Art, Washington, DC, 2011.

Chevallier 2012
Chevallier, Jacques. "Le *piercing* dans l'art de l'histoire." *Histoire des Sciences Medicales* 46, no. 3 (2012): 205–302.

Chiarini 1989
Chiarini, Marco. *Gallerie e musei statali di Firenze: I dipinti olandesi del seicento e del settecento*. Cataloghi dei Musei e Gallerie d'Italia. Rome, 1989.

Chiarini de Anna 1976
Chiarini de Anna, Gloria. "Leopoldo de' Medici e la formazione della sua raccolta di disegni." In Forlani Tempesti and Petrioli Tofani 1976, 26–39.

Colding 1953
Colding, Torben Holck. *Aspects of Miniature Painting: Its Origins and Development*. Copenhagen, 1953.

Conticelli, Gennaioli, and Sframeli 2017
Conticelli, Valentina, Riccardo Gennaioli, and Maria Sframeli, eds. *Leopoldo de' Medici, Principe dei Collezionisti*. Exh. cat. Gallerie degli Uffizi and Palazzo Pitti, Florence, 2017.

Cooper 2012
Cooper, Tarnya. *Citizen Portrait: Portrait Painting and the Urban Elite of Tudor and Jacobean England and Wales*. New Haven, 2012.

Cordellier 2004
Cordellier, Dominique, ed. *Primatice Maître de Fontainebleau*. Exh. cat. Musée du Louvre, Paris, 2004.

Cordellier 2005
Cordellier, Dominique, ed. *Primaticcio: Un Bolognese alla Corte di Francia*. Exh. cat. Palazzo Re Enzo, Bologna, 2005.

Coulter 2019
Coulter, Frances. "Drawing Titian's 'Caesars': A Rediscovered Album by Bernardino Campi." *The Burlington Magazine* 161 (July 2019): 563–71.

Covoni 1893
Covoni, Pier Filippo. *Don Antonio de' Medici al Casino di San Marco*. Florence, 1893.

Crespellani 1884
Crespellani, Arsenio. *La Zecca di Modena nei Periodi Comunale ed Estense*. Modena, 1884.

Croniche 1581
Marco da Lisbona. *Croniche degli Ordini instituiti dal P. S. Francesco . . .* [Part 1]. Translated by Horatio Diola. Parma, 1581.

Cueto 2006
Cueto, David García. *Seicento Boloñés y Siglo de Oro Español: El arte, la época, los protagonistas*. Madrid, 2006.

Dacos 1986
Dacos, Nicole. *Le Logge di Raffaello: Maestro e bottega di fronte all'antico*. 2nd ed. Rome, 1986.

Dallasta 2015
Dallasta, Federica. "Orazio Diola Traduttore delle 'Croniche de gli ordini instituiti da Padre San Francesco' di Marcos de Lisboa (1581–1591) e la sua biblioteca." *Collectanea Franciscana* 85 (2015): 523–93.

Dal Poggetto 1980
Dal Poggetto, Maria G. Ciardi Dupré, ed. *Il Tesoro della Basilica di San Francesco ad Assisi*. Florence, 1980.

De Laurentiis 2011a
De Laurentiis, Elena. "The Liturgical Codices of the Seventeenth-Century Papal Court and the Illuminated Manuscripts of Pope Urban VIII in Toledo (Spain)." In *The Lost Manuscripts from the Sistine Chapel: An Epic Journey from Rome to Toledo*, edited by Elena De Laurentiis, 29–56. Exh. cat. Meadows Museum of Art, Southern Methodist University, Dallas, 2011.

De Laurentiis 2011b
De Laurentiis, Elena. "The Seventeenth-Century Codices." In *The Lost Manuscripts from the Sistine Chapel: An Epic Journey from Rome to Toledo*, edited by Elena De Laurentiis, 152–280. Exh. cat. Meadows Museum of Art, Southern Methodist University, Dallas, 2011.

De Laurentiis 2012
De Laurentiis, Elena. "'Il Pio Genovese': Giovanni Battista Castello il Genovese." *Alumina* 37 (2012): 26–35.

De Laurentiis 2014
De Laurentiis, Elena. "La collezione di 'Italian illuminated cuttings' della British Library: Nuove miniature di Simonzio Lupi da Bergamo, Giovanni Battista Castello il Genovese e Sante Avanzini." In *Il codice miniato in Europa: Libri per la chiesa, per la città, per la corte*, edited by Giordana Mariani Canova and Alessanda Perriccioli Saggese, 673–95. Padua, 2014.

De Laurentiis Accornero 2002
De Laurentiis Accornero, Elena. "Giovanni Battista Castello 'Il Genovese,' Giulio Clovio e lo scriptorium dell'Escorial." In *Genova e la Spagna: Opere, committenti, collezionisti*, edited by Piero Boccardo, José Luis Colomer, and Clario Di Fabio, 157–65. Milan, 2002.

Del Bravo 1961
Del Bravo, Carlo. "G. B. Stefaneschi (1582–1659) e le sue traduzioni da testi del '500 classico." *Paragone* 12, no. 137 (1961): 50–53.

Della Casa 2013
della Casa, Giovanni. *Galateo: Or, The Rules of Polite Behavior*. Edited and translated by M. F. Rusnak. Chicago, 2013.

De Luca and Faietti 2014
De Luca, Maria Elena, and Marzia Faietti, eds. *Jacopo Ligozzi, "Altro Apelle."* Florence, 2014.

Dempsey 2001
Dempsey, Charles. *Inventing the Renaissance Putto*. Chapel Hill, NC, 2001.

De Vesme 1906
De Vesme, Alexandre. *Le Peintre-Graveur Italien: Ouvrage faisant suite au Peintre-Graveur de Bartsch*. Milan, 1906.

Di Fabio 1990
Di Fabio, Clario, ed. *Gio. Battista Castello "Il Genovese": Miniatura e devozione a Genova fra Cinque e Seicento*. Exh. cat. Galleria di Palazzo Bianco, Genoa, 1990.

Di Natale 2020
Di Natale, Pietro, ed. *Galleria Fondantico*. Sale cat., TEFAF Maastricht 2020. Bologna, 2020.

Dotti 2020
Dotti, Davide, ed. *La Seduzione della bellezza: Collezione Luigi Cremonini*. Milan, 2020.

Dzik 2015
Dzik, Janina. "Obrazy wizji św. Bonawentury i św. Franciszka z Asyżu (1. poł. XVIII w.) z klasztoru Franciszkanów reformatów w Przemyślu. Nowe rozpoznanie ikonograficzne." *Ochrona Zabytków* 1 (2015): 153–66.

Fabbri 2017
Fabbri, Giancarlo. "San Benedetto di Guzzano, una storia millenaria." *Savena Setta Sambro* 52 (2017): 13–23.

Ferber Bogdan 2017
Ferber Bogdan, Jasenka. "Patrona and *Servitor*: New Insights into the Patron/Artist Relationship between Duchess Margaret of Parma and Giulio Clovio." *Radovi Instituta za Povijest Umjetnosti* 41 (2017): 109–18.

ffolliott 2020
ffolliott, Sheila. "'La miniatrice di Madama Reale': Giovanna Garzoni in Savoy." In Barker 2020, 46–53.

Fileti Mazza 1993
Fileti Mazza, Miriam. *Archivio del Collezionismo Mediceo: Il Cardinal Leopoldo*. Vol. 2: *Rapporti con il mercato emiliano*. 2 vols. Milan, 1993.

Fischetti 2018
Fischetti, Federico. "Ruolo e Fortuna dei Disegni Estensi della Colonna Traiana." *Kölner Jahrbuch* 51 (2018): 511–20.

Focarile 2020
Focarile, Pasquale. "Vittoria della Rovere's Homage to Giovanna Garzoni: The Stanza dell'Aurora in the Villa del Poggio Imperiale." In Barker 2020, 106–115.

Fontenay 1887
Fontenay, Eugène. *Les bijoux anciens et modernes.* Paris, 1887.

Forlani Tempesti and Petrioli Tofani 1976
Forlani Tempesti, Anna, and Anna Maria Petrioli Tofani, eds. *Omaggio a Leopoldo de' Medici.* Part I: *Disegni.* Exh. cat. Gabinetto Disegni e Stampe degli Uffizi, Florence, 1976.

Forlivesi 2002
Forlivesi, Marco. *Scotistarum Princeps: Bartolomeo Mastri (1602–1673) e il suo tempo.* Fonti e Studi Francescani 11. Padua, 2002.

Fumagalli 2019a
Fumagalli, Elena. "Bolognese Paintings in Seventeenth-Century Medici Collections Reconsidered (1600–75)." In Bohn and Morselli 2019, 139–59.

Fumagalli 2019b
Fumagalli, Elena. "Giovanna Garzoni davanti a Raffaello." *Paragone* 147 (September 2019): 45–50.

Fumagalli 2020
Fumagalli, Elena. "Miniature Painters at the Medici Court in the Seventeenth Century." In Barker 2020, 54–60.

Fumagalli and Signorotto 2012
Fumagalli, Elena, and Gianvittorio Signorotto, eds. *La corte estense nel primo Seicento: Diplomazia e mecenatismo artistico.* Rome, 2012.

Galleni 1975
Galleni, Rodolfo. "Bonaventura Bisi e il Guercino." *Paragone* 307 (September 1975): 80–82.

Galleni 1979
Galleni, Rodolfo. "Il bolognese Bonaventura Bisi, frate e pittore tra i Medici e gli Este." *Il Carrobbio* 6 (1979): 175–88.

Galluzzi 1982
Galluzzi, Paolo. "Motivi Paracelsiani nella Toscana di Cosimo II e di Don Antonio dei Medici: Alchimia, medicina 'chimica' e riforma del sapere." In *Scienze e credenze occulte, livelli di cultura,* 31–62. Convegno Internazionale di Studi, Firenze, 26–30 giugno 1980. Florence, 1982.

García Zapata 2019
García Zapata, Ignacio José. *Gremio y ajuares de platería en Bolonia durante la Edad Moderna.* Murcia, 2019.

García Zapata 2020
García Zapata, Ignacio José. "La platería en la Basílica de San Francisco de Bolonia: El tabernáculo de plata de Virgilio Fanelli." In *Estudios de platería. San Eloy 2020,* edited by Jesús Rivas Carmona and Ignacio José García Zapata, 109–20. Murcia, 2020.

Garrard 2020
Garrard, Mary. "The Not-So-Still Lives of Giovanna Garzoni." In Barker 2020, 62–77.

Gibbons 1977
Gibbons, Felton. *Catalogue of the Italian Drawings in the Art Museum, Princeton University.* 2 vols. Princeton, 1977.

Giglioli 1936
Giglioli, Odoardo H. "Della provenienza di alcuni disegni del Gabinetto degli Uffizi." *Rivista d'Arte* 18 (1936): 311–18.

Giordani 1835
Giordani, Gaetano. "Relazione di un fregio dipinto a figure da Gio. Battista Cremonini nella sala del Palazzo Riorio Sforza ora Donzelli in Bologna." *Almanacco statistico bolognese* 6 (1835): 133–73.

Giorgi 2008
Giorgi, Rosa. *The History of the Church in Art.* Translated by Brian Phillips. Los Angeles, 2008.

Goldberg 1983
Goldberg, Edward L. *Patterns in Late Medici Art Patronage.* Princeton, 1983.

Goldberg 1988
Goldberg, Edward L. *After Vasari: History, Art, and Patronage in Late Medici Florence.* Princeton, 1988.

Gozzi et al. 2013
Gozzi, Fausto, Joanna Kilian, Justyna Guze, and Johanna Sikorska. *Guercino: The Triumph of the Baroque; Masterpieces from Cento, Rome, and Polish Collections.* Exh. cat. National Museum, Warsaw, 2013.

Haquet 2011
Haquet, Isabelle. *L'enigme Henri III: Ce que nous révèlent les images.* Paris, 2011.

Härb 2015
Härb, Florian. *The Drawings of Giorgio Vasari (1511–1574).* Rome, 2015.

Hedesan 2021
Hedesan, Georgiana D. "Alchemy and Paracelcianism at the Casino di San Marco in Florence: An Examination of *La fonderia dell'Ill.mo et Ecc.mo Signor Don Antonio de' Medici*." *Nuncius* 1 (2021): 1–25.

Hermens 1990/91
Hermens, Erma. "Valerio Mariani da Pesaro, a 17th-century Italian Miniaturist and His Treatise." *Miniatura* 3/4 1990/91 (1993): 93–102.

Hermens 1995
Hermens, Erma. "A Seventeenth-Century Italian Treatise on Miniature Painting and Its Author(s)." In *Historical Painting Techniques, Materials, and Studio Practices*, edited by Arie Wallert, Erma Hermens, and Marja Peek, 48–57. Preprints of a Symposium, University of Leiden, June 26–29, 1995. Los Angeles, 1995.

Houbraken 1718–21
Houbraken, Arnold. *De groote schouburgh der Nederlantsche konstschilders en schilderessen. . . .* 3 vols. Amsterdam, 1718–21. English translation, *The Great Theatre of the Netherlandish Painters and Paintresses* (online edition). Translated by Hendrik J. Horn and Rieke van Leeuwen. https://houbraken-translated.rkdstudies.nl.

Howell Jolly 2002
Howell Jolly, Penny. "Marked Difference: Earrings and 'the Other' in Fifteenth-Century Flemish Art." In *Encountering Medieval Textiles and Dress: Objects, Texts, Images*, edited by Desirée Koslin and Janet E. Snyder, 194–207. New York, 2002.

Kawase and Watanabe 2016
Kawase, Yusuke, and Shinsuke Watanabe, eds. *Caravaggio and His Time: Friends, Rivals, and Enemies*. Exh. cat. National Museum of Western Art, Tokyo, 2016.

Koerner 2010
Koerner, Joseph Leo. "The Epiphany of the Black Magus Circa 1500." In Bindman and Gates 2010, 7–92.

Lancellotti 1636
Lancellotti, Abbate Secondo. *L'Hoggidì overo gl'ingegni non inferiori à' passati*. Part 2. Venice, 1636.

Lanza di Scalea 1892
Lanza di Scalea, Pietro. *Donne e gioelli in Sicilia nel Medio Evo e nel Rinascimento*. Palermo, 1892.

Lavin 1998
Lavin, Irving. *Bernini e l'immagine del principe cristiano ideale*. Modena, 1998.

Legati 1677
Legati, Lorenzo. *Museo Cospiano annesso a quello del famoso Ulisse Aldrovandi. . . .* Bologna, 1677.

Levi Bianchini 1904
Levi Bianchini, Marco. "Rassegna scientifica: Superstizioni, pregiudizi e terapia empirica nella razza calabrese." *Rivista d'Italia: Lettere, scienze, arti* 7 (Rome, 1904), 1:688–96.

Levi Pisetzky 1964
Levi Pisetzky, Rosita. *Storia del costume in Italia: Il Trecento, Il Quattrocento*. Vol. 2. Milan, 1964.

Levi Pisetzky 1966
Levi Pisetzky, Rosita. *Storia del costume in Italia: Il Cinquecento, Il Seicento*. Vol. 3. Milan, 1966.

Libro dei conti
Il libro dei conti del Guercino 1629–1666. Edited by Barbara Ghelfi. Bologna, 1997.

Lightbown 1992
Lightbown, Ronald W. *Mediaeval European Jewellery with a Catalogue of the Collection in the Victoria and Albert Museum*. London, 1992.

Loisel 2004
Loisel, Catherine. *Ludovico, Agostino, Annibale Carracci*. Inventaire Général des Dessins Italiens 7. Musée du Louvre, Département des Arts Graphiques, Paris, 2004.

Loisel 2013
Loisel, Catherine. "Francesco I d'Este collectionneur de dessins?" In Casciu, Cavicchioli, and Fumagalli 2013, 61–67.

Loisel Legrand 1998
Loisel Legrand, Catherine. "I Disegni bolognesi nella collezione d'Este." In Bentini 1998a, 30–35.

Longhin 2001
Longhin, Sergio. "Nuove fonti su Giulio Clovio." In Pelc 2001, 17–31.

Luti 2006
Luti, Filippo. *Don Antonio de' Medici e i suoi Tempi*. Florence, 2006.

Luti 2010
Luti, Filippo. "Il miele e la cera nel seicentesco ricettario dei segreti di Don Antonio de' Medici." *L'Apis* (January 2010): 24–28.

Malaguzzi Valeri 1896
Malaguzzi Valeri, Francesco. "La Miniatura in Bologna dal XIII al XVIII Secolo." *Archivio Storico Italiano*, ser. 5, 18, no. 204 (1896): 242–315.

Malvasia 1678
Malvasia, Carlo Cesare. *Felsina Pittrice: Vite de' pittori bolognesi.* 2 vols. Bologna, 1678.

Malvasia 1686
Malvasia, Carlo Cesare. *Le Pitture di Bologna.* Bologna, 1686.

Marciari 2019
Marciari, John. *Guercino: Virtuoso Draftsman.* Exh. cat. Morgan Library and Museum, New York, 2019.

Marioli 1985
Marioli, OFM. Conv., Fra Luigi. "Il P. Bonaventura Bisi, ofmconv. (1601–1659), alias 'Padre Pittorino.'" *San Francesco* (periodico mensile, Basilica di S. Francesco, Assisi): Anno 45 (November 1985): 13–19.

Masini 1666
Masini, Antonio di Paolo. *Bologna perlustrata.* 2nd ed. 3 vols. Bologna, 1666.

Mazza 2011
Mazza, Angelo. "Guercino, Reggio, il ducato estense." In *Guercino a Reggio Emilia: La genesi dell'invenzione*, edited by Angelo Mazza and Nicholas Turner, 13–37. Milan, 2011.

McBurney et al. 2017
McBurney, Henrietta, Ian Rolfe, Caterina Napoleone, and Paula Findlen. *The Paper Museum of Cassiano dal Pozzo.* Series B, Parts 4 and 5. *Birds, Other Animals and Natural Curiosities.* 2 vols. London, 2017.

McCall 2022
McCall, Timothy. *Brilliant Bodies: Fashioning Courtly Men in Early Renaissance Italy.* University Park, PA, 2022.

McDonald 2019
McDonald, Mark. *The Print Collection of Cassiano dal Pozzo (The Paper Museum of Cassiano dal Pozzo).* Series C, Prints, Part 2. *Architecture, Topography, and Military Maps.* 3 vols. Turnhout, 2019.

Meloni Trkulja 1975
Meloni Trkulja, Silvia. "Leopoldo de' Medici Collezionista." *Paragone* 26 (1975): 15–38.

Meloni Trkulja 1976
Meloni Trkulja, Silvia, ed. *Omaggio a Leopoldo de' Medici.* Part 2: *Ritrattini.* Exh. cat. Gabinetto Disegni e Stampe degli Uffizi, Florence, 1976.

Meloni Trkulja 1981
Meloni Trkulja, Silvia. "I miniatori di Francesco Maria II." In *Un Omaggio ai Della Rovere: 1631–1981*, edited by Benedetta Montevecchi and Maria Rosaria Valazzi, 33–38. Exh. cat. Galleria Nazionale delle Marche, Urbino, 1981.

Modesti 2001
Modesti, Adelina. "Alcune riflessioni sulle opere grafiche della pittrice Elisabetta Sirani nelle raccolte dell'Archiginnasio." *L'Archiginnasio* 96 (2001): 151–215.

Modesti 2017
Modesti, Adelina. "'Il pennello virile': Elisabetta Sirani and Artemisia Gentileschi as Masculinized Painters?" In *Artemisia Gentileschi in a Changing Light*, edited by Sheila Barker, 131–46. Turnhout, 2017.

Montecchi 2017
Montecchi, Elisa. "Il vescovo di Reggio Paolo Coccapani (1584–1650) e le sue collezioni. Nuovi documenti." *Figure* 3 (2017): 34–58.

Morandotti and Natale 2020
Morandotti, Alessandro, and Mauro Natale, eds. *Vitaliano IV Borromeo: L'Invenzione dell'Isola Bella.* Exh. cat. Palazzo Borromeo, Isola Bella, 2020.

Morselli 1998
Morselli, Raffaella. *Collezioni e quadrerie nella Bologna del Seicento: Inventari 1640–1707.* Italian Inventories 3, Documents for the History of Collecting. Edited by Anna Cera Sones. Los Angeles, 1998.

Morselli 2014
Morselli, Raffaella. "In the Service of Francesco Maria II Della Rovere in Pesaro and Urbino (1549–1631)." In *The Court Artist in Seventeenth-Century Italy*, edited by Elena Fumagalli and Raffaella Morselli, 49–93. Rome, 2014.

Negro, Pirondini, and Roio 2004
Negro, Emilio, Massimo Pirondini, and Nicosetta Roio. *La Scuola del Guercino.* Modena, 2004.

Nuti 1678
Nuti, OFM Conv., Roberto. *Vita del servo di Dio P.F. Giuseppe da Copertino: Sacerdote dell'Ordine de' Minori Conventuali.* Palermo, 1678.

Oretti MS B. 126
Oretti, Marcello. *Notizie de' Professori. . . .* 4. BCABo MS. B. 126. undated (c. 1760).

Oretti MS B. 133
Oretti, Marcello. *Notizie de' Professori. . . .* 4. BCABo MS. B. 133. undated (c. 1760).

Ostrow 2011
Ostrow, Steven. "(Re)presenting Francesco I d'Este: An Allegorical Still Life in the Minneapolis Institute of Arts." *Artibus et Historiae* 63 (2011): 201–16.

Owen Hughes 1986
Owen Hughes, Diane. "Distinguishing Signs: Ear-Rings, Jews, and Franciscan Rhetoric in the Italian Renaissance City." *Past & Present* 112 (August 1986): 3–59.

Papi 2010
Papi, Gianni, ed. *Caravaggio e i caravaggeschi a Firenze.* Exh. cat. Galleria Palatina, Florence, 2010.

Papini Tartagni 1824
Papini Tartagni, Niccolò. *Notizie sicure della morte, sepoltura, canonizzazione e traslazione di San Francesco d'Assisi.* 2nd ed. Foligno, 1824.

Parisciani 1984
Parisciani, OFM Conv., Gustavo. *La Riforma Tridentina e i Frati Minori Conventuali.* Rome, 1984.

Parisciani 1992
Parisciani, OFM Conv., Gustavo. "Il convento di S. Francesco a Bologna OFM-Conv. nell'inchiesta innocenziana del 1650." *Miscellanea Francescana* 92 (1992): 545–74.

Pazzini 1948
Pazzini, Adalberto. *La Medicina Popolare in Italia: Storia, Tradizioni, Leggende.* Trieste, 1948.

Pelc 1998
Pelc, Milan. *Fontes Clovianae: Julije Klović u dokumentima svoga doba.* Zagreb, 1998.

Pelc 2001
Pelc, Milan, ed. *Klovićev Zbornik: Minijatura, crtež, grafika 1450–1700; Zbornik radova sa znanstvenoga skupa povodom petstote obljetnice rodenja Jurja Julija Klovićea, Zagreb, 22–24 listopada 1998.* Zagreb, 2001.

Pepper 1984
Pepper, D. Stephen. *Guido Reni: A Complete Catalogue of His Works.* Oxford, 1984.

Perini Folesani 2019
Perini Folesani, Giovanna. "La poesia ecfrastica ed encomiastica tra elemento esornativo e documento storico: Il caso della *Felsina pittrice* di Carlo Cesare Malvasia." *Italique* 22 (2019): 191–208.

Perini Folesani 2021
Perini Folesani, Giovanna. "L'apparato illustrativo della *Felsina Pittrice*—Riflessioni su un prodotto editoriale della storiografia secentesca." *Kritiké* 2 (2021): 55–91, 306.

Phillips 1996
Phillips, Clare. *Jewelry from Antiquity to the Present.* London, 1996.

Piccinini and Stefani 2009
Piccinini, Francesca, and Cristina Stefani, eds. *La donazione Sernicoli: Dipinti e argenti.* Exh. cat. Museo Civico d'Arte, Modena, 2009.

Pieri and Varini 2006
Pieri, Marzio, and Diego Varini, eds. *Il Buratto ed il Punto: Concettismo, retorica, e pittura fra Genova e Bologna, 1629–1652.* Trent, 2006.

Pitrè 1896
Pitrè, Giuseppe. *Medicina popolare siciliana.* Turin, 1896.

Porto 2002
Frei Marcos de Lisboa: Cronista Franciscano e Bispo do Porto. Acts of the Porto conference, October 2001. *Revista de Faculdad de Letras do Porto, Série Linguas e Literaturas* 12 (2002).

Potito 1975
Potito, Amedeo. *Il Pittorino Bolognese: Fra Bonaventura Bisi (1612–1659), Lettere dirette al Principe Cardinale Leopoldo de' Medici e al Duca Alfonso d'Este.* Urbania, 1975.

Potter 2008
Potter, Jennifer. *Strange Blooms: The Curious Lives and Adventures of the Tradescants.* Chicago, 2008.

Rivani 1968
Rivani, Giuseppe. "San Benedetto di Guzzano di Pianoro." *Strenna Storica Bolognese* 18 (1968): 91–97.

Robbiani 2001
Robbiani, Marina. *Gli Orecchini: Mito e Seduzione.* Milan, 2001.

Rocca 2000
Rocca, Giancarlo, ed. *La Sostanza dell'Effimero: Gli abiti degli Ordini religiosi in Occidente.* Exh. cat. Museo Nazionale di Castel Sant'Angelo, Rome, 2000.

Roethlisberger-Bianco 1970
Roethlisberger-Bianco, Marcel. *Cavalier Pietro Tempesta and His Time.* Newark, DE, 1970.

Rossi 2010
Rossi, Manuela, ed. *Rare Pitture: Ludovico Carracci; Guercino e l'arte nel Seicento a Carpi.* Exh. cat. Musei di Palazzo dei Pio, Carpi, 2010.

Sgarbi 2015
Sgarbi, Vittorio, ed. *Da Cimabue a Morandi: Felsina Pittrice.* Exh. cat. Palazzo Fava, Bologna, 2015.

Simari and Acanfora 2014
Simari, Maria Matilde, and Elisa Acanfora, eds. *Pergamene fiorite: Pitture di Fiori dalle collezioni medicee / Flowers on Vellum: Floral Paintings from the Medici Collections.* Exh. cat. Villa Medicea di Poggio a Caiano, Florence, 2014.

Sirocchi 2015
Sirocchi, Simone. "Pagine inedite di collezionismo estense: Il Mecenatismo e gli interessi artistici di Alfonso IV (1634–1662) dai registri delle sue spese." *Storia dell'arte* 140 (2015): 73–82.

Sirocchi 2017
Sirocchi, Simone. Entry on drawings of Roman Emperors (Ambito di Passerotti). In *Mutina Splendidissima: La città romana e la sua eredità,* edited by Luigi Malnati et al., 539–40, no. 3 (a-c). Exh. cat. Foro Boario, Modena, 2017.

Sirocchi 2018
Sirocchi, Simone. *Parigi e Modena nel Grand Siècle: Gli artisti francesi alla corte di Francesco I e Alfonso IV d'Este.* Trieste, 2018.

Smith 1964
Smith, Webster. "Giulio Clovio and the 'Maniera di Figure Piccole.'" *Art Bulletin* 46 (September 1964): 395–401.

Spear 2020
Spear, Richard. "'Guercino ritrattista' (1981) rivisto." In Benati and Stone 2020, 47–56.

Steinbach 1995
Steinbach, Ronald D. *The Fashionable Ear: A History of Ear-Piercing Trends for Men and Women.* New York, 1995.

Stone 1989
Stone, David M. "Theory and Practice in Seicento Art: The Example of Guercino." PhD diss., Harvard University, 1989.

Stone 1991a
Stone, David M. *Guercino: Catalogo completo dei dipinti.* Florence, 1991.

Stone 1991b
Stone, David M. *Guercino Master Draftsman: Works from North American Collections.* Exh. cat. Harvard University Art Museums, Cambridge, MA. Bologna, 1991.

Stone 2019
Stone, David M. "Up for Attribution: Guercino's 'Trial Versions' and a New Catalogue Raisonné." *The Burlington Magazine* 161 (March 2019): 206–13.

Stone 2020
Stone, David M. "Il frate con l'orecchino d'oro: Bonaventura Bisi, pittore e mercante d'arte, e un nuovo ritratto del Guercino." In Benati and Stone 2020, 57–70.

Straussman-Pflanzer and Tostmann 2021
Straussman-Pflanzer, Eve, and Oliver Tostmann, eds. *By Her Hand: Artemisia Gentileschi and Women Artists in Italy, 1500–1800.* Exh. cat. Wadsworth Atheneum, Hartford, 2021.

Streliotto 2000
Streliotto, Giuseppe, ed. *Gaspar ab Avibus: Incisore citadellese del XVI secolo.* Cittadella, 2000.

Strocchia 2019
Strocchia, Sharon T. *Forgotten Healers: Women and the Pursuit of Health in Late Renaissance Italy.* Cambridge, MA, 2019.

Sueur 1998
Sueur, Hélène. "Per la storia e la fortuna della collezione di disegni dei duchi d'Este." In Bentini 1998a, 20–28.

Szepe 2001
Szepe, Helena. "Civic and Artistic Identity in Illuminated Venetian Documents." *Bulletin du Musée Hongrois des Beaux-Arts* 95 (2001): 59–78.

Szepe 2009
Szepe, Helena. "Venetian Miniaturists in the Era of Print." In *The Books of Venice / Il Libro Veneziano,* edited by Lisa Pon and Craig Kallendorf. Special issue of *Miscellanea Marciana* 20 (2009): 31–60.

Talamo 2011
Talamo, Emilia Anna. "The Codices of the Sistine Sacristy." In *The Lost Manuscripts from the Sistine Chapel: An Epic Journey from Rome to Toledo*, edited by Elena De Laurentiis, 1–21. Exh. cat. Meadows Museum of Art, Southern Methodist University, Dallas, 2011.

Tongiorgi Tomasi 2014
Tongiorgi Tomasi, Luca. " 'Tutte le pitture dipinte dal vivo dal signor Jacomo Ligozzi, a' quali non mancha se non il spirito.' " In Cecchi, Conigliello, and Faietti 2014, 29–37.

Tostmann 2021
Tostmann, Oliver. "The Advantages of Painting Small: Italian Women Artists and the Matter of Scale." In Straussman-Pflanzer and Tostmann 2021, 31–41.

Turčič 1985–86
Turčič, Lawrence. "More Drawings at Worms." *Master Drawings* 23/24, no. 2 (1985–86): 207–12, 277–85.

Turner 2017
Turner, Nicholas. *The Paintings of Guercino: A Revised and Expanded Catalogue Raisonné*. Rome, 2017.

Turner and Plazzotta 1991
Turner, Nicholas, and Carol Plazzotta. *Drawings by Guercino from British Collections*. Exh. cat. British Museum, London, 1991.

Unglaub 1998–99
Unglaub, Jonathan W. "Bolognese Painting and Barberini Aspirations: Giovanni Battista Manzini in the Archivio Dal Pozzo." *Accademia Clementina: Atti e Memorie* 38–39 (1998–99): 31–75.

Unglaub 2003
Unglaub, Jonathan. "Poussin's *Esther before Ahasuerus*: Beauty, Majesty, Bondage." *Art Bulletin* 85, no. 1 (March 2003): 114–36.

Vasari 1568
Vasari, Giorgio. *Le vite de' più eccellenti pittori, scultori, et architettori*. 2nd ed. 3 vols. Florence, 1568.

Venetucci 2010
Venetucci, Beatrice Palma, ed. *Il Fascino dell'Oriente nelle Collezioni e nei Musei d'Italia*. Exh. cat. Scuderie Aldobrandini, Frascati, 2010.

Venturelli 1999
Venturelli, Paola. *Glossario e documenti per la Gioielleria Milanese (1459–1631)*. Milan, 1999.

Venturi 1882
Venturi, Adolfo. *La regia galleria estense in Modena*. Modena, 1882.

Vranceanu Pagliardini 2017
Vranceanu Pagliardini, Alexandra. "I motivi di una scelta: Stefano Guazzo e il 'Prencipe della Valacchia Maggiore' come modello morale per la corte." *Philologica Jassyensia* 13, no. 1 (2017): 261–73.

Vranceanu Pagliardini 2020
Vranceanu Pagliardini, Alexandra. *Memoriale delle cose occorse a me Franco Sivori dopo la mia partenza da Genova l'anno 1581 per andare in Vallachia*. Canterano, 2020.

Weston-Lewis 1998
Weston-Lewis, Aidan, ed. *Effigies and Ecstasies: Roman Baroque Sculpture and Design in the Age of Bernini*. Exh. cat. National Gallery of Scotland, Edinburgh, 1998.

Winkler 1989
Winkler, Johannes, ed. *La Vendita di Dresda*. Modena, 1989.

Zani 1672
Zani, Valerio. *Memorie imprese, e ritratti de' signori Accademici Gelati di Bologna*. Bologna, 1672.

Zanotti 2013
Zanotti, Gino. *La Provincia Bolognese di Sant'Antonio di Padova dei Frati Minori Conventuali, Sintesi Storica*. Edited by Eugenio Preti. Bologna, 2013.

EXHIBITION CHECKLIST

Francesco Albani (1578–1660)
St. John the Baptist in the Wilderness, ca. 1600
Oil on copper
19⅜ × 14¹³⁄₁₆ in. (49.2 × 37.7 cm)
The John & Mable Ringling Museum of Art,
Sarasota; inv. SN115

Anonymous Venetian
Black Crowned Night Heron (Ardea Nycticorax),
16th century
Various colored washes, gouache, traces of black
chalk
22⅞ × 16⁹⁄₁₆ in. (581 × 420 mm)
Gabinetto dei Disegni e delle Stampe, Uffizi,
Florence; inv. 2132 Orn.

Sisto Badalocchio (1585–ca. 1647)
Susannah and the Elders, ca. 1602–10
Oil on canvas
63¹⁵⁄₁₆ × 43⅞ in. (162.4 × 111.4 cm)
The John & Mable Ringling Museum of Art,
Sarasota; inv. SN111

Fra Bonaventura Bisi (1601–1659)
Angel Appearing to St. Jerome, after 1645 (?)
Tempera on parchment
16¹⁵⁄₁₆ × 14⁹⁄₁₆ in. (43 × 37 cm)
Galleria Estense, Modena; inv. R.C.G.E. 1372

Fra Bonaventura Bisi (1601–1659)
*Holy Family with St. Elizabeth and the Infant St. John
the Baptist*, 1634
Engraving with etching
12½ × 9¼ in. (318 × 235 mm)
Private collection

Fra Bonaventura Bisi (1601–1659)
Madonna and Child (tondo), after 1645 (?)
Tempera on parchment
9¹⁄₁₆ × 8¼ in. (23 × 21 cm)
Galleria Estense, Modena; inv. R.C.G.E. 2294

Fra Bonaventura Bisi (1601–1659)
Madonna, Child, and the Infant St. John the Baptist
(tondo), after 1645 (?)
Tempera on parchment
9¹⁄₁₆ × 8¼ in. (23 × 21 cm)
Galleria Estense, Modena; inv. R.C.G.E. 2295

Luca Cambiaso (1527–1585)
*St. Sebastian with the Madonna and Child, Sts. Mark
and John the Baptist*, early 1560s
Pen and brown ink, with brush and brown wash
21⅜ × 13¹³⁄₁₆ in. (543 × 351 mm)
The John & Mable Ringling Museum of Art,
Sarasota; inv. SN958

Guercino (Giovanni Francesco Barbieri;
1591–1666)
Annunciation, 1628–29
Oil on canvas
76¼ × 108¾ in. (193.7 × 276.2 cm), each section
The John & Mable Ringling Museum of Art,
Sarasota; inv. SN122

Guercino (1591–1666)
Portrait of Fra Bonaventura Bisi, ca. 1658–59
Oil on canvas
37 × 30⅛ in. (94 × 76.5 cm)
The John & Mable Ringling Museum of Art,
Sarasota; inv. SN11531

Guercino (1591–1666)
*Self-Portrait before a Painting of "Amor Fedele et
Eterno,"* 1655
Oil on canvas
45¹¹⁄₁₆ × 37⅝ in. (116 × 95.6 cm)
National Gallery of Art, Washington;
inv. 2005.13.1

Guercino (1591–1666)
Unshaven Monk, 1630s–40s
Pen and ink
6¹⁵⁄₁₆ × 6½ in. (177 × 165 mm)
Princeton University Art Museum; inv. x1948-1308

Adriaen Haelwegh (1637–ca. 1696)
Portrait of Cardinal Leopoldo de' Medici, ca. 1680–99
Engraving
13⁵⁄₁₆ × 9⅝ in. (344 x 244 mm)
The John & Mable Ringling Museum of Art,
Sarasota; inv. SN8563

Lorenzo Loli (ca. 1612–1691) after Giovanni
Andrea Sirani
Fame Blowing a Trumpet Flying over the Globe,
1630–60
Etching
7⁹⁄₁₆ × 5½ in. (19.2 × 14 cm)
The John & Mable Ringling Museum of Art,
Sarasota; inv. SN8701

Luigi Manzini (1604–1657)
Il Punto (Bologna, 1654)
Book
8⅞ × 6⅝ in. (226 × 169 mm)
Biblioteca Comunale dell'Archiginnasio, Bologna;
17. Scritt. Bol. Filol. Poesie Ital. caps II, n. 61

Lucio Massari (1569–1633)
Penitent St. Jerome, ca. 1613
Oil on canvas
30⅛ × 37 in. (76.5 × 94 cm)
Museo Civico, Modena; inv. Ser. 24

Domenico Maria Muratori (1661–1742)
Portrait of Fra Bonaventura Bisi, ca. 1680–89
Engraving
7¼ × 5⅝ in. (185 × 143 mm)
Biblioteca Comunale dell'Archiginnasio, Bologna;
Collez. Ritratti, b.7, fasc. 77, n. 2

Girolamo Pallantieri (1623–ca. 1685)
Lettera . . . Buonaventura Bisi (Bologna, 1646)
Printed pamphlet
7¹¹⁄₁₆ × 5⁵⁄₁₆ in. (196 × 141 mm)
Biblioteca Comunale dell'Archiginnasio, Bologna;
17. Scritt. Bol. Filol. Belle Arti, caps. II, n. 65

Parmigianino (Girolamo Francesco Maria
Mazzola; 1503–1540)
Madonna and Child with Three Female Figures,
ca. 1524–27
Red chalk, white heightening
6¹⁵⁄₁₆ × 6¾ in. (176 × 171 mm)
Gabinetto dei Disegni e delle Stampe, Uffizi,
Florence; inv. 1976 F.

Parmigianino (1503–1540)
Suicide of Dido, ca. 1525–40
Metalpoint on prepared parchment
3¾ × 2⅞ in. (95 × 73 mm)
Gabinetto dei Disegni e delle Stampe, Uffizi,
Florence; inv. 13610 F

School of Bartolomeo Passerotti (1529–1592)
Julius Caesar, ca. 1600–1610 (?)
Pen and brown ink, squared in white chalk
12½ × 8 ⁷⁄₁₆ in. (317 × 214 mm)
Galleria Estense, Modena; inv. 849

School of Bartolomeo Passerotti (1529–1592)
Galba, ca. 1600–1610 (?)
Pen and brown ink, squared in white chalk
12¼ × 8⁷⁄₁₆ in. (311 × 214 mm)
Galleria Estense, Modena; inv. 850

Pordenone (Giovanni Antonio de' Sacchis;
ca. 1484–1539)
Ballo di Putti (Dancing Putti), ca. 1532–36
Black chalk with white highlights on oxidized
blue paper (now turned brown)
7¹⁵⁄₁₆ × 14¹⁄₁₆ in. (202 × 357 mm)
Gabinetto dei Disegni e delle Stampe, Uffizi,
Florence; inv. 729 E

Francesco Primaticcio (1504–1570)
*Carro della Luna (Chariot of the Moon with Two Gods
of Sleep)*, ca. 1526–28
Black chalk, pen and ink, brush and wash, white
highlights
11¼ × 19⁵⁄₁₆ in. (285 × 490 mm)
Gabinetto dei Disegni e delle Stampe, Uffizi,
Florence; inv. 13335 F

Francesco Primaticcio (1504–1570)
Carro del Sole (Chariot of the Sun preceded by Aurora),
ca. 1526–28
Black chalk, pen and ink, brush and wash, white
highlights
12½ × 19⁹⁄₁₆ in. (317 × 497 mm)
Gabinetto dei Disegni e delle Stampe, Uffizi,
Florence; inv. 13332 F

Francesco Primaticcio (1504–1570)
Juno Invoking Somnus to put Jupiter to Sleep,
ca. 1541–44
Pen and brown ink, red wash, traces of black chalk
and stylus, white highlights
8¹¹⁄₁₆ × 13⅛ in. (221 × 333 mm)
Gabinetto dei Disegni e delle Stampe, Uffizi,
Florence; inv. 695 E

Guido Reni (1575–1642)
Virgin Nursing the Christ Child, ca. 1628–30
Oil on canvas
45 × 36 in. (114.3 × 91.4 cm)
North Carolina Museum of Art, Raleigh;
inv. G.55.12.1

Workshop of Guido Reni (1575–1642)
Salome Receiving the Head of John the Baptist,
ca. 1639–42
Oil on canvas
75 × 60 in. (190.5 × 152.4 cm)
The John & Mable Ringling Museum of Art,
Sarasota; inv. SN119

Bartolomeo Schedoni (1578–1615)
Sleeping Christ Child with Mary and Joseph,
ca. 1610–15
Oil on wood
10¼ × 22¼ in. (26 × 56.5 cm)
The John & Mable Ringling Museum of Art,
Sarasota; inv. SN674

Elisabetta Sirani (1638–1665)
Delilah, 1664
Oil on canvas
21⅝ × 17½ in. (55 × 44.5 cm)
Private collection, Connecticut (courtesy Robert
Simon Fine Art)

Elisabetta Sirani (1638–1665)
Madonna, Child, and the Infant St. John the Baptist,
ca. 1659 (?)
Etching
9¼ × 8⁷⁄₁₆ in. (235 × 214 mm)
Biblioteca Comunale dell'Archiginnasio, Bologna;
inv. SAV1420

Elisabetta Sirani (1638–1665)
Portrait of Anna Maria Ranuzzi as Charity, 1665
Oil on canvas
35⅜ × 30½ in. (89.9 × 77.5 cm)
Private collection, Connecticut (courtesy Robert
Simon Fine Art)

Attributed to Elisabetta Sirani (1638–1665)
Venus and Anchises, ca. 1665
Brush and brown wash over black chalk with
traces of white chalk
13¼ × 11 in. (33.7 × 27.9 cm)
The John & Mable Ringling Museum of Art,
Sarasota; inv. SN309

Francesco Stringa, attributed to (1635–1709)
*Allegorical Still Life with Bernini's Bust of Duke
Francesco I d'Este*, ca. 1660
Oil on canvas
53½ × 40⅛ in. (135.9 × 101.9 cm)
Minneapolis Institute of Art; inv. 38.38

Bernardo Strozzi (1581–1644)
Act of Mercy: Giving Drink to the Thirsty, 1620s
Oil on canvas
52¼ × 74⅝ in. (132.7 × 189.5 cm)
The John & Mable Ringling Museum of Art,
Sarasota; inv. SN634

Elia Teseo, attributed to (active, 1648–1669)
Portrait Medal of Duke Alfonso IV d'Este of Modena
Cast and chased silver
3½ in. (88.9 mm) (diam.)
Minneapolis Institute of Art; inv. 67.55.2

Lorenzo Tinti (1626–1672)
Portrait of Luigi Manzini, before 1672
Engraving
5¾ × 4¼ in. (146 × 108 mm)
Biblioteca Comunale dell'Archiginnasio, Bologna;
Collez. Ritratti, b. 36, fasc. 35, n. 1

Taddeo Zuccaro (1529–1566)
Adoration of the Shepherds, ca. 1566
Pen and ink, white highlights on brown paper
16¼ × 11⁵⁄₁₆ in. (413 × 287 mm)
Gabinetto dei Disegni e delle Stampe, Uffizi,
Florence; inv. 11208 F

INDEX

PICTURE CREDITS

Allen Memorial Art Museum, Oberlin College: 116. Allen Phillips / Wadsworth Atheneum: 98 (right). Archivio di Stato, Bologna: 52. Archivio fotografico del Museo Civico di Modena: 20 (conservation by Studio Restauro of Daniela Bursi, Sassuolo, MO). © Archivio fotografico del Sacro Convento di S. Francesco in Assisi: 30–34, 104. Image © Ashmolean Museum, University of Oxford: 16, 97. Biblioteca Comunale dell'Archiginnasio, Bologna: 15, 38, 44, 45 (left), 69 (top left). Biblioteca de Castilla–La Mancha, Toledo: 108. Bibliothèque nationale de France: 90 (right), 91 (left), 96 (right). bpk Bildagentur / Alte Pinakothek, Bayerische Staatsgemäldesammlungen, Munich, Germany / Art Resource, NY: 95. bpk Bildagentur / Gemäldegalerie Alte Meister, Staatliche Kunstsammlungen, Dresden, Germany: 39. British Library, London: 28. Courtesy HSH Princess Rita Boncompagni Ludovisi at the Villa Aurora in Rome: 24 (bottom). Collezione BolognArt di Francesco Bonetti, Bologna: 51. © The Fitzwilliam Museum, Cambridge: 54 (top left). Fondazione Carisbo, Bologna: 53. Foto archivio Borromeo Isola Bella Stresa: 99. Gabinetto Fotografico delle Gallerie degli Uffizi: 21 (bottom left), 42 (left), 50, 57, 69 (bottom), 70–73, 75–76, 93–94, 110, 112, 115. Galleria Fondantico, Bologna: 21 (top). Getty Research Institute: 56. HIP / Art Resource, NY: 58. © KHM–Museumsverband: 42 (right). Library, National Gallery of Art, Washington: 66 (left). Metropolitan Museum of Art, New York: 22–23, 35, 106. Minneapolis Institute of Art: 54 (top right), 55. The Morgan Library & Museum, New York: 88 (top right). © Musée du Louvre, Dist. RMN–Grand Palais / Michel Urtado / Art Resource, NY: 80. Musei di Palazzo dei Pio, Carpi (MO): 59 (top). Museo di Capodimonte, Naples: 65. Museum Heylshof, Worms / Foto Stefan Blume: 27 (right). National Galleries of Scotland, Edinburgh: 27 (left). Courtesy National Gallery of Art, Washington: 18, 114. © National Portrait Gallery, London: 91 (right), 98 (left). Nationalmuseum, Stockholm: 77, 88 (bottom) (photo: Anna Danielsson). New York Public Library: 109. North Carolina Museum of Art, Raleigh: 25. Numismatica Ars Classica: 14. Palazzo Mengoni, Comune di Castel Bolognese (RA): 45 (right). Pinacoteca Civica, Cento: 21 (bottom right). Image courtesy of Princeton University Art Museum / photo: Jeff Evans: 17. Rijksmuseum, Amsterdam: 92. © RMN–Grand Palais / Art Resource, NY: 60, 64, 96 (left), 111. Courtesy Robert Simon Fine Art, New York: 37. Royal Collection Trust / © His Majesty King Charles III 2022: 89, 90 (left). Smith College Museum of Art, Northampton, MA: 36. Courtesy of Sotheby's: 19, 59 (bottom). Sterling and Francine Clark Art Institute Library: 78. Su concessione del Ministero della Cultura—Archivio fotografico delle Gallerie Estensi: 40–41, 43, 62–63, 67–68, 107, 113, 117. © The Trustees of the British Museum: 26. Yale University Art Gallery: 66 (right).